# Constantin Brancusi

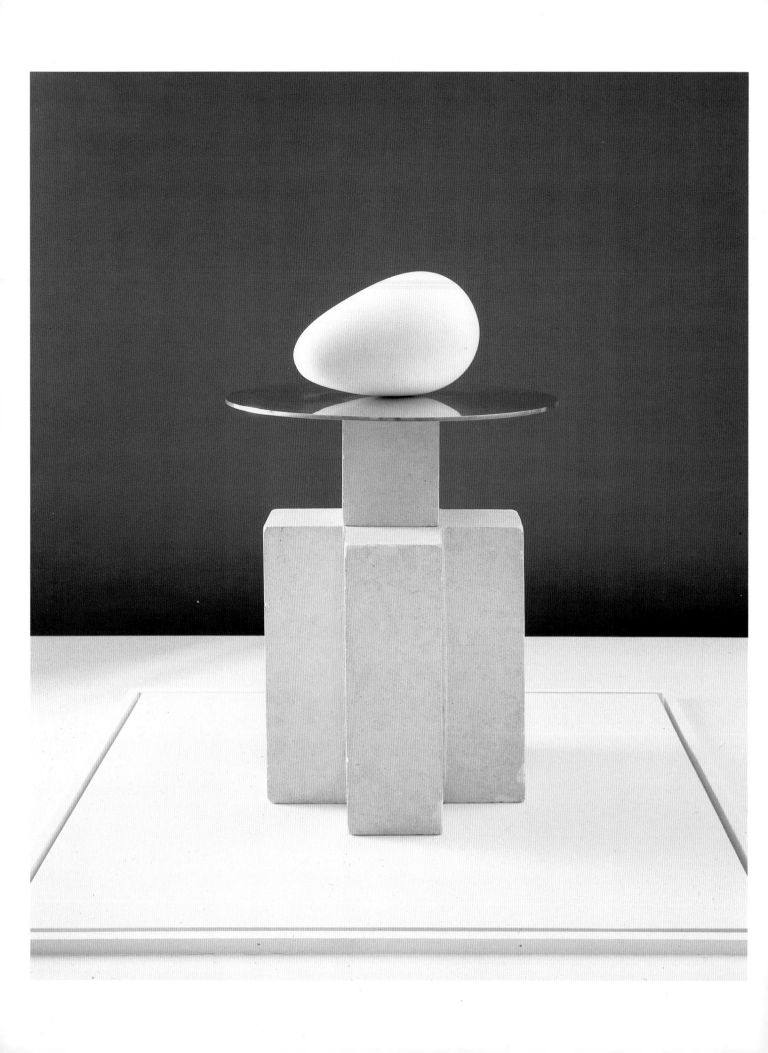

MODERN MASTERS SERIES

# Constantin Brancusi

## Eric Shanes

ABBEVILLE PRESS · NEW YORK

*Constantin Brancusi* is volume twelve in the Modern Masters series.

## For Don and Barbara Malin, with much love

ACKNOWLEDGMENTS: I should especially like to thank Professor Barbu Brezianu, the leading Romanian authority on Brancusi, who was my constant companion and guide to Brancusi's works in Romania in 1982, and whose continuing help has been of inestimable value. Equally I am grateful to the British Council for awarding me the cultural-exchange program tour of the country on which I met him. I must also thank the leading American Brancusi scholar, Sidney Geist; Elena Udriște of the Regional Museum, Tîrgu-Jiu; Dr. John Gage of the University of Cambridge; Peter Darty; Steve Bury, the librarian of Chelsea School of Art, London, for his endless help in locating Brancusi literature; Ian Shipley for being so forward on my behalf; Annemarie Fox; Professor Robert K. Wallace; Jennifer Harris of the Department of Dress, Whitworth Art Gallery, University of Manchester, for helping me trace the Alexandre Golovin costume; Jane Cocking; Nancy Grubb for her intensive and highly creative editorial help with the book; Lisa Peyton for her valuable photographic help with the book; and Jacky Darville for her surpassing help with everything.

Series design by Howard Morris
Designer: Marc Zaref Design, New York
Editor: Nancy Grubb
Picture editor: Lisa Peyton
Production supervisor: Hope Koturo
Exhibitions, Public Collections, and Selected Bibliography compiled by Amy Handy

FRONT COVER: *Mlle. Pogany II* (detail), 1919. See plate 66.

FRONTISPIECE: *Beginning of the World*, c. 1920. Marble, 7⅛ x 10¼ x 6½ in.; polished metal disk, diameter: 19¾ in.; base: stone, height: 22½ in. Dallas Museum of Art; Foundation for the Arts Collection, gift of Mr. and Mrs. James H. Clark

BACK COVER: *Bird in Space*, 1940. Polished bronze, height: 53 in. Peggy Guggenheim Collection, Venice (The Solomon R. Guggenheim Foundation)

FRONT END PAPER, left: Brancusi in his studio, c. 1920–22?

FRONT END PAPER, right: Brancusi in his studio, c. 1933–34

BACK END PAPER: Brancusi in his studio, c. 1923–25

All end paper photographs by Brancusi.

Marginal numbers in the text refer to works illustrated in this volume.

Library of Congress Cataloging-in-Publication Data

Shanes, Eric.
    Constantin Brancusi.

    (Modern masters series; ISSN 0738-0429; v.12)
    Bibliography: p.
    Includes index.
    1. Brancusi, Constantin, 1876–1957—Criticism and interpretation.  I. Title.  II. Series.
NB933.B7S52   1988   730'.92'4   88-7359
ISBN 0-89659-924-8
ISBN 0-89659-929-9 (pbk.)

First edition

# Contents

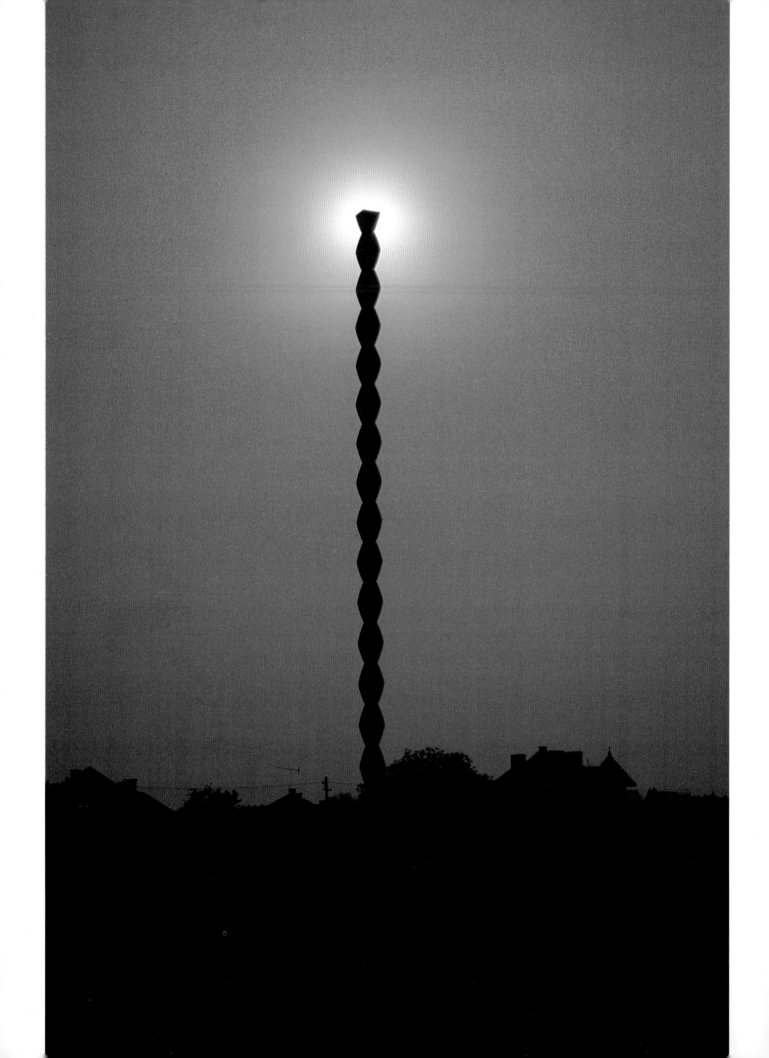

# Introduction

Why should a relatively plain iron column in a provincial town in faraway Romania be regarded as one of the high points of modern sculpture? To answer that and related questions concerning the art of Constantin Brancusi, as well as to give a short account of the sculptor's life, is the primary purpose of this book. Yet the book enjoys a second, more fundamental aim as well.

Brancusi is widely accepted as the most important and original sculptor of this century, and his work exemplifies the new responsiveness to form and materials that was central to the modernist aesthetic. He was regarded as a major figure by such leading members of the avant-garde as Guillaume Apollinaire, Pablo Picasso, Henri Matisse, Marcel Duchamp, Julio González, Kurt Schwitters, Man Ray, Piet Mondrian, Amedeo Modigliani, Francis Picabia, Erik Satie, James Joyce, Tristan Tzara, and Ezra Pound (who wrote an important essay on him in 1921). His work appealed to diverse tastes within modernism, being hailed both by the Dadaists, who eschewed rationalism in art, and by members of De Stijl, who extolled it. He also influenced a great many modernist sculptors and painters, including Wilhelm Lehmbruck, Barbara Hepworth, Henry Moore, Fernand Léger, and David Smith; and his ensemble at Tîrgu-Jiu inspired several environmental sculptors, such as Christo and Walter De Maria.

Paradoxically, the view of Brancusi as a leading member of the modern movement has tended to obscure rather than clarify his artistic aims. Brancusi has long been hailed as an abstract sculptor by nonrepresentational artists and by writers favoring abstract art, who have frequently rejected the symbolic and metaphorical meanings of his sculptures because they would detract from the status of the works as purely abstract objects. Even those meanings supplied by the sculptor himself have often been ignored. Instead, it has been asserted that Brancusi really wanted to be a wholly abstract artist but, lacking the courage to do so, he cloaked his pure abstractions in symbolic meaning.[1] Yet the sculptor frequently and vehemently denied that his work was at all abstract. He held that it represented a level of existence beyond everyday appearances, and

1. *Endless Column*, 1937–38
Cast iron, 96 ft. 2⅞ in. x 35⅜ x 35⅜ in.
Tîrgu-Jiu, Romania

7

it was in order to address that reality that he employed allegory and symbolism.

Another oft-encountered misconception is the notion that Brancusi's passing interest in African carving during the mid-1910s made him a "primitive" artist and that "African art was the most important influence in Brancusi's career."[2] Such a view, which has been propounded by a great many Western writers, ignores the fact that the formal influence of African carving on Brancusi's work became apparent only about 1913—some six years after the sculptor had struck out in a completely new artistic and aesthetic direction with *The Prayer* of 1907. The apprehension of Brancusi himself as a primitive is totally contradicted by the extent of his academic training and by the formal sophistication of the majority of his works.

Such misconceptions are linked to conflicting artistic and political ideologies. Brancusi was undoubtedly committed to modernism, but his commitment has been misinterpreted as an exclusive one: while it is permissible for a modernist to have embraced African "primitivism," as Picasso, Georges Braque, and a great many others did, some leading Western writers have not accepted Romanian "primitivism" as an equally potent influence on Brancusi. Instead, they claim that he turned his back on the visual and folkloric traditions of his native Romania by choosing to live in Paris for the major part of his career.[3] As a counter to this Western bias, some nationalist Romanian writers on Brancusi have asserted that he was influenced by Romanian traditions to the exclusion of all others, which is equally untrue.[4] All these misconceptions have resulted in multiple, mutually exclusive views of Brancusi: as a sculptor whose highly abstract works contain no meanings other than purely formal ones; as an abstractionist who cloaked his works in factitious meanings; as a primitivistic sculptor; as a sculptor who cut himself off from his Romanian origins; and as a sculptor who cut himself off from anything but those origins.[5]

As is usual with such disputes, the fact of the matter lies somewhere in the middle: Brancusi was as responsive to the folk traditions of his homeland as he was to the demands of his own pioneering aesthetic. For a time after 1913 the sculptor was certainly influenced by the forms (though not the content) of African carving; but throughout his life he also maintained and developed a wide repertory of forms that were derived from Romanian folk art and architecture, as well as from other Slavonic, Egyptian, Buddhist, and Cycladic sculptural traditions. Although he lived in Paris rather than Romania for a variety of cultural and economic reasons, until the late 1940s he always maintained his connections with his country of origin and, indeed, created his greatest work there in 1937–38.

The deeper aim of this book is to offer an appraisal of Brancusi's work that takes its cue from the sculptor's own frequent statements concerning his art, most particularly those touching upon the "working philosophy" that compelled him. It respects his view that his work was not abstract and seeks to illuminate what he was attempting to express. His meanings were never afterthoughts appended to his sculptures; for the most part, they generated the

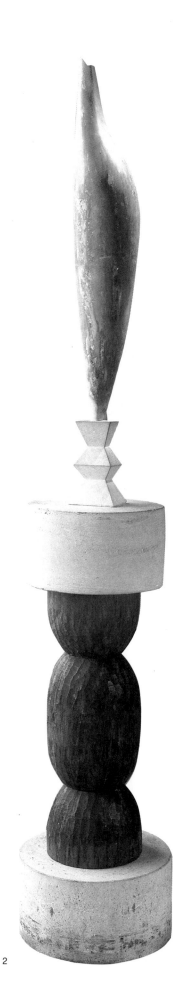

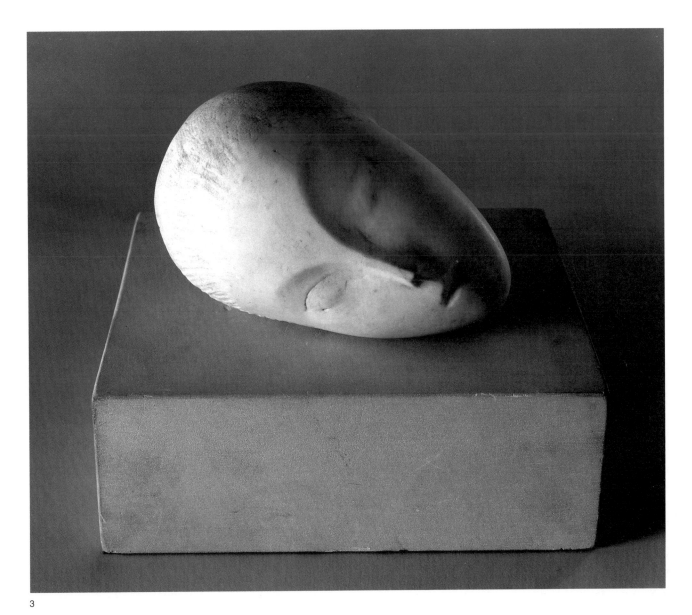

3

forms of his works. The diverse influences on Brancusi are examined here within the framework of the associative thinking that was integral to his art, and thus the true significance of those influences may become clearer.

This book differs from the previous Brancusi literature in one other important respect: departures from a strictly chronological narrative of the sculptor's life have been made in order to trace an essential creative process. Throughout his maturity Brancusi worked simultaneously on series of sculptures with different themes. For example, he made twenty-eight marble and bronze sculptures of birds over a period of nearly forty years. When these are divorced from one another and examined amid the works in other series made during the same period, the clear formal and thematic links within a series, and from series to series, can be obscured. It is hoped that by departing from a chronological approach in order to track each series, a more revealing account of the most coherent body of twentieth-century sculpture will emerge.

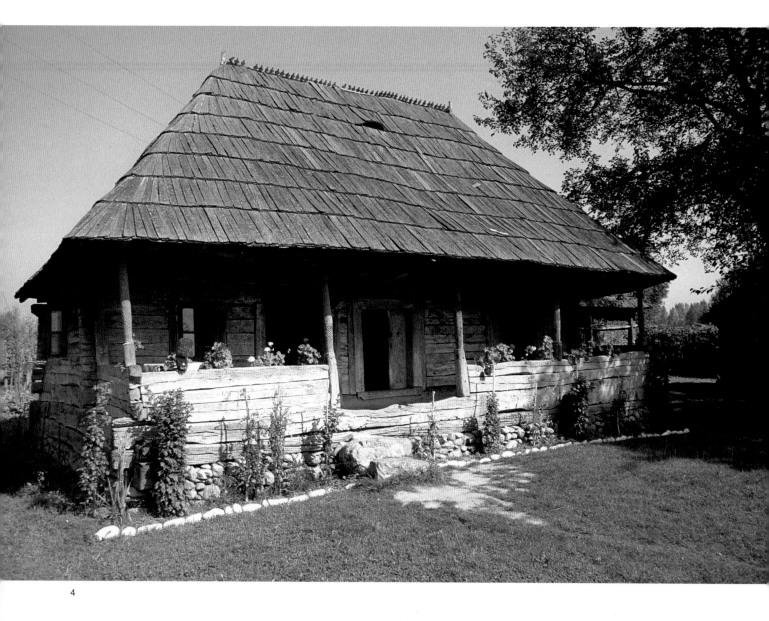

4

# 1 Early Life and Work

Constantin Brancusi was born on February 19, 1876, in the tiny hamlet of Hobiţa, Gorj County, Romania, to Nicolae Brâncuşi, a reasonably prosperous peasant, and his wife, Maria, a weaver.[6] Like many a peasant's son, Brancusi was pressed into service as a shepherd while still a child. Bullied by his father and older brothers, he frequently ran away, sometimes to the nearest large town, Tîrgu-Jiu. He was inevitably fetched back again, but his schooling was very disrupted. Eventually, in 1889, at the age of just thirteen, he made his way to Craiova, capital of the adjacent Dolj County, where he worked at a variety of places, including a grocery store. His skill at carving various objects quickly came to the attention of his employer at the store, Ion Zamfirescu.

In 1894, along with one of the store's customers, Zamfirescu raised the money to send Brancusi to the Craiova School of Crafts, which he was already attending part-time. By the summer of 1898 he had so advanced as a sculptor that he was invited by the school's director to make a plaster portrait of the founder of the school. Neither this nor any other sculpture from those years has survived, although the museum in Craiova owns a number of highly ornate objects, including picture frames, a casket, and a chair, that Brancusi apparently carved at this time.[7]

After graduating with honors from the Craiova School of Crafts in 1898, Brancusi immediately enrolled at the major national institute for the study of sculpture, the Bucharest School of Fine Arts. His efforts as a student were highly skilled but rigorously academic; yet one of these sculptures—an *Ecorché*, or statue of a man with the skin removed to reveal the musculature—points the way to things to come. The work, made under the guidance of a leading Bucharest anatomist, derived from a close study of anatomy. The posture of the piece was based on that of the Capitoline Antinoüs, a Roman copy of a Greek statue of Hermes, as can be seen in a 1901 photograph of the *Ecorché* alongside a cast of the Hermes. By concerning himself with the muscle beneath the skin, Brancusi made a statement about the human body in universal and immutable terms, rather than merely in a particular, outward sense.

4. Brancusi's birthplace (reconstructed), Hobiţa, Romania

After receiving several honorable mentions and a silver medal, Brancusi graduated from the School of Fine Arts in spring 1902 and worked there until returning in the fall to Hobiţa and Tîrgu-Jiu, where he labored as a carpenter in the surrounding villages. Throughout 1903 he worked in Bucharest, but by the next May he had come to feel that the city was uninspiring and made his way by train to Munich. Equally uninspired by Munich, and having exhausted his finances, he set out to walk to Paris. As he later recalled: "I walked along country roads . . . I rambled through forests singing my joy and happiness. In the villages I was given food and drink, the peasants welcomed me with open arms, gave me provisions and wished me a pleasant journey. They realized I was one of them. . . . During that whole walking trip, I was very happy. People don't realize how good it is to be alive; they don't know how to look at the wonders of Nature."[8] By mid-July he had got only as far as Langres, in Haute-Marne, France, where he collapsed from exhaustion and wrote to a Romanian friend in Paris, Daniel Poiana, who sent him the money to complete the journey by train. Although Brancusi would occasionally return to Romania and travel even farther afield, he made Paris his home for the remaining fifty-three years of his life.

Paris was experiencing an unrivaled cultural dynamism in 1904. In addition, it was the home of an extensive Romanian community, French being the second language of educated Romanians and the French franc and the Romanian leu enjoying parity. Here Brancusi could drink at the fount of artistic modernism while seeking support from his countrymen, which he received from the outset. By 1905 he had obtained a small stipend from the Romanian Ministry of Education and was enrolled at the Ecole Nationale des Beaux-Arts, where he became a pupil of Antonin Mercié.[9] Even though he spent every free moment studying and sculpting, the winter of 1905–6 was clearly a difficult one for him: by February 1906 he was earning less than twenty francs a week. By the following month, however, his fortunes had picked up with a renewal of his scholarship, which was extended again in June. He exhibited at the Salon des Beaux-Arts that summer and had three works accepted for the Salon d'Automne. One of these was a fine portrait bust in plaster, *Pride*, which was also cast in bronze.

Early in 1907 Brancusi was invited by Auguste Rodin to become one of the many sculptors and assistants working in his studio at Meudon, just outside Paris. Brancusi applied himself there for about two months (a fact he later tried to obscure), then left because, as he put it, "nothing can grow under big trees."[10] That summer he exhibited four works in the Salon des Beaux-Arts. All of them show the influence of Rodin, particularly in Brancusi's treatment of surfaces. Rodin had evolved a powerful surface tension in his modeled works, allowing the unsmoothed clay to function expressively and using the play of light across his bronze casts to create the kind of surface dynamism encountered in Impressionist painting. Brancusi followed Rodin in this, obtaining a surface restlessness in his clay models and a brilliant variety of reflected light in the bronzes made from them. At the Salon, Brancusi asked Rodin's opinion of his sculptures: "'Not bad, not bad,' muttered

5

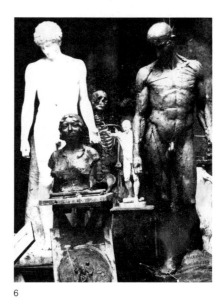

6

5. *Ecorché*, 1901–2
Plaster, height: 69⅝ in.
N. I. Grigorescu Art Institute, Bucharest, Romania
Photograph by Brancusi

6. Photograph taken at the Bucharest School of Fine Arts in 1901 showing the *Ecorché* near a cast of the *Capitoline Antinoüs*. In front of the latter is a clay model by Brancusi entitled *Character Study*, which won a prize. (The study was subsequently destroyed.)

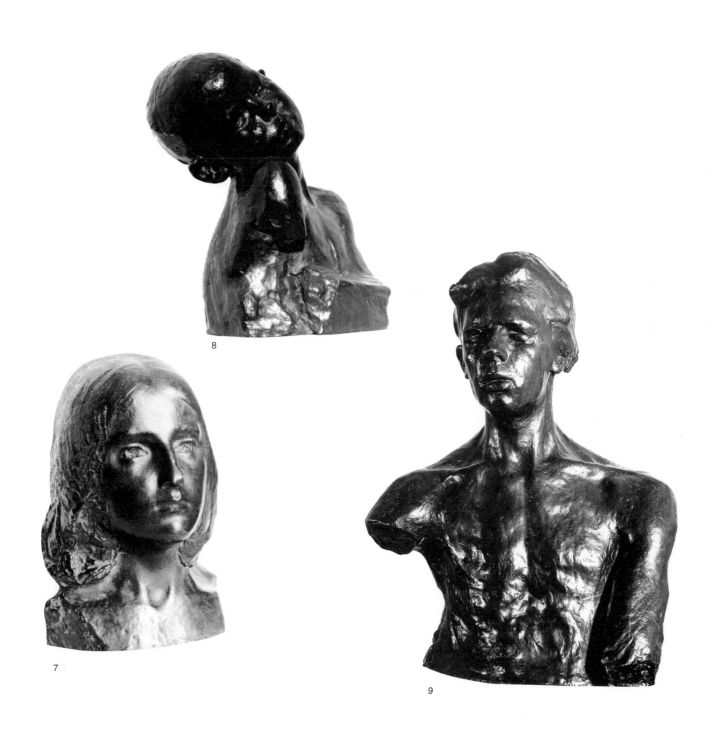

7. *Pride*, 1905
Bronze, height: 12 in.
Museum of Art, Craiova, Romania

8. *Torment I*, 1907
Bronze, height: 14¼ in.
Private collection, Bucharest

9. *Portrait of Nicolae Dărăscu*, 1906
Bronze, height: 25¼ in.
Socialist Republic of Romania Museum of Art,
Bucharest

Rodin. 'Master, anyone could say that,' Brancusi insisted. 'I expect something more from you.' 'Well, then, my dear fellow, above all don't work too quickly,' the great sculptor answered."[11] Brancusi seems to have followed this advice, for his working practices in his maturity were profoundly patient, if not necessarily slow.

Brancusi's exhibited sculptures of 1907, including *Torment I*, are adroit, perceptive studies that express a certain vulnerability. This sense of vulnerability—also evident in a more ambitious piece, the *Portrait of Nicolae Dărăscu* of 1906—may reflect the responses of an artist who must himself have felt very vulnerable while attempting to survive in a foreign city. Such a personal note was soon to move onto a more universal plane when Brancusi discovered his mature artistic identity with *The Prayer*.

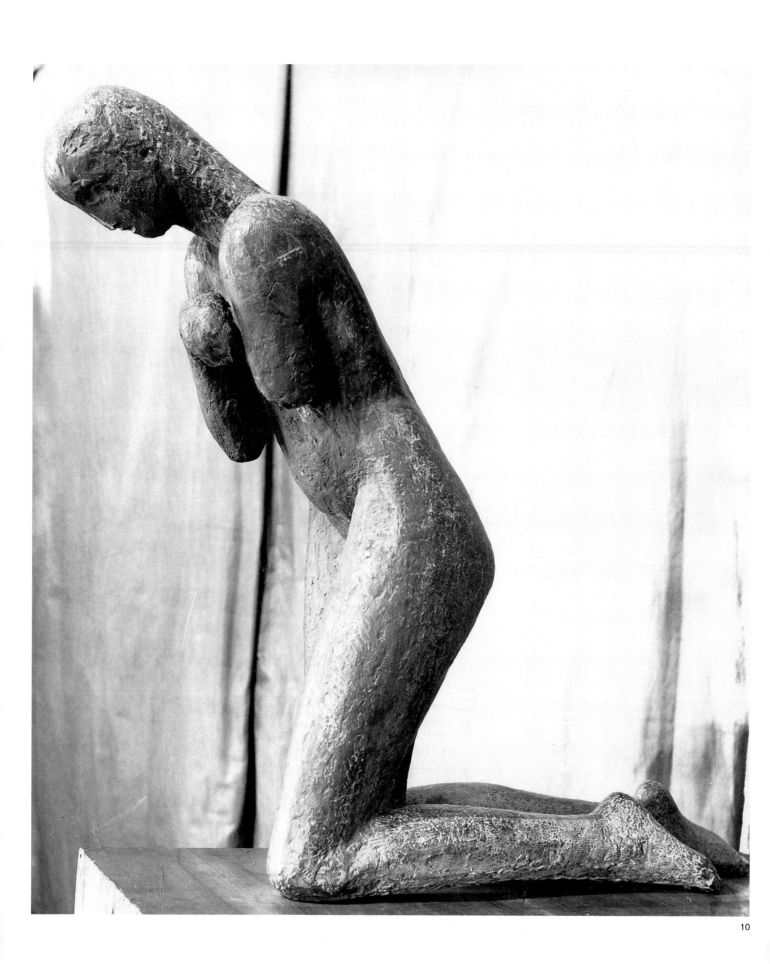

# 2 Maturity

In April 1907 Brancusi was asked by the widow of Petre Stănescu to make a portrait bust of her husband for his grave in Buzău, a small town northeast of Bucharest. The bust was to be accompanied by an allegorical statue of a weeping woman, *The Prayer*. Brancusi modeled the two sculptures in plaster and cast them in bronze by October 1907, but the whole installation was not completed until May 1914, when he traveled to Buzău and fashioned bases for the two works. The portrait of Petre Stănescu combines the clear influence of Rodin with a degree of formal simplification that anticipates Brancusi's later style. The elongation of the neck was intentional, to compensate for the distortion caused by viewing the bust from below.

11

10

The Stănescu portrait is still somewhat conventional, but *The Prayer* marks the turning point in Brancusi's development. Initially the work caused him great difficulty. The painter Stefan Popescu, who had obtained the Stănescu commission for Brancusi and who shared his studio in 1907, recalled that "the work was begun time and time again, the modelled figure thrown back into the boxful of clay, and so he went on and on, changing and rechanging not only figures but also the stylistic vision of his work."[12] The conflict was caused not by any modeling difficulties or problems with anatomy, but by a deeper dissatisfaction with the nature of representation itself. The resolution of this problem would permanently alter the language and content of Brancusi's work, as he gradually realized that what concerned him was "not the outer form but the idea, the essence of things."[13]

Since arriving in Paris in 1904, if not before,[14] Brancusi had been profoundly influenced by Greek philosophy, especially Plato. In Plato's dialogues he encountered the theory of Forms or Ideas, which holds that all animate beings and inanimate objects in the universe are but imperfect imitations of supreme models, or Ideas, that exist solely and eternally in the mind of God. Plato denied the validity of art because he held that the representation of appearances is twice removed from "true" reality—it merely imitates the appearance of "imitations." Artists and art theorists have tradi-

10. *The Prayer*, 1907
Bronze, height: 43⅞ in.
Socialist Republic of Romania Museum of Art,
Bucharest

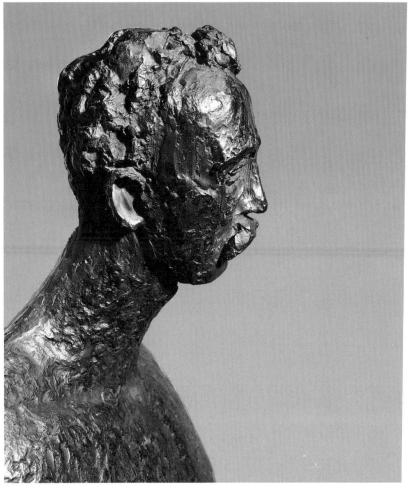

11

tionally ignored this denial, however, asserting that the duty of the artist is not to "imitate" transitory forms but to synthesize observed forms into an imagined archetype that might approximate the divine model. Platonic and Neoplatonic theories formed the basis of the idealism predominant in Western visual art from the Renaissance until the nineteenth century, and that idealism has continued into the present day through the works of Brancusi.

Invaluable insight into Brancusi's basic aesthetic attitude, which evidently matured about 1907, comes from the record of a visit to his studio in 1925 by the American art critic Dorothy Adlow:

Remind [Brancusi] of the beauty of classical drapery, the power of Michelangelo's muscle . . . he will answer briefly. He pinches the flesh of his wrist, makes a funny face, and mutters "Biftek.". . . He identifies his subject [in his own sculptures] with what is real and elemental in its nature. He tries to differentiate it from everything else, and give it a unique character. As for the representation of every external fact, clothes, limbs, facial features, all of this is "biftek.". . . People are afraid, they are content with the external, with clothing and flesh, with what is physical and not mental. Of course, it is not easy to give what is purely mental a tangible form, and so artists resort to the simplest way of conveying their thoughts. They proceed to exult in the grandeur of draperies, in exaggerated movement, in sentimentality, "Biftek."

For Brancusi has purified his sculpture of every attracting feature. He has swept out of his plan every motive that might distract him or the observer from what he considers the central idea. . . . He has tried to make of his sculpture a working philosophy. He calls it the philosophy of Plato.

11.  *Portrait of Petre Stănescu*, 1907
Bronze, height: 30¼ in.
Socialist Republic of Romania Museum of Art,
Bucharest

12.  Funerary group, Dumbrava Cemetery,
Buzău, Romania. Seen here are the cast-stone
replica of *The Prayer* and the bronze replica of
the *Portrait of Petre Stănescu* (both original
works are now in the Socialist Republic of
Romania Museum of Art, Bucharest).

16

One glances about the studio. . . . There is a portrait in wood of Socrates, an enormous skull with large, far-seeing eyes. . . . It is the *idea* that should be related, that is all. Everything else is superfluous. . . . Brancusi is not satisfied with the things of the moment, he looks out for what is true of all time. The mere "shadows and reflections" are substituted by what is real.[15]

Here we have evidence of Brancusi's Platonism, both explicit— "He calls it the philosophy of Plato"—and implicit: the reference to his portrait of Socrates (who was, of course, Plato's great teacher), certain paraphrases of Plato's concepts, and the quotation of the phrase "shadows and reflections." About 1919–20 Brancusi worked on a sculpture of Plato, before destroying most of it.[16] Adlow's stress (no doubt at Brancusi's insistence) on the word *idea* makes clear both its Platonic meaning in this context and its importance to the sculptor. The phrase "shadows and reflections" is probably quoted from part 7, book 7 of *The Republic*, where Plato discusses

74

52

12

the Ideas; Adlow most likely took the phrase from Brancusi himself.

Such aesthetic sophistication belies any notion that Brancusi was some kind of simpleminded backwoodsman or rustic mystic who evolved his sculptural forms merely through intuition. He had graduated from the Bucharest School of Fine Arts with an honorable mention in aesthetics, and a survey of his library in Paris shows the breadth and depth of his reading.[17] This collection of books includes an edition of five of the dialogues of Plato that has disintegrated, obviously through frequent use.[18]

In time, Plato's influence on Brancusi would be augmented by that of other thinkers, including the Theosophist Helena Blavatsky, the eleventh-century Tibetan monk Milarepa (whose biography was first published in French in 1925), and the sixth-century B.C. Chinese philosopher Lao-tzu. What links all of Brancusi's wide-ranging interests in philosophy is his concern with differentiating the essential from the ephemeral. As the sculptor himself made clear, his intent was to make his sculpture express reality, not simply the singular forms of transitory experience: "The natural element in sculpture means allegorical thinking, symbol, sacredness or the search for essences hidden in the material and not the photographic reproduction of external appearances. The sculptor is a thinker and not a photographer of some ridiculous, multiform and contradictory appearances."[19]

In *The Prayer*, Brancusi gave mature utterance to that "natural element" for the first time. The statue is purged of all individual personality—it is not one woman but a generalized representation of all praying human beings. What Brancusi conveyed with profound economy are introspection and supplication, the essentials of true prayer. The sense of supplication in *The Prayer* was greatly enhanced in the cemetery at Buzău by the lowness of the piece in relation to the Stănescu portrait above it. Unfortunately, both original bronzes have been replaced by casts in the cemetery and are now displayed separately in the Bucharest museum. Yet even a photograph of their substitutes demonstrates how Brancusi underscored the effect of supplication in *The Prayer* by means of its placement. The photograph also demonstrates another link between the two sculptures: the triangle formed by the diagonal of the back of the kneeling figure and the vertical of the plinth supporting the portrait. This triangle leads the eye up to the bust and intensifies the impression of its height, thus increasing the effect of a serene transcendence of all worldly concerns by Petre Stănescu.

After completing these two sculptures, Brancusi turned to the direct carving of stone. This was another major discovery of 1907, for it revealed something essential about himself. Unlike Rodin, but like Michelangelo, Brancusi was at heart a carver rather than a modeler. The methods are diametrically opposed, modeling being an additive process in which form is accumulated upon an armature, while carving is a reductive process, and thus more intellectually complex.[20] Brancusi soon came to share with Michelangelo the notion that his material already contained the forms he wished to express and that he just had to cut away the extraneous matter to reveal them. As he later noted, "The artist should know how to dig out the being that is within matter and be the tool that brings out its

13. *The Kiss*, 1907–8
Stone, height: 11 in.
Museum of Art, Craiova, Romania

cosmic essence into an actual visible existence."[21] The reference to "cosmic essence" again indicates Brancusi's Platonism, which would govern all he did after 1907.

In 1907–8, after abandoning or destroying some stone carvings, Brancusi produced his next major works, two versions of *The Kiss*. Motivated by the same Platonic principles that had shaped *The Prayer* and having become aware of "how far off the mirroring of the exterior forms of two people was from fundamental truth,"[22] in *The Kiss* he created a profound statement about human bonding, in which a man and a woman kiss not diagonally but frontally. Such a position is possible in reality only for anyone who lacks a nose, but Brancusi, no longer bound by the constraints of literal reality, found it easy to ignore the dictates of anatomy (which he had thoroughly mastered). The man and the woman (who is clearly denoted by the curve of her breast and by her longer hair) are linked at their mouths and stare deeply into each other's eyes. Only the treatment of the arms in the first version of *The Kiss* is still vaguely tinged with naturalism. 13

The influence of other works on *The Kiss* has been suggested: an ancient menhir, a Romanesque capital, sculpture by André Derain, and of course Rodin's *The Kiss* as an antithetical model.[23] But Brancusi transcended mere influence. The simplicity of the

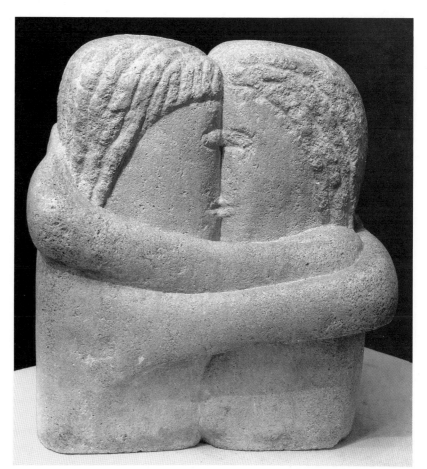

13

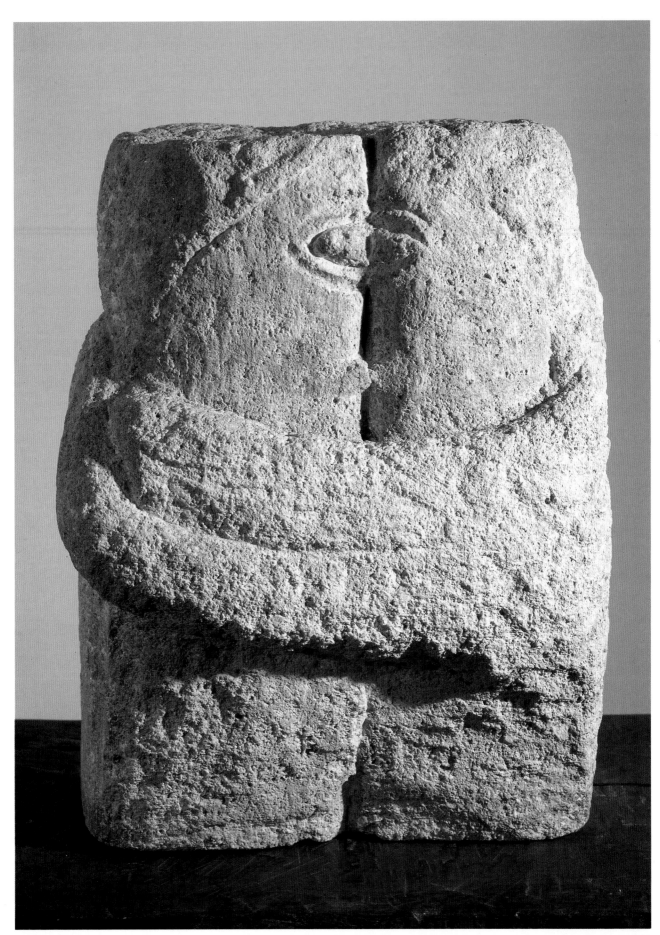

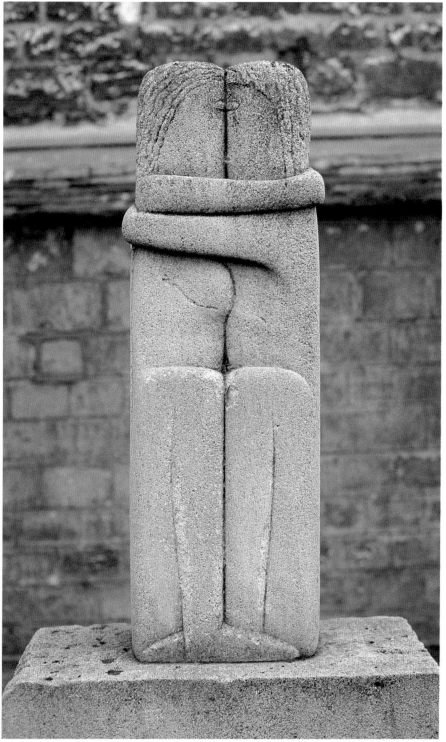

15

14. *The Kiss II*, c. 1908
Stone, height: 12½ in.
Private collection, U.S.A.

15. *The Kiss*, 1909
Stone, height: 35¼ in.
Montparnasse Cemetery, Paris

21

piece arose as the solution to a problem of content, not style: how to effect the greatest possible fusion between two figures. A second version of *The Kiss* carved about 1908 makes this very clear. On one side of the work the eyes are much enlarged and surrounded by pronounced rims, which recall the eyes with emphatic rims that are so frequent in Picasso's works after 1906. This enlargement of the eyes makes them the dramatic focal point of the entire sculpture, and it stresses further the mental and spiritual union of the figures. The top of the sculpture is flattened, which suggests that the couple may originally have been intended as caryatids (i.e., figures that hold up an entablature or lintel). In this version the arms are more angular and hence less at odds with the overall square-cut configuration.

In 1909 Brancusi carved a full-length version of *The Kiss*, which was later installed in Montparnasse Cemetery over the grave of a young Russian suicide, Tatiana Rashewskaia. Once again gender is denoted by the curve of the breast and the length of the hair. Here the squaring off of the arms is even more successful, and it is reinforced by the squared-off legs and interlocking feet, while the

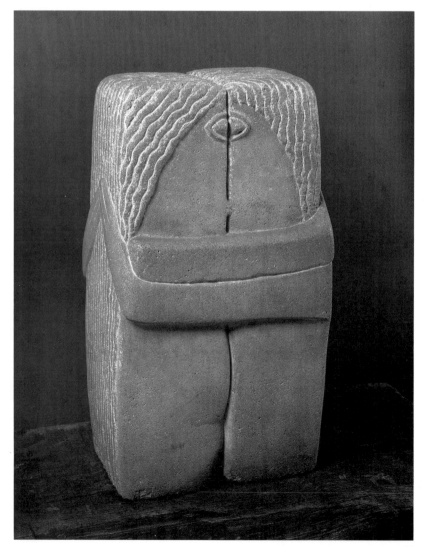

16

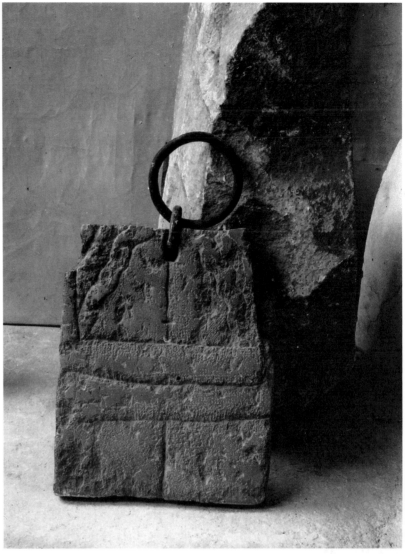

17

16

sense of union is even more effective than before because it is expressed from head to toe. A version of *The Kiss* made in 1916 improves even upon this, with a linear clarity that greatly advances the sense of bonding between the figures.

A restatement of the subject made about 1918–19, entitled *Medallion*, conveys yet another important element of Brancusi's personality—his sense of paradox. Medals are conferred mainly in wartime and predominantly for acts of bravery that usually entail killing and death. This medallion, however, is inscribed with a shallow, rough-hewn carving of the Kiss motif. Here, and not for the last time in Brancusi's oeuvre, love transcends hatred. The statement had particular relevance just after a world war had come to an end. About 1933 Brancusi made *Column of the Kiss* and, in 1937–38, *Gate of the Kiss*. The latter was part of a war memorial, so again he was offering a foil to the hatred of war by celebrating love. In the early 1940s Brancusi carved a severely angular version of *The Kiss* in yellow stone; its overall rectilinearity stresses the contrasting circularity of the immense eyes.

16. *The Kiss*, 1916
Limestone, 23 x 13 x 10 in.
Philadelphia Museum of Art; Louise and Walter Arensberg Collection

17. *Medallion*, c. 1918–19
Volcanic stone with iron rings, height: 23⅜ in.
Brancusi studio, Musée National d'Art Moderne, Centre Georges Pompidou, Paris
Photograph by Brancusi

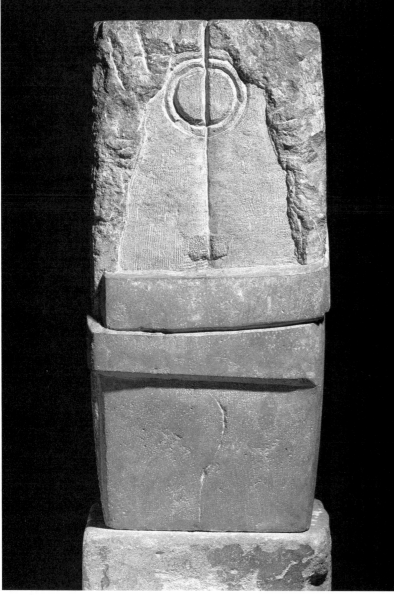

18

Finally, in 1945, in what was virtually his last sculpture, Brancusi
19 transformed *The Kiss* into *Boundary Marker,* squaring off the
shapes even more in the process. As with *Medallion* and *Gate of the
Kiss,* he again expressed his sense of paradox: wars are fought over
national boundaries, and yet this postwar boundary marker pro-
jects the image of love in all directions and across every frontier. At
top and bottom are blocks incised with the Kiss motif, which is
also realized three-dimensionally as caryatid figures in the center.
*Boundary Marker* may also denote the boundary of life itself, for
by the time he made this sculpture Brancusi was conscious of aging
(he would be seventy years old in 1946). If the work does contain
that biographical element, acting almost as a fetish with which to
face death, it also reminds us that love and regeneration—the kind
of replication seen at top and bottom—transcend the limitations
of mortality.

18. *The Kiss*, early 1940s
Yellow stone, height: 28¼ in.
Brancusi studio, Musée National d'Art
Moderne, Centre Georges Pompidou, Paris
Photograph by Brancusi

19. *Boundary Marker*, 1945
Stone, 72¾ x 16 x 12 in.
Brancusi studio, Musée National d'Art
Moderne, Centre Georges Pompidou, Paris
Photograph by Brancusi

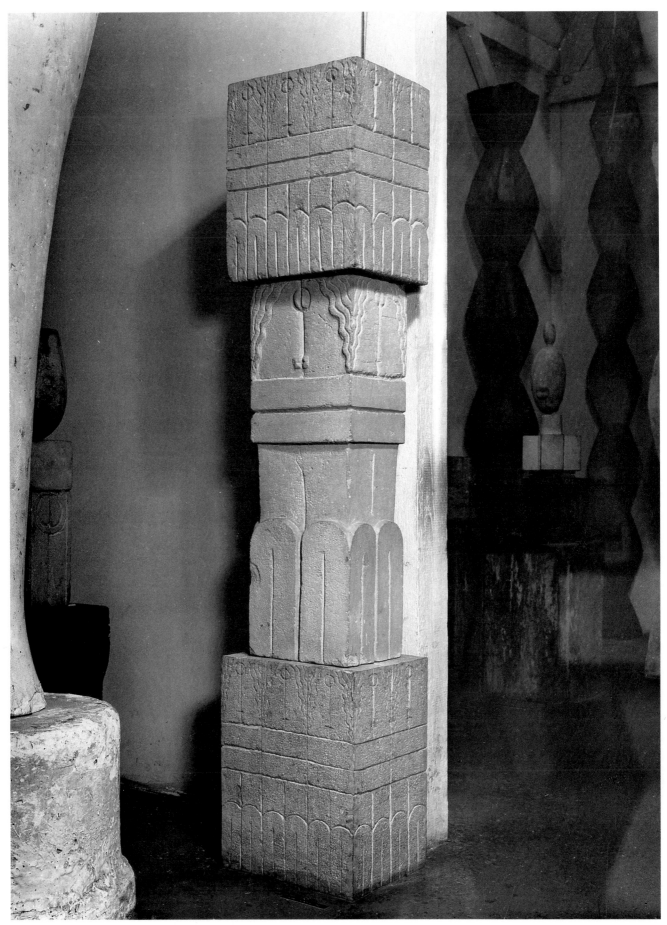

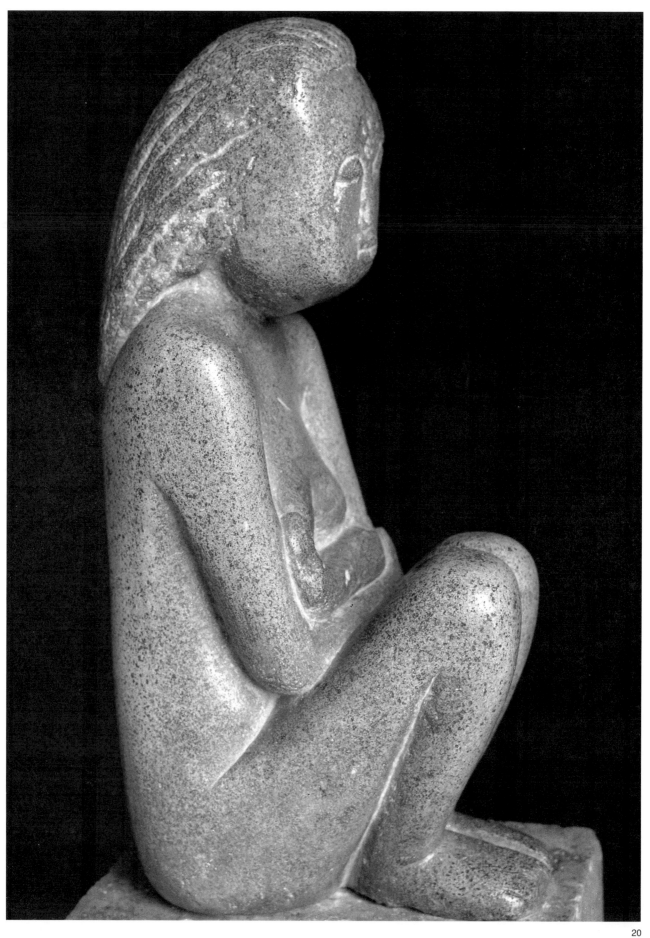

To return to 1908: while working on the first two versions of *The Kiss*, Brancusi also began *Wisdom* (originally titled *The Wisdom of the Earth*). This carving demonstrates strong influences from archaic Greek sculpture, in the symmetry of the form; from Egyptian art, in its compression and rectilinearity; and from Oriental sculpture, in the partial obliteration of the facial features, possibly to suggest associations with weathered outdoor statues of the Buddha, which *Wisdom* strongly resembles. Symmetry being an attribute of ideal form, the work also projects religious idealism, albeit of an Oriental, mystical kind. Brancusi's use of materials to advance both meaning and feeling is evident in his polishing of the limestone, whose rich burnt-gold coloring subtly imparts other Oriental associations. At the time of making *Wisdom,* Brancusi clearly shared the interest that other artists were taking in non-European cultures. It is an indication of his range that he investigated Middle Eastern and Far Eastern prototypes as readily as he would later explore African art.

In 1908 Brancusi began carving two figures in the form of caryatids, in a rough-hewn manner reminiscent of the second version of *The Kiss*, which dates from the same year. These caryatids would, in fact, be given a block to support, upon which would rest the first of Brancusi's many birds. The whole piece (with a base beneath) was completed in 1912 and entitled *Maiastra*. In Romanian folklore Maiastra is an incomparably beautiful and eternal golden bird, whose song "surpasses all earthly music," and who has the power both to foretell the future and to cure the blind.[24] In connection with this work Brancusi would recount the tale that Maiastra had guided Prince Charming through the forest to the place of his beloved's imprisonment.[25] Yet *Maiastra* is far from being merely a sculpted treatment of a folktale. As far as Brancusi's Platonism and use of "allegorical thinking, symbol, sacredness or the search for essences hidden in the material" are concerned, it is the key work in his oeuvre.

20. *Wisdom*, 1908
Limestone, height: 19⅞ in.
Socialist Republic of Romania Museum of Art,
Bucharest

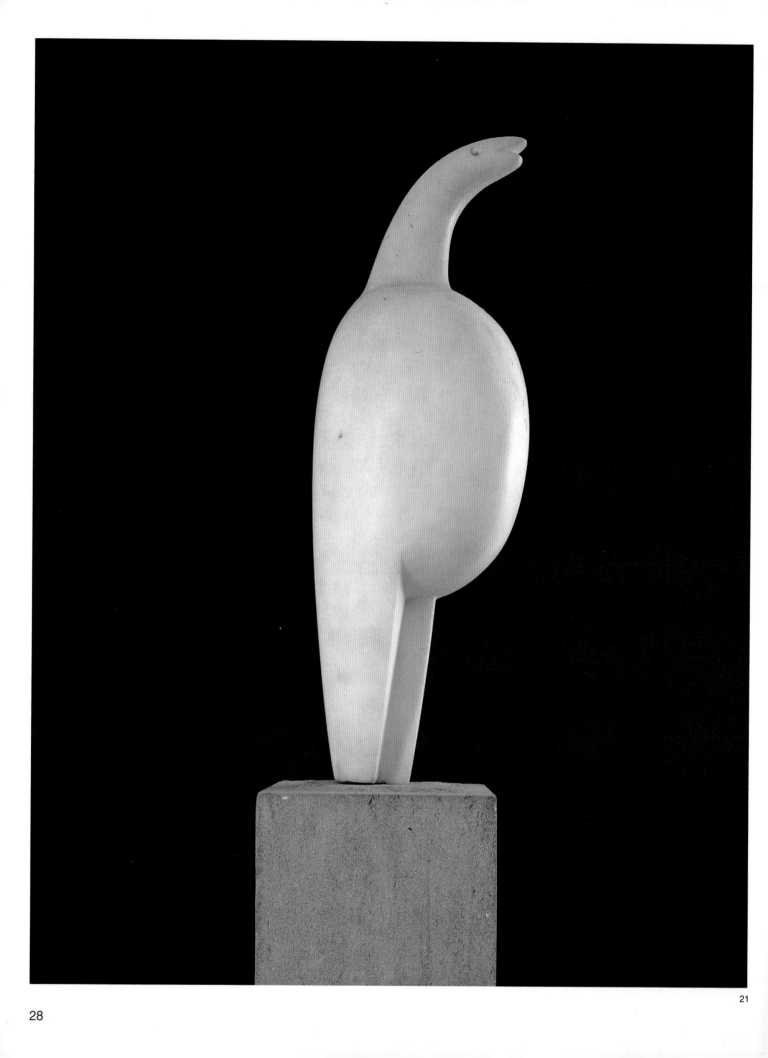

21

# 3 The Natural World

The bird in *Maiastra* is recognizable as a bird, but once more [21] Brancusi's idealizing imagination has been at work: this is not a skylark nor an eagle nor any other precise species. Instead, it is an avian archetype. The aperture of the beak, the slight indentations for the eyes, the swell of the breast, and the symmetry of the legs establish its links to avian form, while the purity of the white marble and the height of the piece suggest, respectively, lightness and a link with the sky.

Brancusi had made a number of small, highly representational sculptures of birds when he first arrived in Paris, but he kept them out of sight and later probably destroyed them.[26] A singular Parisian event may have inspired the new kind of birdlike form that supplanted them. In 1910, the year the bird part of *Maiastra* was begun, the musical hit in Paris was Igor Stravinsky's *Firebird*. This ballet, which received its premiere on June 25, 1910, has as its plot a tale clearly related to the Romanian folk story that Brancusi recounted in connection with *Maiastra*. *The Firebird* ballet had costumes by Alexandre Golovin, and the shapely hats worn by [24] King Kastchei's several attendants closely resemble the birds with rounded necks and heads buried in their breast that Brancusi drew [25] in relation to *Maiastra*. He even incised such birds in low relief on the stone base he made in 1910 and later supplied for a bronze *Maiastra* of 1912. Moreover, the ballet not only features a su- [26] premely beautiful bird with masterful magic powers, but at the climax of the work the firebird reveals to the prince an egg that contains the soul of the evil King Kastchei, who has imprisoned his beloved. The prince then smashes the egg, killing Kastchei and freeing his beloved. It may be that this image influenced Brancusi when, some years later, he created a series of egglike forms.

*Maiastra* comprises four distinct elements, of which three are [22] sculptural in purpose: the bird itself, a block that serves as an entablature, and the huddled caryatid figures upon which the block rests. These are all placed on a base that elevates the bird so it will properly tower over the viewer.

The caryatid figures in *Maiastra* may be lovers—perhaps Prince

21. Originally titled *Maiastra*; currently known as *Magic Bird (Pasarea Maiastra)*, 1910–12 (detail)
White marble, height: 22 in.
Collection, The Museum of Modern Art, New York; Katherine S. Dreier Bequest

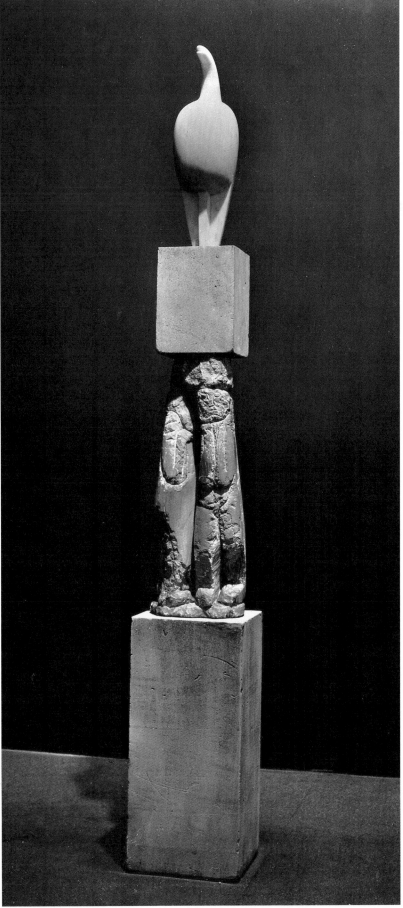

22. Originally titled *Maiastra*; currently known as *Magic Bird (Pasarea Maiastra)*, 1910–12
White marble, height: 22 in.; lower section: limestone in three parts, the middle of which incorporates the *Double Caryatid*, begun c. 1908, height: 70 in.
Collection, The Museum of Modern Art, New York; Katherine S. Dreier Bequest

23. Timber columns on a house from the village of Olari, near Tîrgu-Jiu, Romania, built between 1790 and 1803
Curtişoara Ethnographic Village, Gorj County, Romania

Charming and his beloved—but at the same time they seem to personify human imperfection: they are intentionally primitive, both anatomically and materially, being perhaps the most rough-hewn of all of Brancusi's sculptures. The figure on the left buries its head in the shoulder of the figure on the right, who stands in an almost paraplegic pose. The conjunction of the figures with the block they support and the contrast of their "deformed," pitted surfaces with the pure, ethereal weightlessness of the bird above them again communicate Brancusi's Platonism. Here on earth all is mundane, transitory, awkward, the human body evidently being for Brancusi "a mass of perishable rubbish" (or "biftek"), just as it had been for Plato. Yet resting on, weighing down, rising over, and existing beyond the sight of mankind is a magic reality poised for flight. *Maiastra* is a statement of man's relationship to the eternal world, as well as to myth and magic, and surely the supreme declaration by Brancusi of human transcendence by a higher, ideal power.

The symbolic use of the entablature in *Maiastra* had diverse sources. Rodin's *Gates of Hell*, which has a large sculpted entablature that contains *The Thinker* and is surmounted by *The Three Shades*, was still in progress at the Dépôt des Marbres when Brancusi worked for Rodin at Meudon. It certainly could have

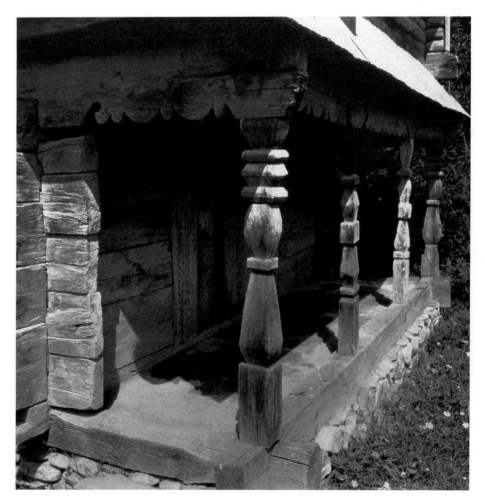

23

been a model for Brancusi's placement of the magical bird on an entablature supported by a lesser and inadequate mankind. It was only a small step from seeing Rodin's doorway as a symbolic divide to symbolizing division vertically within one sculpture. The use of a block as a symbolic boundary between humanity and a higher world, or as a symbolic weight, is a key device in Brancusi's work.

The sculptor's use of gates and entablatures could also have derived from the ornately decorated gateways that were common in rural Romania during his childhood.[27] These often have emphatic lintels that are much wider than their supporting doorposts; 107 see, for example, the gate at the entrance to a reconstruction of the artist's birthplace in Hobiţa. Though not the original structure, it typifies the most ornate (and thus most renowned) gates found in the region during the late nineteenth century. With its variety of forms stacked vertically, the first *Maiastra* also relates to another aspect of Romanian folk architecture—namely, the columns sup-23 porting the porches of peasant houses. Equally evident when the bird in *Maiastra* is viewed frontally is its marked similarity to the 27 outline of the "skylark" ridge tiles—so named because of their shape—that capped the roofs of many houses in Hobiţa and elsewhere in the area.

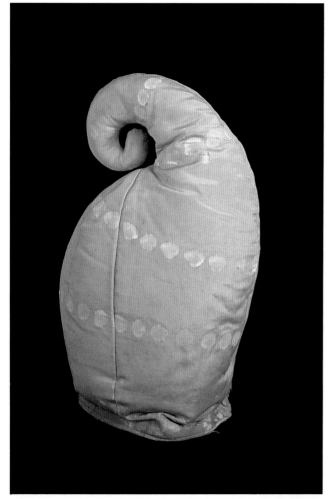

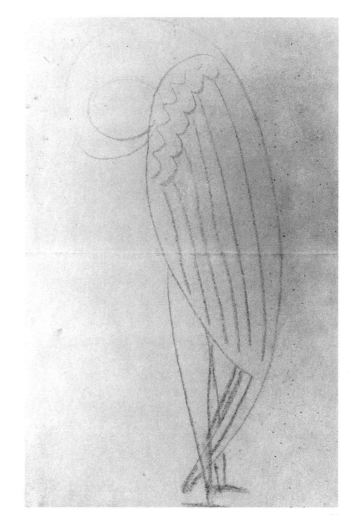

24

25

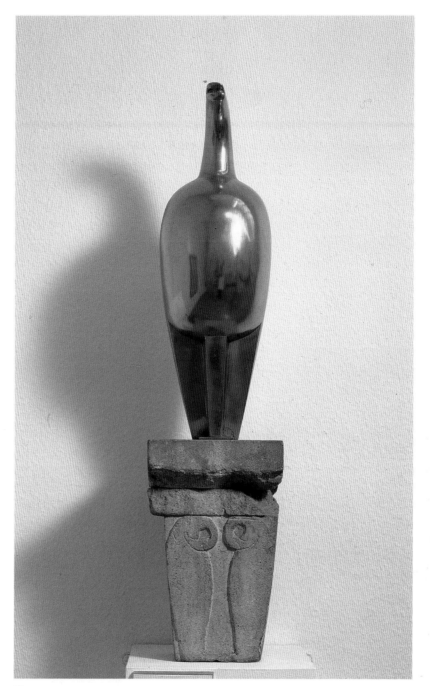

26

In the bronze *Maiastra* of 1912, cast indirectly from the marble, Brancusi again used part of the base to carry a meaning: the imperfect low-relief birds support a narrow horizontal block, upon which rests the perfected, transcendent bird. An associative link between sculpture and base occurs in another bronze *Maiastra* of 1912, where a serrated shape appears for the first time in Brancusi's output, a form that would become highly characteristic. In connection with the bird above it, this zigzag shape introduces an unmistakable (and clearly intentional) sensation of movement, like that of a bird flapping its wings.

Brancusi made four bronze versions of *Maiastra* in 1912. The

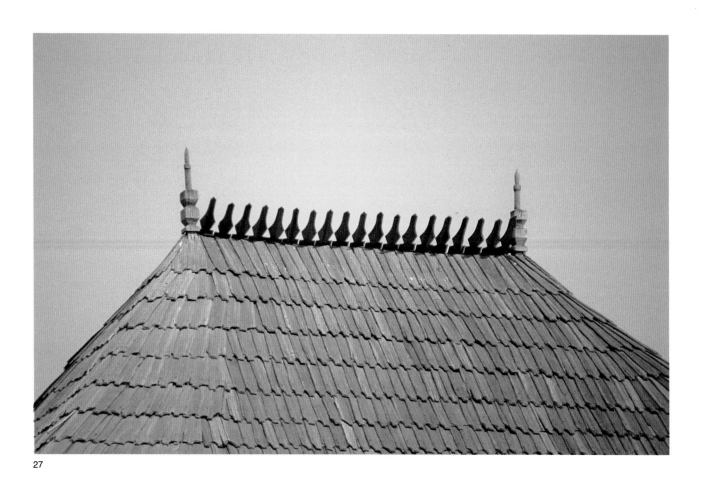

27

elongation of form apparent in two of them is even more evident in a white marble *Maiastra* made between 1915 and about 1930, which consequently has a slightly stronger sense of upward motion through the form (originally much longer, the "legs" were broken off during the German shelling of Paris in 1918). With this work Brancusi solved a problem that had worried him: "I wanted to show the Maiastra as raising its head but without putting any implication of pride, haughtiness or defiance into this gesture. That was the most difficult problem and it was only after much hard work that I managed to incorporate this gesture into the motion of flight."[28]

In 1919 Brancusi made marble and bronze sculptures entitled *Yellow Bird* and *Golden Bird*, respectively, thus signaling a change in the way he wanted his representation of birds to be approached. By abandoning the title *Maiastra*, he moved away from emphasizing magical properties, although this does not mean that the sculptures convey those qualities any less than before. His use of yellow marble and bronze enhances the radiance projected by both works. In the *Yellow Bird* the marble has a marvelous dappled richness, as though the bird is in some sunlit forest glade; the vertical linear reflections on the bronze of the *Golden Bird* augment the sense of upward motion. In both works the serration of the bases projects motion upward.

Another title change, in 1923–24, signaled a more specific concentration on one aspect of Brancusi's avian subject: *Bird in Space.*

29, 30    28    2, 31    32 (margin reference numbers)

27. "Skylark" ridge tiles on a house from the village of Bumbeşti-Piţic, near Tîrgu-Jiu, Romania, built between 1865 and 1870
Curtişoara Ethnographic Village, Gorj County, Romania

28. *Maiastra*, 1915–18, reworked c. 1930
White marble, height: 24⅜ in.; base: white marble cylinder, height: 6 in.
Philadelphia Museum of Art; Louise and Walter Arensberg Collection

29. *Maiastra*, 1912
Polished bronze, height: 24 in.
Des Moines Art Center

30. *Maiastra*, 1912
Polished bronze, height: 24¼ in.
Peggy Guggenheim Collection, Venice (The Solomon R. Guggenheim Foundation)

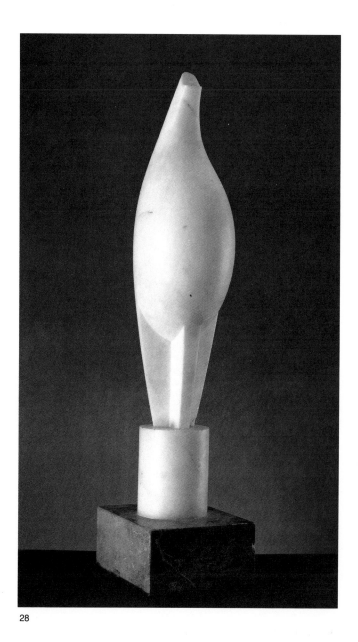

28

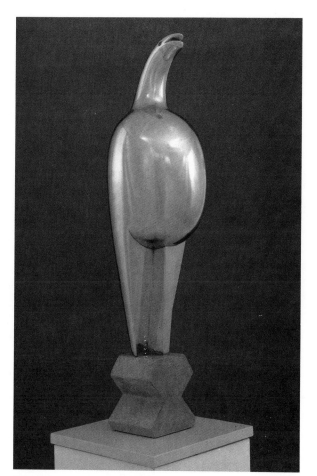

29

30

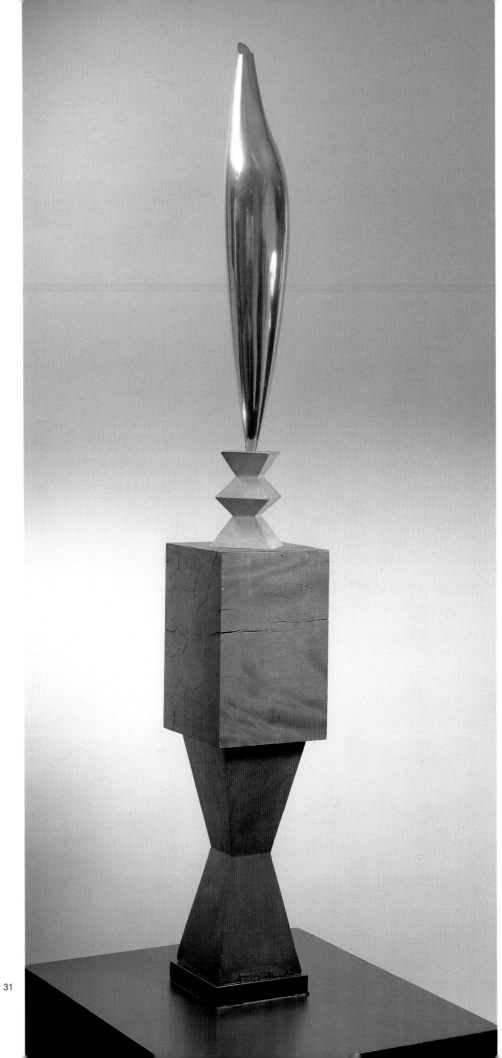

31

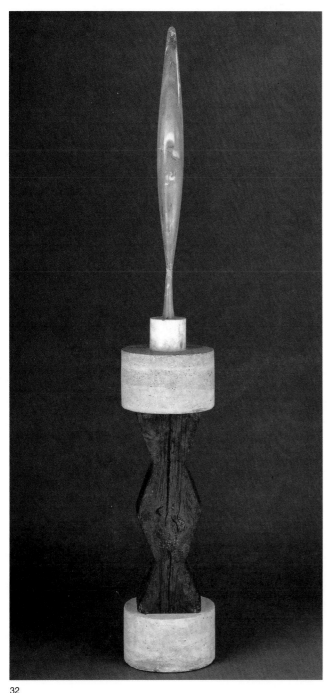

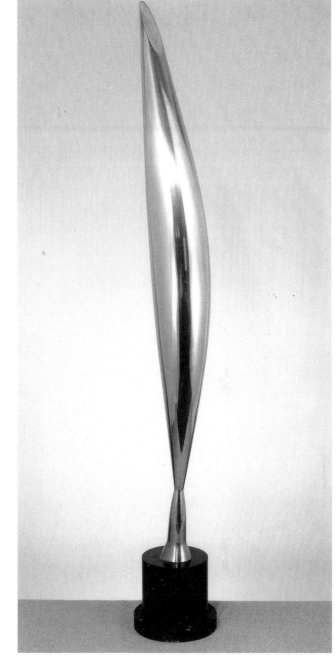

32

33

The effect of verticality is stimulated by a subtly undulating form
in the footing (the area below the narrowest part of the bird), which
enhances the rhythmic flow of the upper part. In the next *Bird in*    33
*Space* a small bulge becomes apparent at the very bottom of the
footing, but this disappears in the *Bird in Space* that succeeded it,    34
being replaced by a subtle upward sweep. In this work Brancusi
used white marble for its subtle translucence; carving such a slen-
der form in such a fragile medium demonstrates his absolute tech-
nical mastery.

The next five versions of *Bird in Space*, made in 1926–28, seem    35, 125
to express flight itself rather than even the idea of birds. One of    35
them greatly mystified some of Brancusi's less idealistic contem-
poraries. When he sent the work to New York for the second of

34

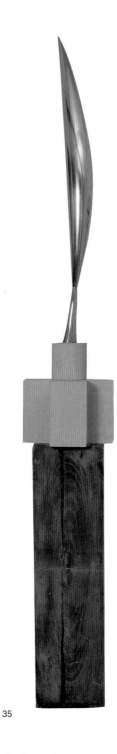

35

his one-man exhibitions in 1926, the United States Customs Service refused to allow it free entry as a work of art, instead requiring Brancusi to pay forty percent of its value as "an object of manufacture." He paid the duty under protest and sought legal redress. When the case finally came to court in November 1928, Brancusi was vindicated and the impost was refunded.

36, 37, 119    The remaining versions of *Bird in Space*, some ten in all, [29] display a subtle formal variety. Although they do not significantly add to the form that had been attained by 1928, there is no sense of waning inspiration. As Brancusi commented in 1936: "The height of the birds tells nothing in itself. It is the inner proportions of the object which do everything. In the last birds, the differences between

34.  *Bird in Space*, 1925
White marble, height: 71 in.; base: stone and wood sections, height: 64½ in.
National Gallery of Art, Washington, D.C.; Gift of Eugene and Agnes Meyer

35.  *Bird in Space*, 1926
Polished bronze, height: 53¼ in.; base: one oak and two stone sections, height: 61½ in.
Hester Diamond

36.  Left: *Bird in Space*, c. 1931–36
White marble, height: 72½ in.; base: limestone and sandstone sections, height: 52⅞ in.
(sandstone base reconstructed in 1982)
Right: *Bird in Space*, 1931–36
Black marble, height: 76⅛ in.; base: marble and sandstone sections, height: 53¼ in.
(sandstone base reconstructed in 1982)
Australian National Gallery, Canberra

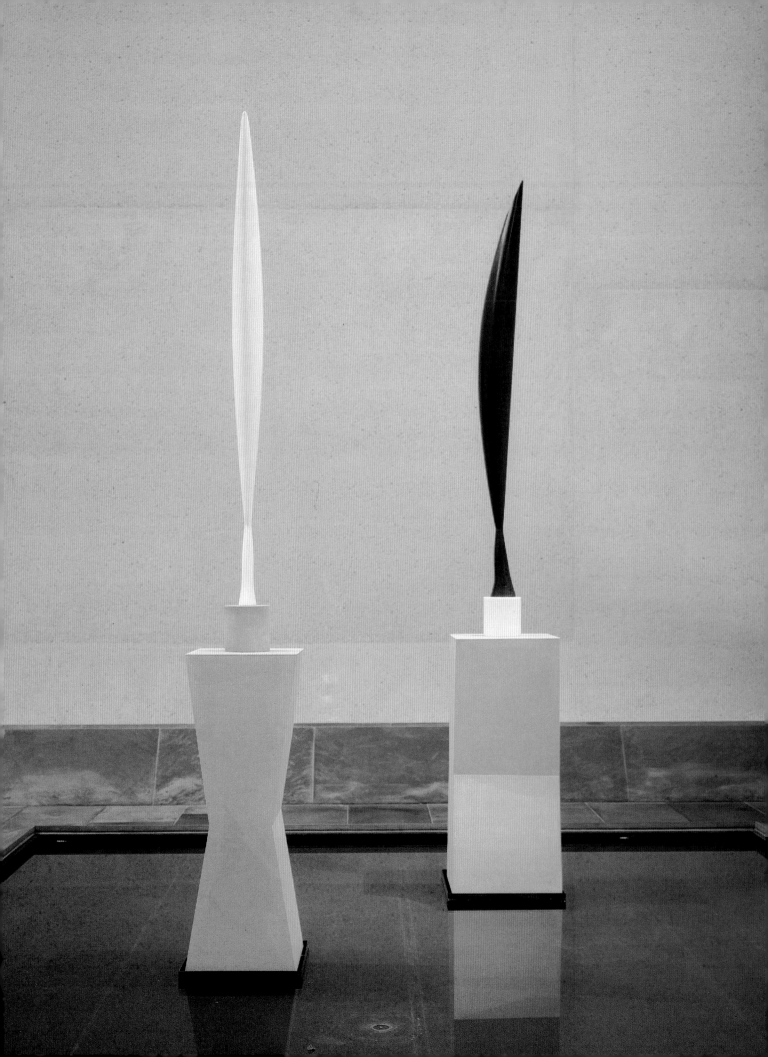

them hardly appear in photographs. Each, however, is a new inspiration, independent of the preceding one."[30] These "inner proportions" principally concern the relationship of girth to height and the ratio of the footings. In the last Birds, which are made of bronze, black-and-white marble, and painted plaster, the footings project an especially graceful contour.

Brancusi produced more variants of *Bird in Space* than of any other theme, for the subject was spiritually, aesthetically, and formally fundamental to him. He declared in 1936, "My birds are a series of different objects in a central research that remains the same."[31] Every *Bird in Space* bears witness to the artist's statement that "All my life I've been looking for one thing, the essence of flight. . . . What a marvellous thing flight is."[32] But the sculptor was not concerned with mere physical flight in his *Bird in Space* sculptures. Through distilling the fundamentals that sustain birds, he embodied a flight of the spirit.

At the time Brancusi made his first birds in 1910–12, his life was already settling into the ordered and undramatic pattern of concentrated work, growing fame, and increasing financial independence that it would thereafter follow. In 1912 he participated in the twenty-seventh Salon des Indépendants, along with Alexander Archipenko, Ossip Zadkine, and Marcel Duchamp, as well as several Cubists. *The Prayer* made a strong impression there, especially upon other sculptors, including Wilhelm Lehmbruck.

Brancusi began to move in the most progressive artistic circles, frequenting cafés such as the Rotonde, the Closerie des Lilas, and the Dôme, where his friends and acquaintances included Picasso, Guillaume Apollinaire, Marcel Duchamp, Fernand Léger, Jean Cocteau, Erik Satie, Robert and Sonia Delaunay, Julio González, Chaim Soutine, André Derain, Max Jacob, Paul Fort, and Blaise Cendrars. Amedeo Modigliani became a close friend, and it is easy to detect Brancusi's influence on his work (which is not surprising, since he taught the Italian how to carve). Another friend was Henri Rousseau. Brancusi was one of the guests at the banquet that Picasso organized in Rousseau's honor in 1908, and two years later he carved the inscription (by Apollinaire) on Rousseau's tombstone. Duchamp was to prove an especially good friend, buying and selling Brancusi's works on his behalf in America in the 1920s, as well as arranging for their exhibition and transportation. Eventually he kept three pieces for himself.

Brancusi's work first reached America in 1913, with five sculptures included in the landmark Armory Show. They were singled out for abuse by hostile members of the press and public. However, a leading American collector of modern art, the lawyer John Quinn, bought two pieces and later bought more: at the time of Quinn's death in 1924, he owned more than thirty sculptures by Brancusi. The appreciation of Brancusi's work in America received further stimulus in March–April 1914, when the artist had his first one-man show. Held at Alfred Stieglitz's Little Galleries of the Photo-Secession in New York, it was a great critical and financial success. Indeed, a number of wealthy American collectors thereafter formed the basis of Brancusi's support, setting the high level of his prices. He would later remark of such enlightened patronage: "Without

37. *Bird in Space*, 1941
Polished bronze, height: 76⅛ in.
Brancusi studio, Musée National d'Art
Moderne, Centre Georges Pompidou, Paris

40

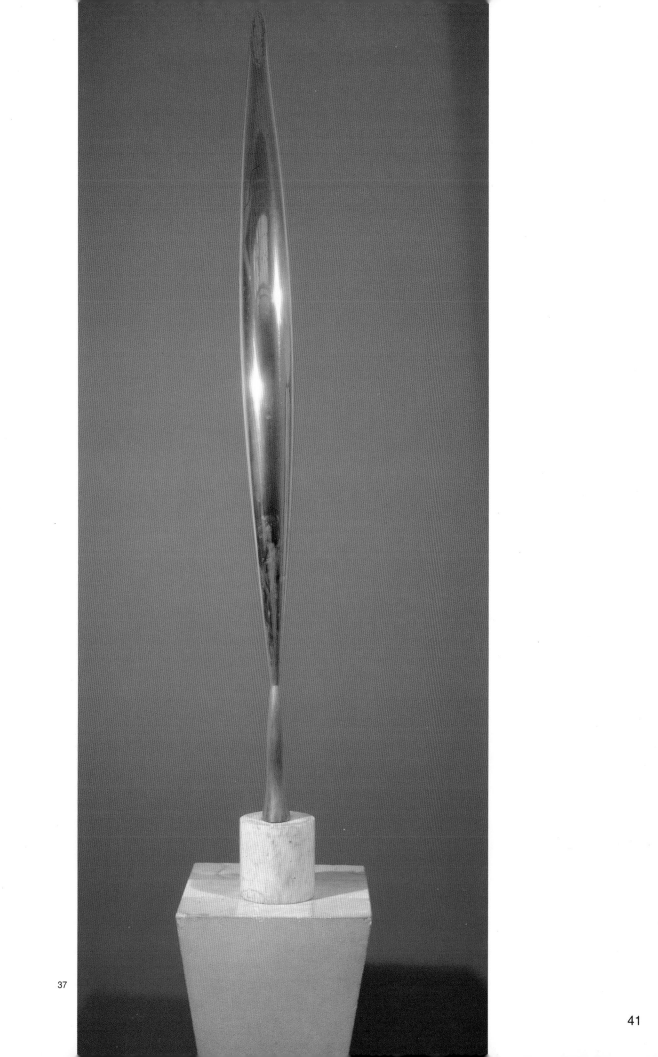

37

38

the Americans, I would not have been able to produce all this or even to have existed."[33]

Other, more specific types of birds joined the first versions of *Maiastra* in and after 1912. *Three Penguins* was inspired by an illustrated lecture on the Antarctic expedition of 1908–10 given by the explorer Jean Charcot, which Brancusi attended in 1910,[34] and the work certainly projects a sense of huddling together against the cold. *Two Penguins*, which followed in 1914, shares that effect of interdependency, albeit in a more austere, formalized way.

In 1924 Brancusi produced another bird, *The Cock*. The artist had once kept a rooster in his studio and even worked with it on his shoulder; it "would get down only at the jerkier movements of Brancusi's arms."[35] In *The Cock* the sculptor again addressed aspects of reality beyond mere appearance; as he stated to a New York newspaper reporter in 1926: "In shape and form I wanted my rooster to sing. Yes, I would like my rooster to sing."[36] Such crowing is metaphorically communicated by the zigzag forms of the underside of the sculpture, serrations that introduce associations with the ragged folds of skin hanging beneath the throat of a rooster and with the staccato sound of its crowing.

In the first version of *The Cock*, carved in walnut, Brancusi's responsiveness to materials is especially marked, for he cut the timber so that the grain adds to the cohesion of the work. Brancusi also made plaster and bronze versions of *The Cock*, some of the plasters being comparatively huge. At one time he proposed erecting a large Coq Gaulois on some public site in Paris, but the project was never developed. In 1935 Brancusi produced a definitive statement of *The Cock* in bronze, linking it to a small serrated stone support. As in some versions of *Bird in Space*, the support contrib-

38. *Three Penguins*, 1911–12
White marble, 24 x 21 x 14⅛ in.
Philadelphia Museum of Art; Louise and Walter Arensberg Collection

39. *The Cock*, 1924
Walnut, height: 36⅛ in.; base: walnut, height: 11½ in.
Collection, The Museum of Modern Art, New York; Gift of LeRay W. Berdeau

40. *The Cock*, 1935
Polished bronze, height: 40¾ in.; base: stone and wood sections, height: 76⅛ in.
Brancusi studio, Musée National d'Art Moderne, Centre Georges Pompidou, Paris

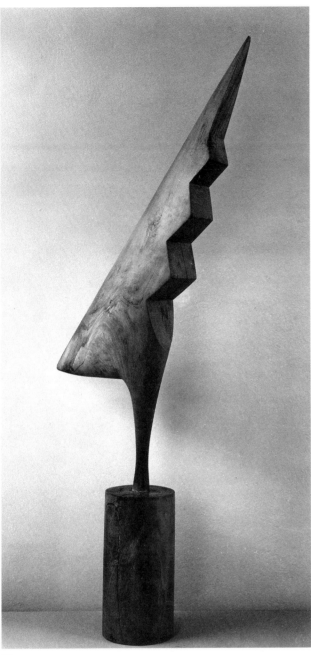

39

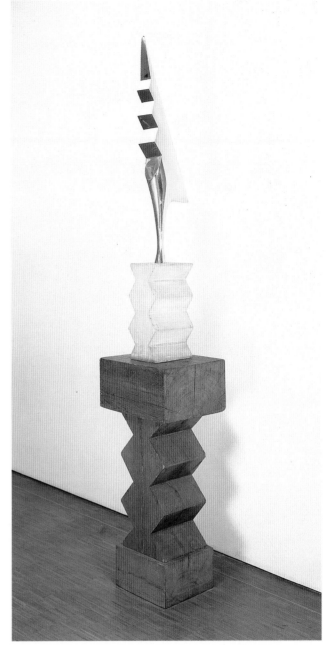

40

utes strong associations of upward movement and reinforces the serration occurring above it. *The Cock* and its immediate support are mounted on a wooden block that serves as an entablature above a serrated column. The eye reads the zigzag movement as continuing through the divide, above which the brilliant golden bird seems to exist in a more exalted kind of space.

An equally subtle sense of spatial movement was achieved by other means in *Fish*. Brancusi said of this sculpture: "When you see a fish, you do not think of its scales, do you? You think of its speed, its floating, flashing body seen through water. . . . Well, I've tried to express just that. If I made fins and eyes and scales, I would arrest its movement and hold you by a pattern or a shape of reality. I want just the flash of its spirit."[37] The phrase "a pattern or a shape of reality" is, again, unmistakably Platonic in origin.

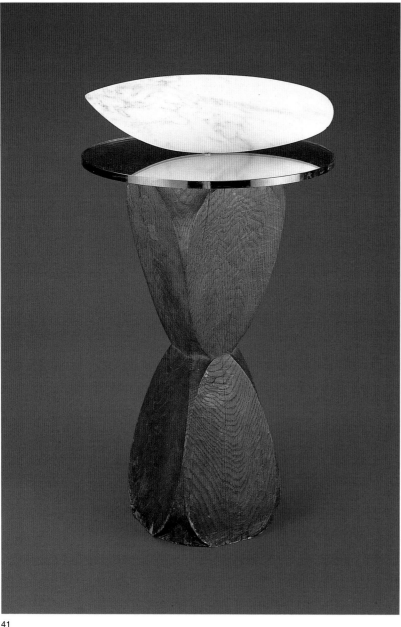

41

Modern science has subsequently demonstrated just how accurate Brancusi's imagination was in distilling the essence of this creature: in overall shape *Fish* is virtually identical to a contemporary submarine, whose hydrodynamic efficiency has been determined only after countless hours of testing. Brancusi intuited such ideality, and at a time when submarines were much more primitive in form than they are today.

41  The first *Fish* is in marble and dates from 1922; it is mounted on a mirror, which introduces appropriate associations of the reflec-

42  tivity of water. There were two polished bronze casts of *Fish* dating from 1924, and three more of 1926; all but one of the bronzes were mounted on brilliantly reflective metal disks. Because the *Fish* is convex in cross section (i.e., it bulges out at the middle), the bronzes tend to reflect things horizontally. Their reflectivity adds

41.  *Fish*, 1922
White marble, 5¼ x 16⅞ x 1¹⁄₁₆ in.; base: mirror, diameter: 17 in.; oak, height: 24 in. Philadelphia Museum of Art; Louise and Walter Arensberg Collection

42.  *Fish*, 1924
Polished bronze, 5 x 16½ x 1⅜ in.; base: polished steel disk, diameter: 19⅝ in. Formerly collection of Museum of Fine Arts, Boston (destroyed, 1979)

43.  *Fish*, 1930
Gray marble, 21 x 71 in.; base: one marble and two limestone cylinders, height: 29⅛ in. Collection, The Museum of Modern Art, New York; Acquired through the Lillie P. Bliss Bequest

44

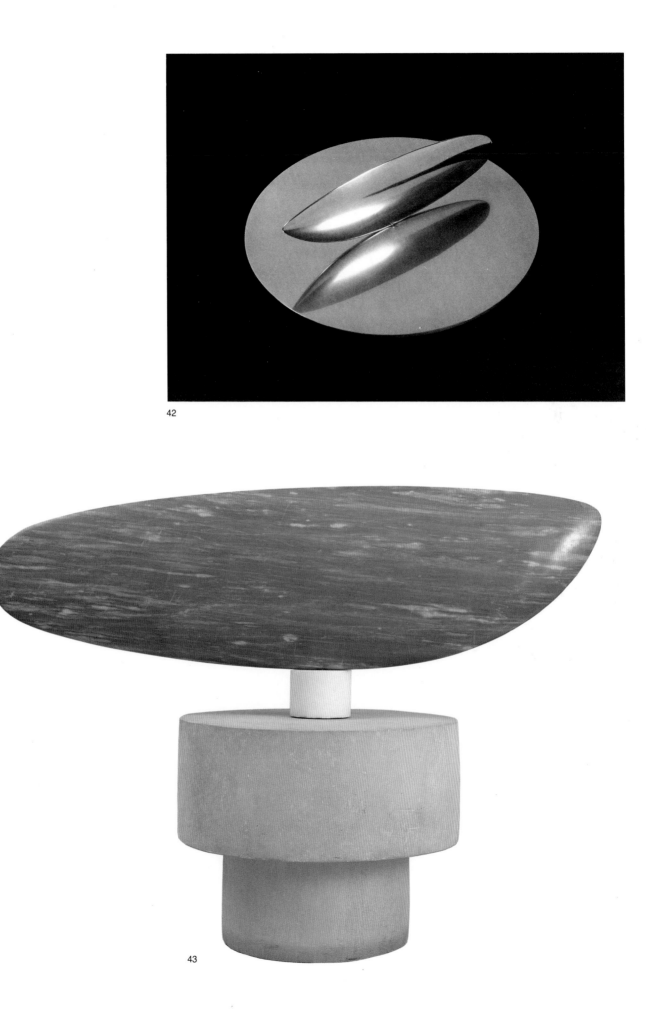

42

43

to the work a flashing linearity that is akin to the "flash of spirit"
43 Brancusi mentioned. In a gray marble *Fish* of 1930 he took advantage
of the horizontal striations of the stone to suggest levels of water.
The bronze versions of *Fish* seem to dart, the marble versions to
float. In several versions implied movement is made actual, for the
sculptures are mounted on pivots that allow them to turn 360
degrees. The 1930 *Fish* is mounted by a pivot to a small marble
drum, which in turn is placed on two big drums, the top one larger
than the lower one. This combination of two large drums can be
seen in a number of bases, and it eventually evolved into an
96 independent sculpture, *Table of Silence*.

If one imagines *Fish* turned upside down, its outline resembles
44 that of *Nocturnal Creature*. This carving from about 1930 is one of
Brancusi's wittiest and most disturbing sculptures. Again the piece
is mounted on a pivot. The subtly undulating wooden carapace is
so totally enveloping that it leaves only a very slight gap around
the edges. That gap is tantalizing, for it invites us to peer beneath
the shroud; our frustration at not being able to do so creates a
kind of tension and mystery that parallels the unnerving experi-
ence of hearing some unseen creature scuttering across the floor in
the dark.

45 There are two versions of *The Seal*—one in white marble, of
46 1924–32, the other in blue-gray marble, of 1943. Each stands on a
base composed of a large drum mounted on a smaller one. In both
versions Brancusi vividly captured the mammal's sleek form and
lumbering gait. The alternative title of the first version, *Miracle*,
arose from the inspiration for the work, which occurred when

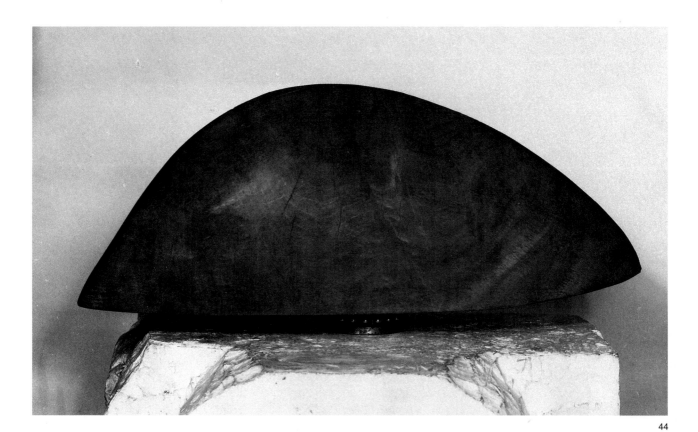

44

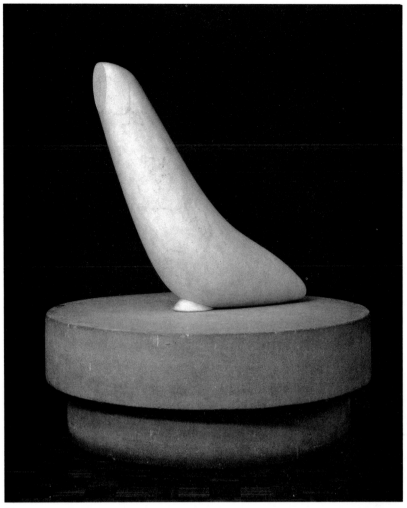

45

Brancusi observed the "liberating upward movement" of a girl's neck as she freed herself from unhappiness. The artist apprehended her return "from the dark confinement of psychic imprisonment to the fullness of the world" as a miracle, and he perceived in her movement "the gleaming gesture of an aquatic animal"—hence the alternative titles.[38] The pronounced striation of the blue-gray marble version strongly suggests the glistening coat of a seal. In both versions the sculpture presents a blank face to the world, for Brancusi considered the individuation of facial features to be supremely unimportant.

The final animal form (aside from humans) in Brancusi's menagerie was the turtle, which exists in two versions. The first, *Walking Turtle*, was carved in wood between 1941 and 1943 and was subsequently copied in plaster; the other, carved in marble between 1940 and 1945, is called *Flying Turtle*. In *Walking Turtle* legs appear on either side of the form. In *Flying Turtle* the head and neck are condensed into a long, squarish, tapering form that emerges from the shell. James Johnson Sweeney recalled the artist's comments on these works:

*Walking Turtle* is carved from a single block of wood but is, unfortunately, badly worm-ravaged. Brancusi . . . explained that once, with [the] possibility of deterioration in mind, he had the thought of making another version in marble. But in

44. *Nocturnal Creature*, c. 1930
Wood, 9¾ x 27¼ x 7 in.
Brancusi studio, Musée National d'Art
Moderne, Centre Georges Pompidou, Paris

45. *The Seal (Miracle)*, 1924–32
White marble, 42¾ x 44⅞ x 13 in.
Solomon R. Guggenheim Museum, New York

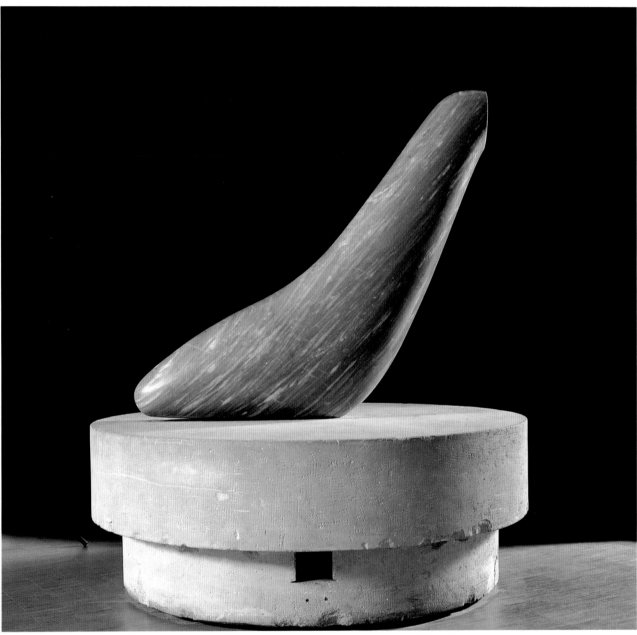

46

46. *The Seal*, 1943
Blue-gray marble, height: 43¾ in.
Musée National d'Art Moderne, Centre
Georges Pompidou, Paris

47. *Walking Turtle*, 1941–43
Pearwood, 9¾ x 20 x 22¾ in.
Brancusi studio, Musée National d'Art
Moderne, Centre Georges Pompidou, Paris

48. *Flying Turtle*, 1940–45
White marble, 12 x 36½ x 27½ in.
Solomon R. Guggenheim Museum, New York

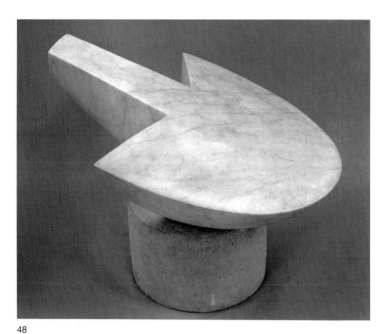

48

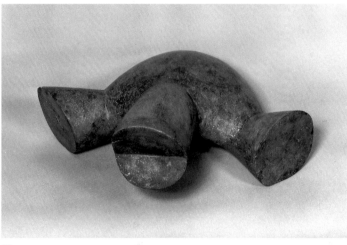

47

studying the two materials he realized at once that the curved grain of the wood expressed the rounded movement of the walking animal—"how it clung to the earth"—in a way that the straight grain of the marble never would. The straight grain of the marble was only adaptable to the communication of a taut, outstretched movement—the tension of flying, as he saw it. So his marble version took that character—*The Flying Turtle*.[39]

Brancusi originally made *Flying Turtle* to be seen the other way up, with the curve of its "shell" uppermost and the flat side of the work resting on the floor. However, when it was exhibited in the sculptor's retrospective shows at the Guggenheim Museum in 1955 and at the Philadelphia Museum of Art in 1956, it was displayed the wrong way up. Brancusi saw photographs of the work in this state and liked it, saying, "Now my turtle is flying."[40] That he should have wanted such an earthbound creature to fly at all is fully in keeping with the similar, if less surprising, emancipation from worldly constraint that he effected in the Bird in Space sculptures.

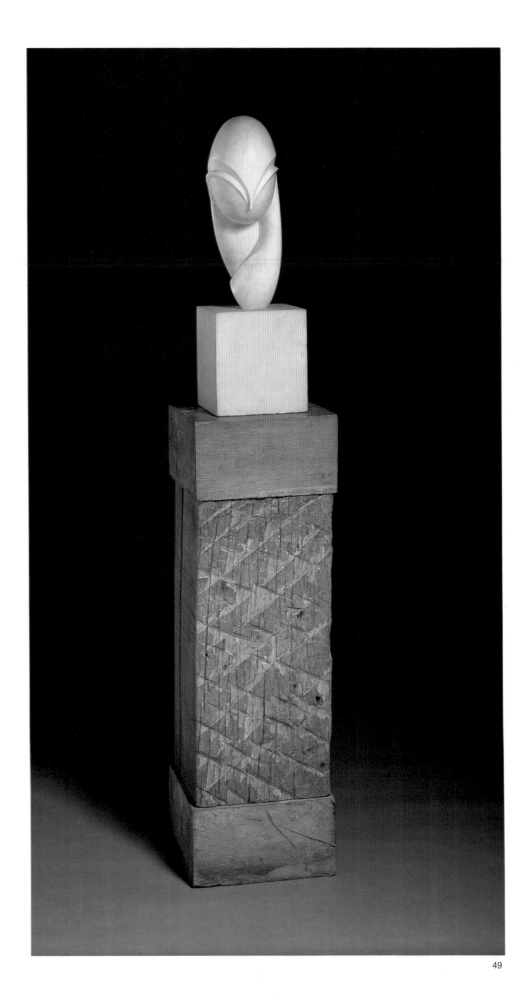

# 4. The Human World

In 1913 Brancusi returned to wood carving (although he had not *sculpted* in wood before). The similarity of some of his wood carvings to African sculptures becomes apparent about this time. Yet the much-debated influence of African art affected neither the overall direction nor the content of Brancusi's art, as it had done with, say, Picasso's painting a few years earlier. By assimilating some of the characteristic forms of African art, Brancusi was merely broadening a stylistic range that already encompassed Romanian, Cycladic, Egyptian, and Oriental sources. (His statement in the 1950s that "Only the Africans and the Romanians know how to carve wood" clearly referred to the profound feeling for materials expressed by those peoples rather than to any similarity of content in their work.[41]) Elements from African art did prove dramatically useful to him in sculptures such as *Caryatid* and *The Prodigal Son*, 53–55 in which the cultural associations of African art heighten the meaning of the works. Brancusi was a prejudiced man of his own era in that he regarded Africans as "savages"; it was that supposed savagery he drew upon to extend the content of some of his works.[42]

Brancusi's first wood carving, entitled *The First Step*, was completed in 1913; he later destroyed it. While he was carving his next piece in wood, he again used the title *The First Step*. It is now called *Little French Girl*, but its correct title is *Child*, the name 50 under which Brancusi exhibited the carving in the Brummer Gallery, New York, in 1933–34.[43] Yet originally the sculpture may have been intended to represent Plato: Brancusi later carved an extremely similar piece, which he allowed to be photographically reproduced under the title *Plato* (eventually he destroyed all but the head of 52 it[44]). Moreover, in about 1917 the sculptor took a photograph 51 that shows *Child* standing next to a column supporting a carved wooden cup, which Brancusi later identified as symbolizing the cup of hemlock taken by Socrates.[45] The sculptor called this ensemble *The Child in the World*, and if *Child* was in fact originally conceived as a portrayal of Plato, then the group must represent Plato standing beneath Socrates' fatal cup of hemlock. The suicide of Socrates was an event that, metaphorically speaking, surely did

49. *Mlle. Pogany III*, 1931
White marble, height: 17¾ in.
Philadelphia Museum of Art; Louise and Walter Arensberg Collection

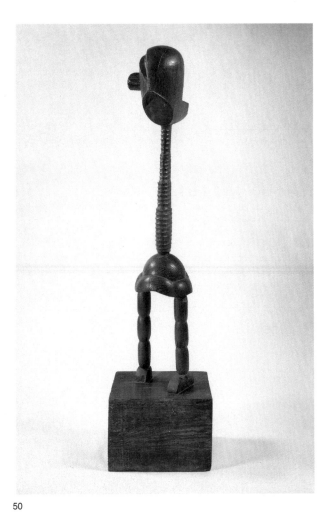

50

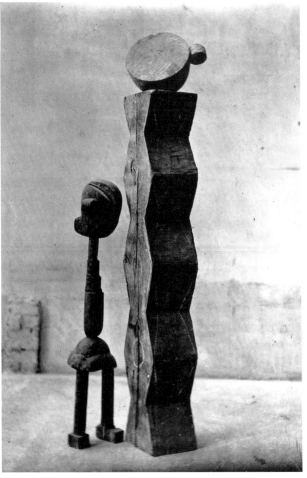

51

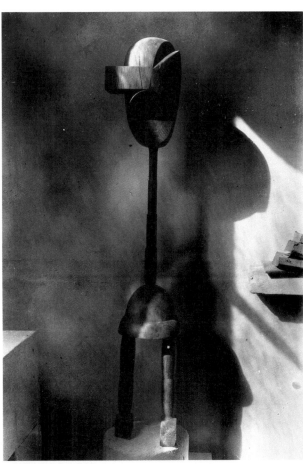

52

50.  Originally titled *Child*; currently known as *Little French Girl*, 1914–18
Oak, 49 x 8¾ x 8½ in.
Solomon R. Guggenheim Museum, New York

51.  *The Child in the World* ensemble, consisting of *Child*, *Column*, and *Cup*
Photograph by Brancusi, c. 1917

52.  *Plato*, 1919–20
Wood, height: approximately 43 in.
Destroyed (except head, completed 1923, now in the Tate Gallery, London)
Photograph by Brancusi

53.  *Caryatid*, 1914, reworked 1926
Red oak, 65⅝ x 17 in.
The Harvard University Art Museums (Fogg Art Museum); Gift in part—William A. Coolidge, Hazen Foundation, and Mrs. Max Wasserman, and Purchase in part—Francis H. Burr and Alpheus Hyatt funds

54.  *Caryatid*, 1943–48
Wood, height: 90⅛ in.
Brancusi studio, Musée National d'Art Moderne, Centre Georges Pompidou, Paris

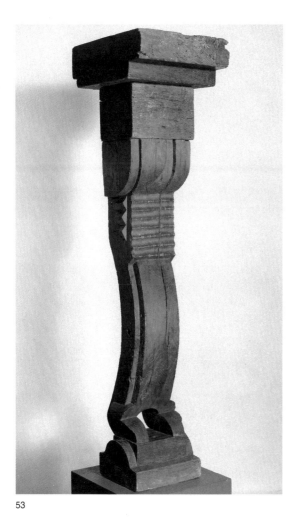

53

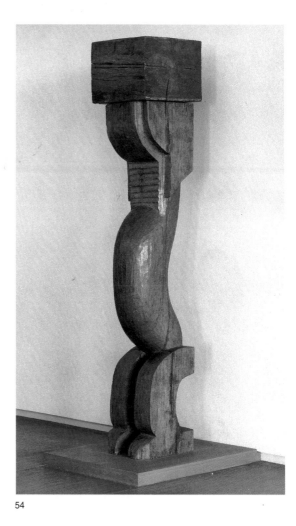

54

make Plato feel like a child in the world, about to take his first step without his master. (Further evidence for this interpretation is to be discussed in connection with the sculpture entitled *Socrates*.) 74 The titles *The First Step*, *Child*, and *Little French Girl* do not seem inappropriate to the piece, however, given the spindly legs, little skirt, skinny torso, and bawling head that can also be read in it.

Another sculpture begun in 1914 (but reworked in 1926) again 53 indicates how form consistently followed content in Brancusi's art. In *Caryatid* the stylized shapes of the figure clearly derived from African art. From bottom to top, the figure comprises: feet, whose semicircular form is amplified by similar shapes on either side of the base below them, semicircles that create a pivotal effect; a bowed torso; a serrated section reminiscent of the long necklaces worn by certain African tribeswomen; and curves suggestive of upraised arms, with the head between them. Serrated shapes are also carved on the back. The figure supports a massive stepped entablature. Once again, Brancusi's placing of an emphatic entablature above a figure indicates his preoccupation with the relationship of humanity to a higher power, even if that higher power is invisible here. Instead of directly stating mankind's primitivism by carving the human form in a rough manner, as he had done earlier, in *Caryatid*, Brancusi addressed that primitivism indirectly, through the cultural association with African art. In 1943–48 he created a similar *Caryatid* with legs that reiterate the bowing of the trunk. In 54

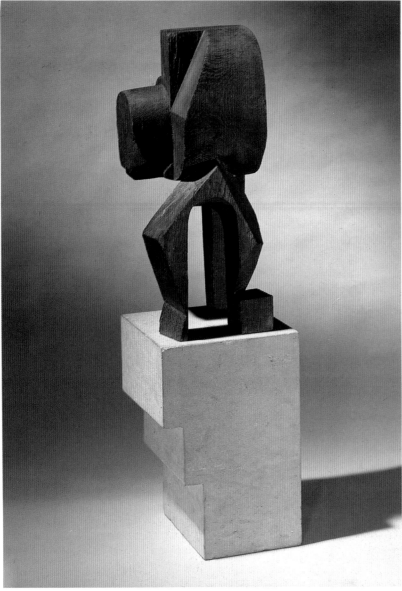

55

that work the entablature is a simple large block, but the symbolic statement remains unchanged.

55    *The Prodigal Son* of 1914–15 is a kneeling supplicant, recalling
10 *The Prayer* of 1907. Though abstracted, the pose of the figure is not too difficult to read, consisting of a bowed head and curved back, with one leg bent behind and an arm reaching forward to touch the ground. The sense of supplication is underscored by the shape of the base, which subtly projects the figure forward. *The Prodigal Son* is often cited as having been influenced by African art, but as Sidney Geist has convincingly suggested, its stylistic sources seem instead to be Cubism and Futurism, the piece being perhaps the most spatially complex of all of Brancusi's sculptures.[46] The handling of the wood itself has a raw, primitive feel that is evocative of African carvings, but this is surely because Brancusi wanted his prodigal to be seen as a somewhat primitive being who is declaring his subservience to a higher power, in this case his father.

55.  *The Prodigal Son*, 1914–15
Oak, height: 17½ in.; base: stone, height: 12½ in.
Philadelphia Museum of Art; Louise and Walter Arensberg Collection

56.  *Princess X*, 1916
White marble, height: 23⅛ in.
Sheldon Memorial Art Gallery, University of Nebraska-Lincoln; Gift of Mrs. Olga N. Sheldon

57.  *Princess X*, 1916
Polished bronze, 23 x 16½ x 9 in.; base: stone, height: 7¼ in.
Philadelphia Museum of Art; Louise and Walter Arensberg Collection

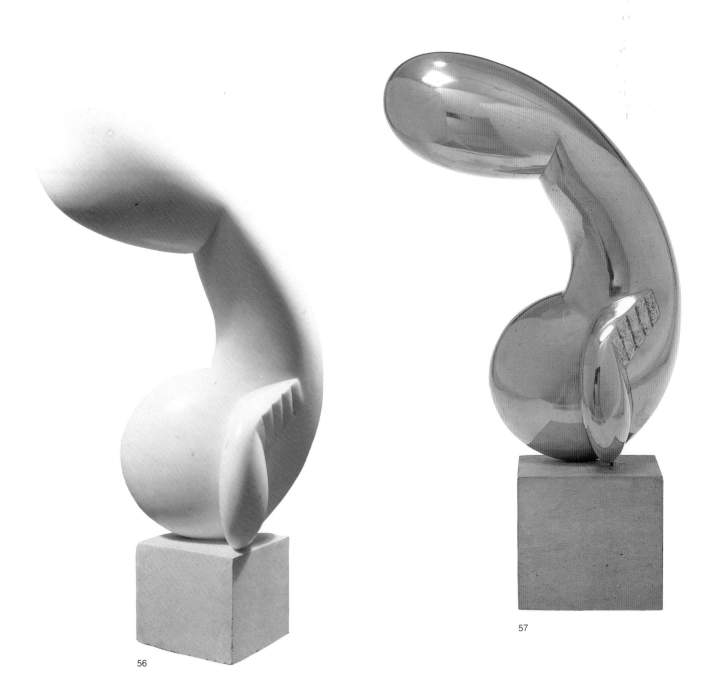

56

57

While making "primitive" statements such as these, during the mid-1910s Brancusi was simultaneously creating some of his most sophisticated and decidedly unprimitive designs. One such is *Princess X*, sculpted in marble and then cast in bronze. The work has <span>56, 57</span> its origins in an earlier, destroyed sculpture entitled *Woman Looking into a Mirror*. The subject of that piece, Princess Maria Murat Bonaparte, was so vain that she took a mirror everywhere, even to dinner parties, where she would look at herself while eating. In his earlier sculpture Brancusi represented her head as being bent to catch her reflection as she eats. In both versions of *Princess X* this anecdotal element has been replaced by a complete idealization of the form: an implied ovoid represents the head, the long neck terminates in the full bust, and delicate ripples behind the juncture of head and neck denote the hair.

The bronze *Princess X* figured in a significant scandal in 1920.[47] When the sculpture was displayed in the Salon des Indépendants,

either Picasso or Matisse drew attention to it by saying, "Voilà, le phallus!" Embarrassed by the work, the organizers pressured Brancusi to withdraw it, which he did in great anger. Apparently unaware of its phallic connotations, he had been seeking a Platonic ideal in the sculpture, as he subsequently told a newspaper reporter:

My statue is of Woman, all women rolled into one, Goethe's Eternal Feminine reduced to its essence. . . . That, sir, was my first version [destroyed]. Then for five years I worked, I simplified, I made the material speak out and state the inexpressible. For indeed, what exactly is a woman? Buttons and bows, with a smile on her lips and paint on her cheeks? . . . That's not Woman. To express that entity, to bring back to the world of the senses that eternal type of ephemeral forms, I spent five years simplifying, honing my work. And at last I have, I believe, emerged triumphant and transcended the material. Besides, it is such a pity to spoil a beautiful piece by digging out little holes for hair, eyes, ears. And my material is so beautiful, with its sinuous lines that shine like pure gold and sum up in a single archetype all of the female effigies on Earth.[48]

This passage illuminates many of Brancusi's other human forms as well. Between 1917 and 1925 he created wood and bronze versions of *Torso of a Young Man* and onyx carvings of *Torso of a Young Woman*. Like *Princess X*, these idealized sculptures were clearly attempts "to bring back to the world of the senses that eternal type of ephemeral forms." Brancusi's strong propensity to match the content of a sculpture with its material is especially vivid in these works, in his use of hard wood or shining bronze for the male forms and pearly onyx for the female. The attenuated trunks of the male forms build on cultural associations, calling to mind countless classical torsos in museums around the world. In some of the female forms dating from between 1908 and 1918, Brancusi represented just the midriff of a young woman leaning slightly forward and created some incredibly subtle curves, particularly one slight depression around the mons veneris[49]; subsequent versions abstract the form completely, so that it resembles a vase.

Despite Brancusi's objections to the misreading of *Princess X*, *Torso of a Young Man* makes apparent his willingness to address human sexuality, for although the torso lacks genitalia, this is obviously because the overall tripartite form recapitulates the male sexual apparatus. Clearly, it was the seeing of things that he had not intended in *Princess X* that Brancusi objected to, not sexual imagery itself.

Brancusi's concern with sexuality became even more explicit with *Adam and Eve* of 1916–21. *Eve* comprises two opening spheres, the lower of which resembles the lips both of the mouth and of the female sexual orifice. These buds are supported by a precise if simplified representation of an erect penis and testicles. The sculptor said of the work: "Eve is above, Adam is below. Eve's part is to continue life. She is charming and innocent. She is fertility, a bud opening, a flower germinating. Adam below tills the earth, he toils and sweats."[50] The block that separates *Eve* "above" from *Adam* "below" may symbolize their fusion, for in addition to being a base for *Eve* the block serves as an entablature for *Adam*, who is therefore yet another caryatid figure. And, of course, by placing Eve on a pedestal above Adam, Brancusi stated

58

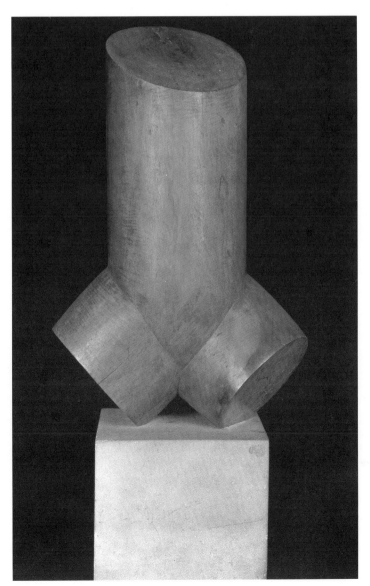

58. *Torso of a Young Woman III*, 1925
Onyx, height: 10⅜ in.
Brancusi studio, Musée National d'Art
Moderne, Centre Georges Pompidou, Paris

59. *Torso of a Young Man*, 1917(?)–1922(?)
Maple, height: 19 in.; base: limestone, height:
7 in.
Philadelphia Museum of Art; Louise and Walter
Arensberg Collection

59

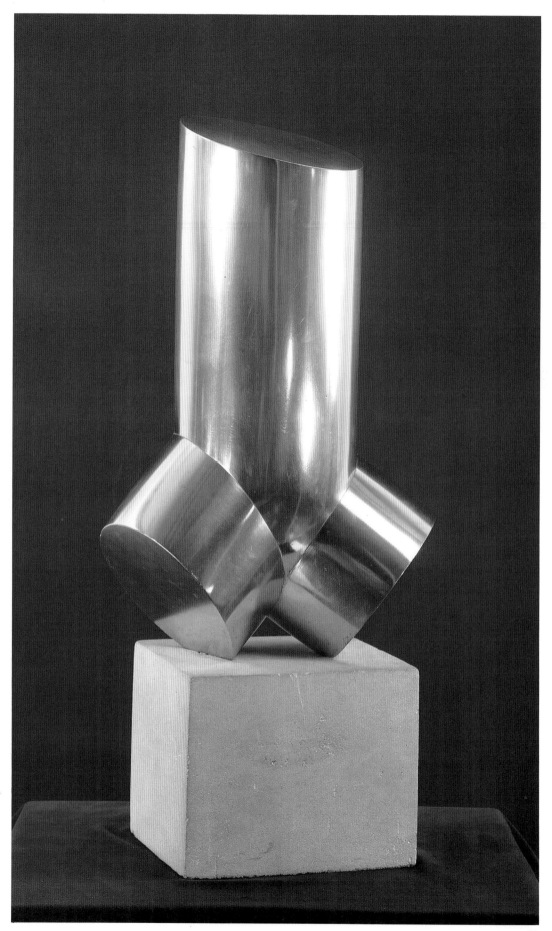

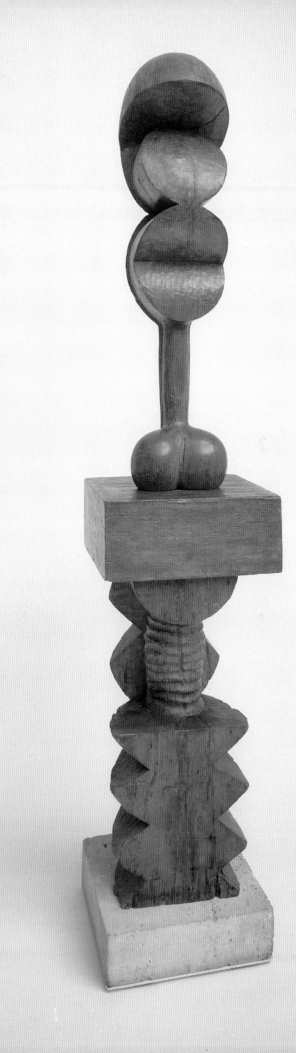

60.  *Torso of a Young Man*, after 1924
Bronze, 18⅜ x 12 x 6⅝ in.
The Cleveland Museum of Art; The Hinman B.
Hurlbut Collection

61.  *Adam and Eve*, 1916–21
Chestnut and oak, respectively, height: 89 in.;
base: limestone, height: 5¼ in.
Solomon R. Guggenheim Museum, New York

61

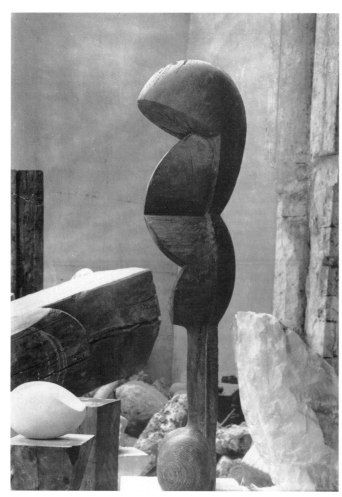

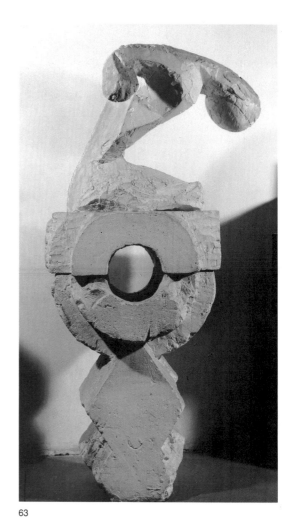

62

63

that woman can represent an ideal for man. The sculptor also reinforced the difference between the two personifications by employing chestnut for *Adam* and oak for *Eve*. Below the entablature *Adam* seems truly weighed down, with the curve of his back and the serrated form at the front yielding strong effects of compression. Other pertinent associations are stimulated by looking at the sculpture from the side. From this angle *Eve* has the ungainly, protruding shape of a heavily pregnant woman, with the uppermost "bud" resembling a protective hood. That Brancusi especially wanted the sculpture to be seen from the side is indicated by the fact that he photographed that view.

Between 1910 and 1913 Brancusi made a model entitled *Narcissus Fountain*, and in 1913 he proposed to enlarge it for a memorial being planned in Bucharest to the recently deceased Romanian mathematician Spiru Haret. His idea for a drinking fountain was rejected in favor of a more conventional statue by a local sculptor, which Brancusi called "an architectonic and plastic horror." In *Narcissus Fountain* a figure peers downward, his face a blank. Obviously it is blank not because Brancusi lacked the ability to reproduce human features but because, as in *Princess X*, he sought an ideal generalization of the head. Such idealization is highly appropriate to the portrayal of someone who fell in love with his own beauty, but Brancusi must have intended some larger meaning as well. The sculptor's own copy of Ovid's *Metamorphoses*,

62. *Eve*, c. 1920
Oak, height: 56 in.
Photograph by Brancusi

63. *Narcissus Fountain*, 1910–13
Plaster, 20⅝ x 25⅝ x 17⅜ in.
Brancusi studio, Musée National d'Art
Moderne, Centre Georges Pompidou, Paris

64. *Mlle. Pogany*, 1912
White marble, 17½ x 6 in.; base: stone,
6 x 6½ in.
Philadelphia Museum of Art; Given by Mrs.
Rodolphe Meyer de Shauensee

65. *Mlle. Pogany*, 1913
Polished bronze with black patina, height:
17¼ in.
Collection, The Museum of Modern Art, New
York; Acquired through the Lillie P. Bliss
Bequest

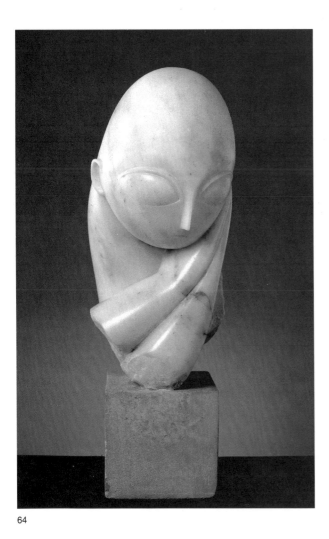

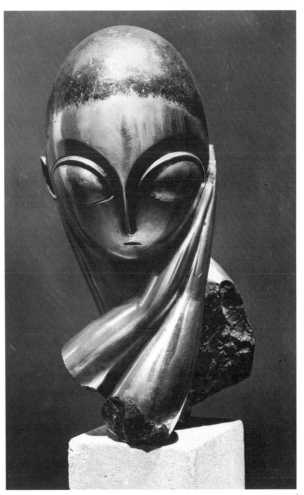

64

65

from which he derived the subject, suggests what that meaning might be: "While [Narcissus] drinks, captivated by his image which he sees in the mirror of the waters, he loves a vain shadow and lends it a body."[51] *Narcissus Fountain* was to have been placed directly above a water trough, and therefore would have embodied yet another Platonic comment on the difference between appearance and reality: as people drank from the fountain they would have seen the ideal form of Brancusi's sculpture behind their own "vain shadows." *Narcissus Fountain* was intended to be a *vanitas* object, reminding us that the normal images we have of ourselves are but "shadows and reflections"[52] of true reality—in this case true reality being represented by Brancusi's ideal form.

Idealized forms also flourish in the series of portraits of Mademoiselle Pogany that Brancusi made from 1912 onward. The lady portrayed was a young Hungarian artist he had befriended in 1910. At first he modeled her head in straightforward representations, which he subsequently destroyed. In a marble of 1912 he featured just the large eyes, with pronounced Picasso-like rims; the hands are drawn up beneath the cheek and the head is reduced to an ovoid. Only slightly more individuality is apparent in the four bronze versions of *Mlle. Pogany* dating from 1913, one of which the subject herself purchased. In three of the versions Brancusi added a black patina to denote the hair. Such secondary characteristics subsequently disappeared as an ever greater sense of idealiza-

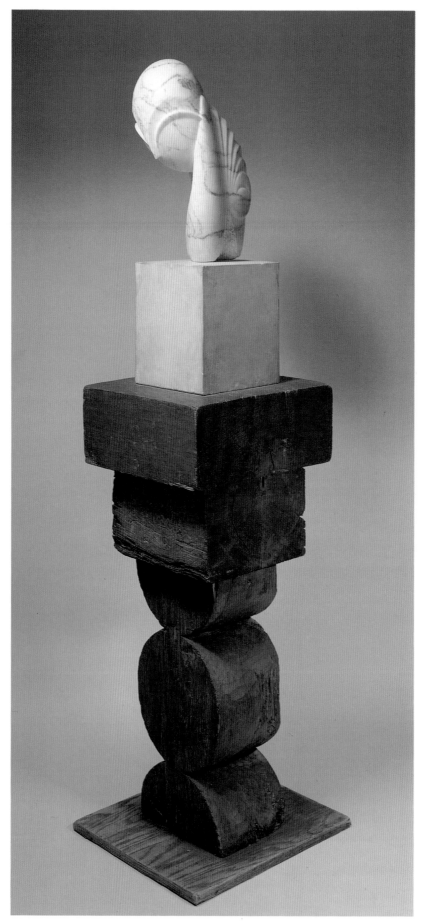

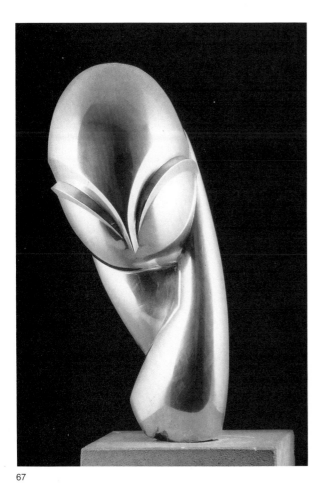

67

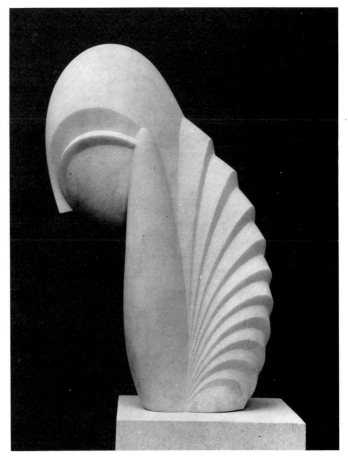

68

66. *Mlle. Pogany II*, 1919
Veined marble, height: 17⅜ in.; base: lime-
stone and wood sections, height: 49 in.
Mr. and Mrs. James W. Alsdorf, Chicago

67. *Mlle. Pogany II*, 1920
Polished bronze, 17¼ x 7 x 10 in.
Albright-Knox Art Gallery, Buffalo; Charlotte A.
Watson Fund, 1927

68. *Mlle. Pogany III* (detail), 1931
See plate 49
Photograph by Brancusi

tion emerged. A marble of 1919 displays even more sensuality,  66
tenderness, and stylishness, with the hair flowing down the back in
a series of sweeping curves. The next year Brancusi made bronze  67
casts of a highly mechanical appearance, with machinelike forms
and a brilliant clarity of contour. And a marble of 1931 is the  49, 68
apotheosis of all the earlier versions, with elegant curves in the
hair and a seemingly infinite series of sweeps throughout, the curves
of the eyebrows, hands, and head continuously intersecting as one
moves around the sculpture. What had begun as a representation
of one individual now embodies the ideal and timeless.

In another series of female heads Brancusi again made paradox
serve higher ends. *The White Negress*, in marble, and *The Blond*  69, 70
*Negress*, in bronze, date from 1923 to 1933 and were inspired
by seeing a beautiful black girl in Marseilles. Brancusi distilled her
ethnic features to prominent lips, balanced at the neck by a shape
denoting a scarf and by a small chignon atop the head. As always,
he wanted to express an inner, universal beauty underlying the
vagaries of outer guise, which he achieved here by changing the
color of the girl from black to white or blond. *The White Negress*
and *The Blond Negress* are not statements about skin color at all;
they transform the skin to reveal an inner radiance, just as in the
black marble *Portrait of Mrs. Eugene Meyer, Jr.*, Brancusi trans-  71
formed a white woman to reveal a dark, more perfect luster within.

Wit and idealism appear in equal measure in the wood and

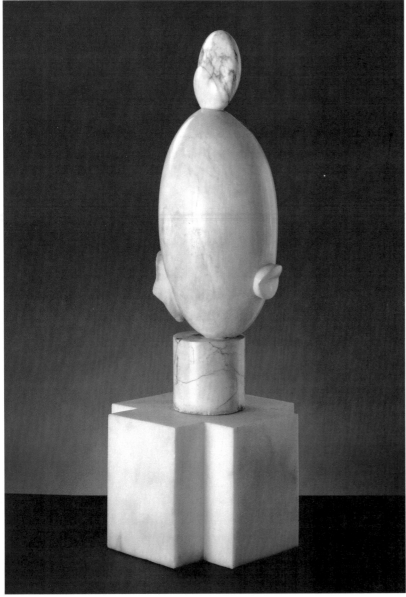

69

bronze versions of *Portrait of Nancy Cunard*, dating from 1925–27 and 1928–32, respectively. Nancy Cunard, the granddaughter of the founder of the Cunard shipping company, lived mainly in France after 1918. She was a founder of a Parisian publishing house, The Hours Press, which produced the works of Samuel Beckett, Ezra Pound, and Havelock Ellis, among others. Also in the forefront of attempts to enhance the appreciation of contemporary black culture, she collected African objets d'art. Her friends included Man Ray, who was very close to Brancusi, and Tristan Tzara, the Romanian poet and cofounder of the Dada movement, through whom she met the sculptor in 1924. As in his other representations of worldly women, Brancusi reduced the face to a blank to denote some universal physiognomy, but the length of the facial area may acknowledge the fact that Nancy Cunard did have a rather long face. The severe simplicity of the head underscores the

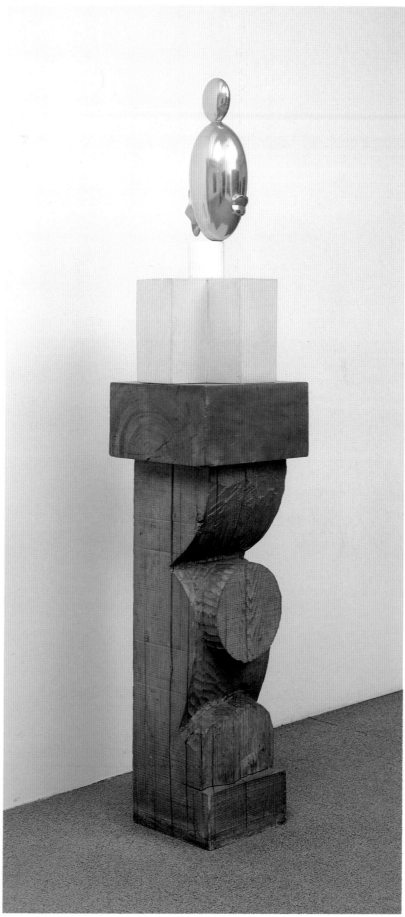

69.  *The White Negress*, 1923
White marble, height: 19 in.; base: marble,
height: 6⅜ in.
Philadelphia Museum of Art; Louise and Walter
Arensberg Collection

70.  *Blond Negress II*, 1933
Polished bronze, height: 15¾ in.; base:
marble, limestone, and two wood sections,
height: 55½.
Collection, The Museum of Modern Art, New
York; The Philip L. Goodwin Collection

70

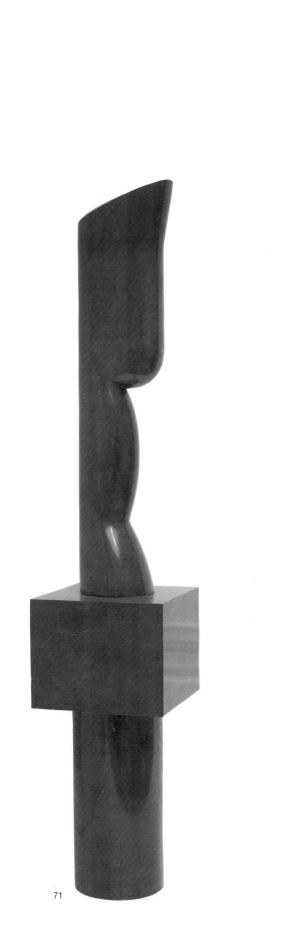

71

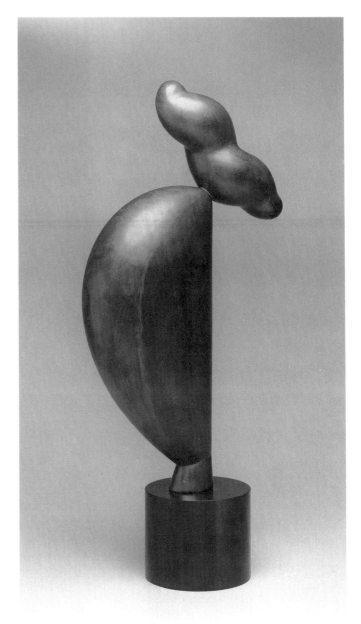

72

66

gaiety of the whorl on top of it, which may represent a chignon.

Such reduction of human features to serve ideal ends is even more striking in the *Portrait of Mrs. Eugene Meyer, Jr.*, of 1930. Agnes 71 E. Meyer was a poet, literary critic, and writer on Chinese art, as well as the wife of the publisher of the *Washington Post*. The Meyers were great patrons of the arts and were especially friendly with Alfred Stieglitz; they paid the shipping costs for Brancusi's first one-man show at Stieglitz's gallery and eventually owned five Brancusi sculptures. The portrait came into being because Brancusi was disgusted with Agnes Meyer for having commissioned her portrait from Charles Despiau, a rather conventional pupil of Rodin; he wanted to demonstrate what a real portrayal should look like.[53] Once more using paradox to reveal "truth," he represented in black marble without any facial features whatsoever, a woman famous for her creamy skin and good looks. Topped by a form derived from the pillbox hats that were fashionable in the 1920s, this portrait is supported by a block-entablature that rests on a column, both in black marble as well. Meyer recorded in her memoirs that Brancusi first called her portrait *La Reine pas dédaigneuse*, which might be translated as "The queen without disdain."[54] The precision of shape throughout the sculpture makes it look especially like a product of the machine age, and the lower part clearly influenced the American sculptor David Smith.[55]

Throughout the 1910s, '20s, and '30s, Brancusi made other idealizations of the head, entitled *Danaïde*, *A Muse*, and *Sleeping Muse*. 3 Perhaps the most reductive of them is the *Head of a Woman*, begun 73 in 1910 and completed about 1925. Here a gathering (of hair?) at the back of the neck lends character, but facial features have again been entirely subsumed by some higher, abstracted ideal of womanhood.

After making the *Narcissus Fountain* (1910–13), Brancusi rarely represented men. Of such portrayals, he allowed just three to survive, and only one stands for a named individual. These sculptures are *Socrates* (1922), *The Chief* (1924–25), and *King of Kings* (c. 1938). Other males appear in *Adam and Eve* and the various versions of *The Kiss*, but in each case the man is more or less inseparable from a woman. All three portrayals of independent males have some kind of philosophical or religious associations.

Brancusi stated of *Socrates*: "The whole universe flows through. 74 . . . Nothing escapes the great thinker. He knows all, he sees all, he hears all. His eyes are in his ears, his ears in his eyes. Not far from him, like a simple and docile child, Plato seems to be soaking up his master's wisdom."[56] The final sentence demonstrates why *The Child in the World* ensemble might well have been a statement about Plato's relationship to Socrates. It also indicates that the sculpture today called *Little French Girl* but initially entitled *The First Step* and then *Child* was almost certainly intended to represent Plato, while revealing why such a portrayal should resemble a first step or a child. The tripartite sections of "neck" supporting the head of Socrates are identical to the tripartite forms of the legs in *Child*; such a similarity might have arisen because Brancusi wanted to create a formal connection between the two sculptures.

*Socrates* is a statement about philosophical comprehension, with

71. *Portrait of Mrs. Eugene Meyer, Jr.*, 1930
Black marble, height: 90⅝ in.
National Gallery of Art, Washington, D.C.; Gift of Eugene and Agnes Meyer

72. *Portrait of Nancy Cunard*, 1925–27
Wood, 20½ x 11 x 4¾ in.
Mr. and Mrs. Raymond D. Nasher, Dallas

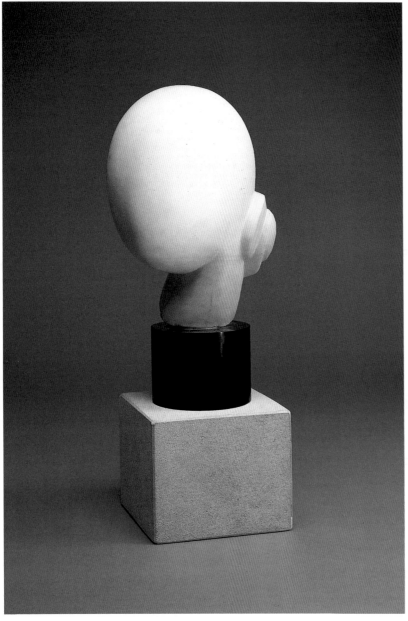

73

the cavernous head, huge eyes, and open mouth projecting the sense of all-knowingness that Brancusi verbally specified.[57] The bulbous sections below the head embody a pulsing rhythmic flow similar to that encountered in Brancusi's columns and may have been intended to stress the emancipation of mind from body. This interpretation gains support from a photograph taken by Brancusi sometime after 1934,[58] which shows *Socrates* with the "cup of hemlock" resting on its head. That cup served to part Socrates from his bodily existence, and its death-bearing role explains why the sculpted cup is solid—it is full of poison.

*The Chief*, apparently a caricature of the pope, is one of Brancusi's wittiest pieces. The sculptor had "no religion,"[59] and considering his highly developed philosophical views one can imagine his contempt for conventional religious leaders. The pope's authority is brutally debunked by a junk crown and a leering, foolish mouth.

75

76

73.  *Head of a Woman*, 1910–c. 1925
White marble, height: 11¼ in.
Private collection

74.  *Socrates*, 1922
Wood, height: 51¼ in.
Collection, The Museum of Modern Art, New York; Mrs. Simon Guggenheim Fund

75.  *Socrates*
Photograph by Brancusi, taken after 1934, with "cup of hemlock"

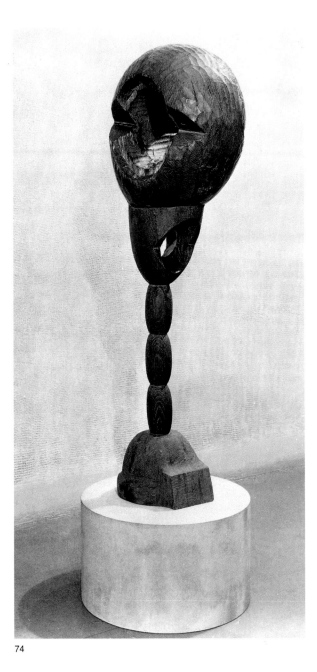

74

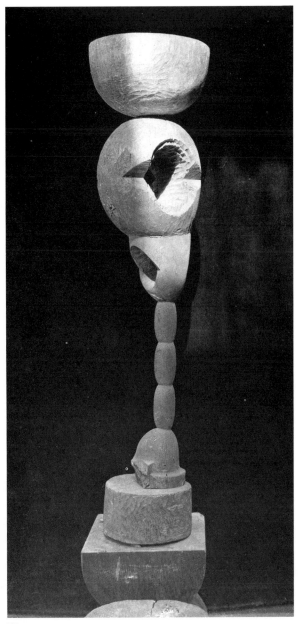

75

Brancusi's final portrayal of a man, the monumental wood carving entitled *King of Kings* begun in the early 1930s, was originally called *Spirit of Buddha*; only later did the sculptor rename it. The lotus, which serves as a crown, has Buddhist associations, and the fact that Brancusi wanted the large eyes of *Socrates* to be interpreted as all-seeing suggests a similar interpretation for the large orbs of *King of Kings*. The vertical segmentation of the piece recalls the variety of forms stacked up on Romanian veranda posts, a variety also evident in sculptures such as the first *Maiastra*, *Adam and Eve*, and *Chimera*.

An even stranger conjunction of forms appears in *Chimera*, a work related to the world of myth and magic. Traditionally, a chimera has the body of a goat with a lion's head and a snake's tail. Only the bottom part of Brancusi's chimera follows that tradition, with its undulant form suggesting a snake. The other two components are wholly alien, and much more disturbing. The

77

78

69

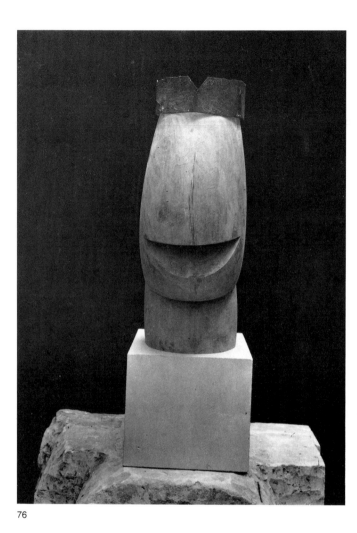

76

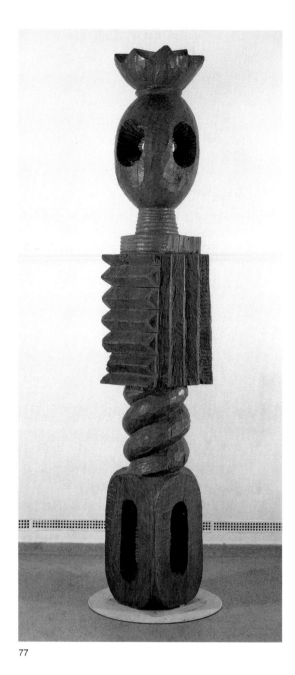

77

hollow central element may be intended to introduce associations of the stomach, an organ that essentially motivates all wild creatures, while the uppermost element may have derived from Brancusi's memories of a Romanian peasant Christmas ritual (pagan in origin) in which children wore long-beaked bird masks to ward off evil spirits.[60] The head of Brancusi's *Chimera* seems both birdlike and suitably frightening.

By all accounts magic was something that Brancusi took extremely seriously, perhaps because of his peasant origins. The forms of *The Sorceress* of 1916–24 derived from the triple-forked piece of maple from which it was carved. The shape at the top clearly suggests a witch's pointed hat, while the protruding cylinders at the rear may allude to her passage through the air. As elsewhere, the face is a blank, although it incorporates a knot of the wood, perhaps to suggest an all-seeing eye. Facial characteristics would seem redundant here, for the overall form expresses an uncanny

79

76. *The Chief*, 1924–25
Wood and iron, height: 20⅛ in.
Private collection, Chicago
Photograph by Brancusi

77. *King of Kings*, c. 1938
Oak, height: 118⅛ in.
Solomon R. Guggenheim Museum, New York

78. *Chimera*, 1918
Oak, in two sections: upper, height: 36½ in;
lower, height: 23¾ in.
Philadelphia Museum of Art; Louise and Walter
Arensberg Collection

79. *The Sorceress*, 1916–24
Wood, height: 39⅜ in.
Solomon R. Guggenheim Museum, New York

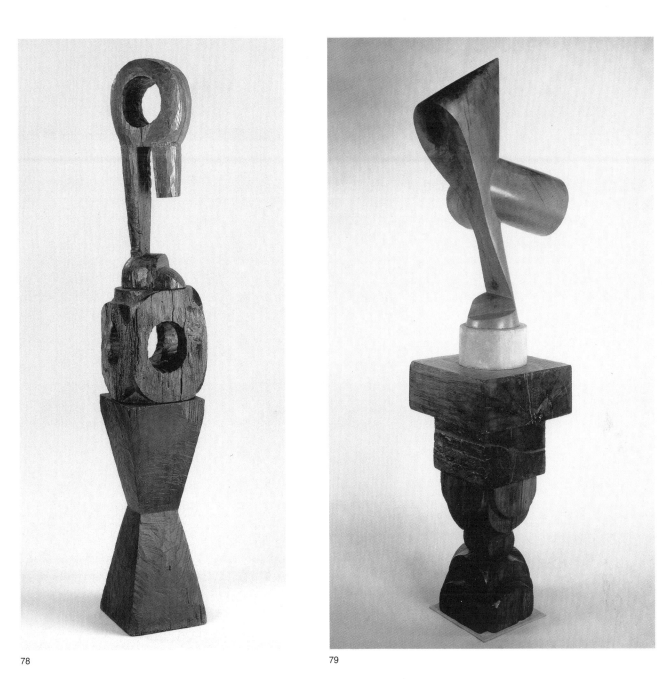

78

79

sense of urgency. The relationships of the flatter forms at the base of the head demonstrate a particularly felicitous modulation away from the diagonal plane above. In its unusual arrangements of angles, as well as in its responsiveness to the expressive and formal potentialities of wood, *The Sorceress* is one of Brancusi's most inventive carvings.

*Socrates, King of Kings, Chimera,* and *The Sorceress* use complex combinations of form to effect spiritual, mythical, and formal associations and meanings. In another major group of works a single, subtle, and gradually purified shape was employed to create such meanings. In its very simplicity reside some of the ultimate complexities of Brancusi's art.

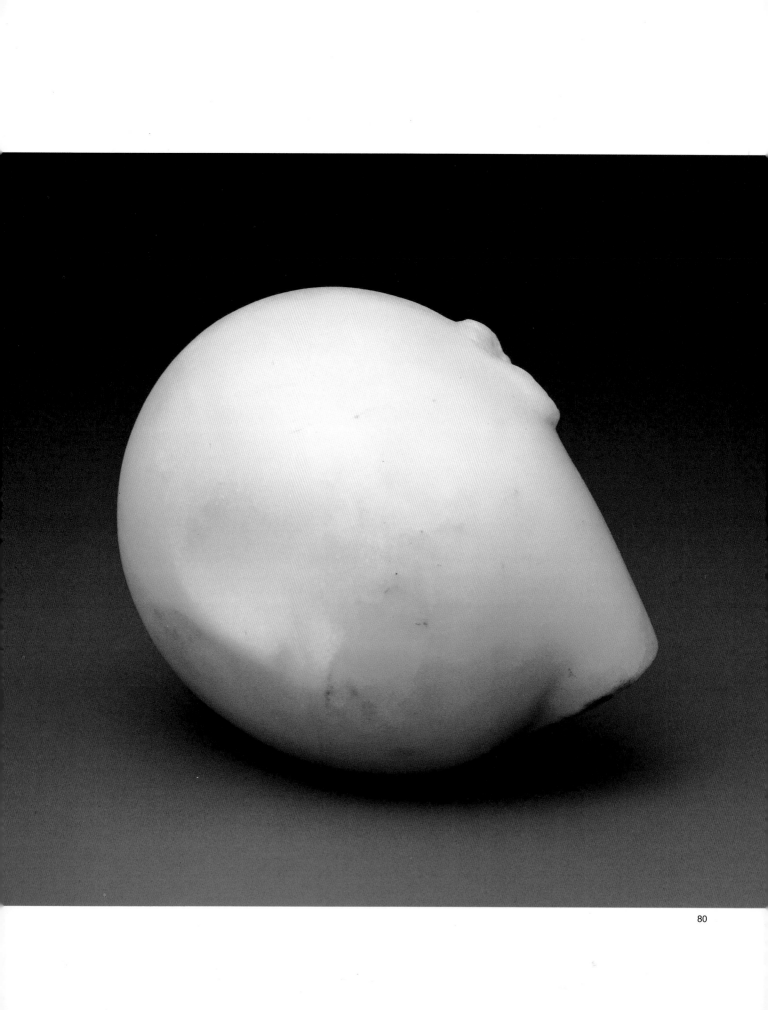

# 5 The Beginning of the World

81

80. *Prometheus*, 1911
White marble, 5 x 7 in.
Philadelphia Museum of Art; Louise and Walter
Arensberg Collection

81. *Sleep*, 1908
White marble, height: 10¼ in.
Socialist Republic of Romania Museum of Art,
Bucharest

In 1908 Brancusi carved *Sleep* in marble, a sculpture that combines 81
both the new and the old, for although it was his first work to be
directly cut in marble, of all his sculptures it is the one most
heavily influenced by Rodin. That Brancusi returned to such a
style after having abandoned it a year earlier with *The Prayer* is 10
explained by the fact that *Sleep* was commissioned as a replica of a
plaster model from 1906. It was obviously because his economic
survival was still far from assured in 1908 that Brancusi reverted to
an earlier sculptural language. *Sleep* indicates how fully he under-
stood Rodin's style and use of visual metaphor, for the vagueness
of the rough-hewn marble around the head surely denotes the
subject's dreamy state of mind.

The implied ovoid of the head in *Sleep* was made explicit in later
heads by Brancusi. In 1909–10 he carved a white-marble *Sleeping* 3
*Muse* in which greatly simplified features are stated within a self-
sufficient ovoid. Brancusi had worked on circular, self-sufficient,
and fairly representational heads of a child between 1906 and 1908,[61]
but the 1909–10 *Sleeping Muse* is far more abstract, which can only
be explained by Brancusi's burgeoning desire to state the essence
of things, both in form and content. As in the 1908 *Sleep*, Brancusi
addressed the subject metaphorically, using vaguely defined eyes to
convey the nebulousness of sleep itself, while the disembodiment
of the head imparts the detachment from everyday reality brought
about by sleep. In 1910 Brancusi made a nearly identical bronze of
the form, of which there are four further casts, each subtly modified.
In both its marble and bronze guises, *Sleeping Muse* demonstrates
how far the sculptor had developed since breaking from the
"biftek" tradition with *The Prayer* just three years before. The
formal sophistication of the *Sleeping Muse* is also a long way from
primitivism and demonstrates that the notion of African primitiv-
ism as a determining force on Brancusi's development is untenable;
by 1910, or some three years before he showed any signs of looking
creatively toward Africa, Brancusi was already creating extremely
idealized designs.

Linked to the *Sleeping Muse* is *Prometheus*, produced in white 80

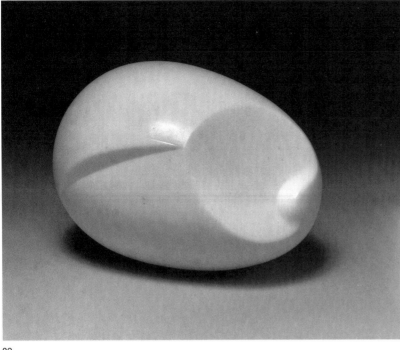

82

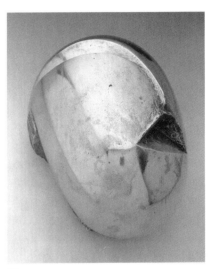

83

marble in 1911 and subsequently in bronze between 1911 and 1917. This more spherical ovoid represents the head of Prometheus falling "over on his shoulder as the eagle devoured his liver."[62]

A similar use of an ovoid appears in *The Newborn*, a marble of 1915. By the time he made this piece, Brancusi had carved the first of his works to be influenced by African art, *The First Step* of 1913, which he subsequently destroyed. That sculpture represented a child walking uncertainly, and *The Newborn* portrays an analogous beginning of things, albeit by very unprimitivistic means. In this witty head of a crying baby the curved ridge signifies the nose and a large oval plane indicates the mouth, in which a raised intrusion denotes the puckering of the lower lip. In 1917 the sculptor developed a related design: *The First Cry*. Yet another statement of beginnings, this representation has a greater literalness that makes it a less poetic conception than *The Newborn*.

Before Brancusi created *The First Cry* he had already carved the marble *Sculpture for the Blind* of 1916, a work far more reductive than anything he had previously made; indeed, it is nothing but an ovoid. Yet this is not to say that the sculpture is therefore abstract. Henri-Pierre Roché, Brancusi's friend and patron, recalled that when the work was displayed in New York in 1917, it "was exhibited . . . enclosed in a bag that had two sleeves through which the hands could enter."[63] The presentation of the work in this manner almost certainly occurred in the exhibition of the Society of Independent Artists in New York, where it was submitted at the last moment (and hence is not in the exhibition catalog). The previous year the carving had very likely been conventionally exhibited at the Modern Gallery, New York, for a magazine cartoon of December 1916 satirizing Brancusi's "eggs" represented the work in a straightforward manner, which it would hardly have

82. *The Newborn*, 1915
White marble, 6 x 8½ in.
Philadelphia Museum of Art; Louise and Walter Arensberg Collection

83. *The First Cry*, 1917
Polished bronze, 6¾ x 10⅛ in.
Art Gallery of Ontario, Toronto; Purchased with assistance from the Volunteer Committee Fund, 1981

84. *Sculpture for the Blind*, 1916
White marble, 6 x 12 in.
Philadelphia Museum of Art; Louise and Walter Arensberg Collection

85. *Beginning of the World*, c. 1920
Marble, 7⅛ x 10¼ x 6½ in.; polished metal disk, diameter: 19¾ in.; base: stone, height: 22½ in.
Dallas Museum of Art; Foundation for the Arts Collection, gift of Mr. and Mrs. James H. Clark Photograph by Brancusi, lit to emphasize the metaphysical aspect of the work

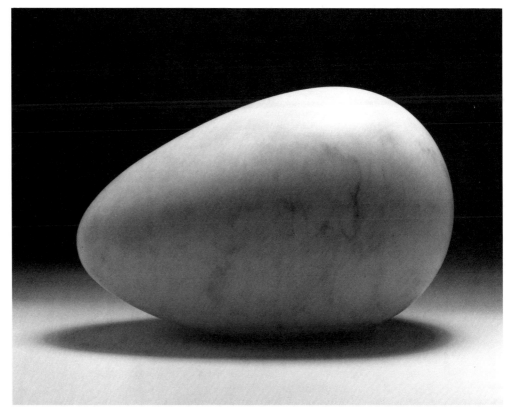

84

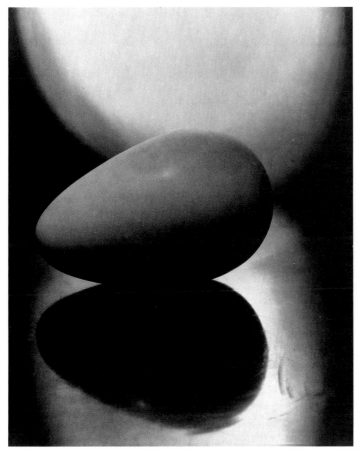

85

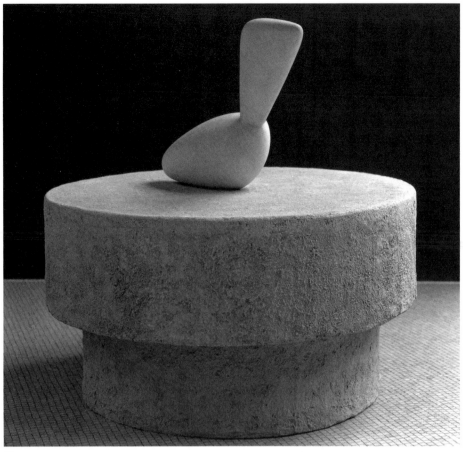

86

done had the sculpture been "invisible." Brancusi may have presented *Sculpture for the Blind* in a bag for a number of reasons. Primarily, of course, by displaying it that way he forced the "viewer" to respond to the work in a wholly tactile way. He may also have had a cultural reason for showing it in this unorthodox fashion. His friend Marcel Duchamp had submitted to that same Independents' exhibition a sculpture entitled *Fountain*—the infamous urinal signed "R. Mutt"—which was thrown over a partition by members of the hanging committee and had thus become invisible. Brancusi may have been led to ponder the invisible by the unwonted invisibility of Duchamp's sculpture and may also have wished to demonstrate his solidarity with the French artist. But it is possible to discern still another, more profound reason Brancusi displayed his work in a bag. By insisting that the sculpture be felt in order to form some idea of what it might look like, Brancusi was making us blind in order to "see," stressing the supremacy of ideas over appearances. Such a lofty Platonic purpose transcended comradely feelings and the more limited cultural change of consciousness that Duchamp had attempted to catalyze.

Brancusi carved another pure ovoid about 1920, which he gave profound implications by calling it *Beginning of the World*. Because the beginning of the world for most species involves the fertilization of an egg, it is surely permissible to see Brancusi's ovoid as an egg, which is the usual interpretation. It is perhaps the most essential of all the essential statements in Brancusi's art. The sculptor mounted the work on a mirrorlike metal disk, which

p. 2, 85

86.  *Leda*, 1920
White marble, 21 x 9½ in. (plaster base not by Brancusi but probably made to his specifications)
The Art Institute of Chicago: Katherine S. Dreier Bequest, 1953

87.  *Leda*, 1926
Polished bronze, height: 21¼ in., base: polished steel disk, diameter: 36⅝ in.; and two black marble sections, one cylindrical and one cross-shaped, height: 20½ in.
Brancusi studio, Musée National d'Art Moderne, Centre Georges Pompidou, Paris

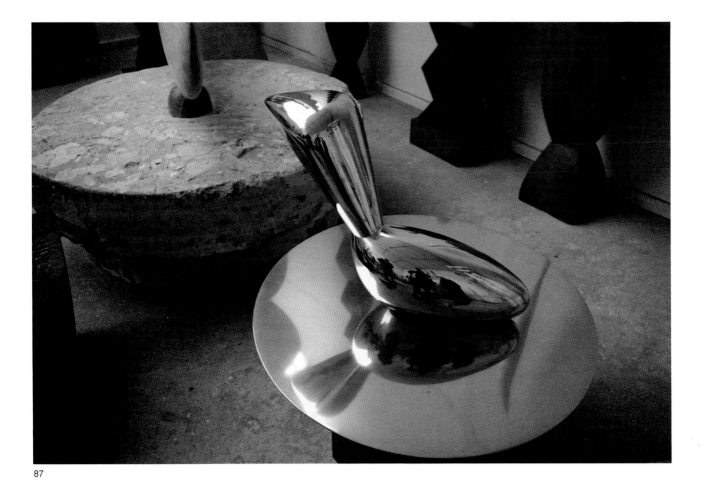

makes it seem to float in space, an effect that Brancusi must have welcomed as much for conceptual as for visual reasons.

Understanding *Beginning of the World* as an egg illuminates *Leda*, which also dates from 1920. It too features an ovoid, but 86 with a protruding wedge. Brancusi mounted a 1926 polished-bronze 87 version of *Leda* on a highly reflective metal disk, which is powered by a motor that rotates it through 360 degrees.

According to Greek myth, Leda rejected the advances of Jupiter, who then changed himself into a swan; when Leda embraced the lovely bird, he raped her. Brancusi objected to the story, as the American sculptor Malvina Hoffman recalled:

Brancusi suddenly said, "you remember the story in mythology, when a god is changed into a swan and Leda fell in love with this bird. . . . Well," he whispered, "I never believed it!" A strange brass form, poised on a revolving disk, began to turn around slowly, almost imperceptibly before us, reflecting on its mirrorlike surface all the objects in the studio in melting, changing, lights and shades. "You see," said Brancusi, "I could never imagine a male being turned into a swan, impossible, but a woman, yes, quite easily. Can you recognize her in this bird?"[64]

Indeed, it is easy to recognize *Leda* as a swan, especially from above. From that viewpoint the triangulation of the wedge makes the form seem especially avian, while the reflectivity of the disk in the bronze version makes the swan appear to float, as if on water. Yet Brancusi also dealt with the violation of Leda: an egg being punctured by a wedge is an effective metaphor for the act of rape.

Between 1920 and 1933 Brancusi went on to make other versions

of all these ovoid forms, from *Sleeping Muse* to *Leda*, many of which were subtly refined. Outstanding among them are the polished-bronze 1924 version of *Beginning of the World*, the 1925 onyx *Sculpture for the Blind,* and the stainless-steel *The Newborn II* of 1927.

Brancusi worked steadily throughout the 1920s despite a swelling stream of visitors seeking Parisian culture for whom a trip to his atelier in the Impasse Ronsin became de rigueur. Resolutely self-sufficient, he was a fine cook and an inventive handyman who made much of what he needed, from simple chairs to doorways, stoves, and fireplaces. By the mid-1920s his studio had become much more than just a working space: surrounding himself with his works, Brancusi created a highly spiritual environment.

The British sculptor Barbara Hepworth visited the Impasse Ronsin in 1932 and later recalled: "In Brancusi's studio I encountered the miraculous feeling of eternity mixed with beloved stone and stone dust. . . . The simplicity and dignity of the artist; the inspiration of the dedicated workshop with great millstones used as bases for classical forms; inches of accumulated dust and chips on the floor; the whole great studio filled with soaring forms and still, quiet forms, all in a state of perfection in purpose and loving execution, whether they were in marble, brass or wood—all this filled me with a sense of humility hitherto unknown to me." Brancusi radiated harmoniousness as much through his personality as through his work surroundings, as Hepworth also testified: "I felt the power of Brancusi's integrated personality and clear approach to his material very strongly. Everything I saw in the studio workshop itself demonstrated this equilibrium between the works in progress and the finished sculptures round the walls, and also the humanism, which seemed intrinsic in all the forms. The

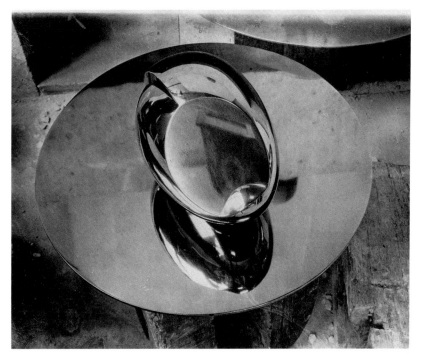

88

89

90

quiet, earthbound shapes of human heads or elliptical fish, soaring forms of birds, or the great eternal column in wood, emphasized this complete unity of form and material."[65] Even before Hepworth visited Brancusi—say, by about 1920—his art and life were in a state of "absolute equity,"[66] of aesthetic, physical, emotional, and spiritual harmony.

The comparative asceticism of Brancusi's everyday existence and of his surroundings did much to propagate the widespread view of him as a mystic living apart from the twentieth century. But the humble, hardy peasant and the bearded sage was also a man fully capable of sharing the pleasures of life: Brancusi enjoyed the company of beautiful women, he liked drinking, cooking, singing, visiting the theater and dance halls, and listening to music ranging from Bach, Mozart, Beethoven, and Chopin to moderns such as Erik Satie, Arthur Honegger, and Francis Poulenc, to Oriental, African, and Romanian folk music. He made his own phonograph and speaker, and owned over a thousand records of folk music. He was even photographed playing golf, and a set of golf clubs still 90 stands in his atelier in Paris. He also indirectly participated in some 117 of the more absurd artistic happenings of his age, as an anecdote connected with one of the Dada manifestations in 1920 demonstrates:

Brancusi stood in the wings near a young woman, an artist's model, who had been instructed to walk out nude before the audience and shout "Shit!" but she was riveted to the spot, panic-stricken by the uproar. "So," Brancusi [said], "I persuaded her to put everything out of her mind and walk right out there saying 'shit' over and over in a loud voice. She confidently strode out before the audience, and it all went over pretty well."[67]

Given Brancusi's idealism, one might assume that he would have felt antipathetic to Dada; instead he relished it. Although he would never artistically indulge in the irrationality of Dada—for idealism is a profoundly rational and serious business, even when being witty and paradoxical—nonetheless, he was sympathetic to the Dadaists' desire to overthrow the official canons of beauty and

88. *The Newborn II*, 1927
Stainless steel, length: 9⅞ in.; base: polished metal disk, diameter: 17¾ in.
Brancusi studio, Musée National d'Art Moderne, Centre Georges Pompidou, Paris
Photograph by Brancusi

89. Brancusi with Erik Satie and Jeanne-Robert Foster at Saint Germain, France, 1923

90. Brancusi playing golf with Jeanne-Robert Foster and Henri-Pierre Roché at Saint Germain, France, 1923

taste, to fight bourgeois values, to counter all that Brancusi meant by "biftek."

Peggy Guggenheim, the art collector who bought a *Bird in Space* from Brancusi in 1940, provided a particularly vivid picture of the sculptor and his surroundings:

The walls were covered with every conceivable instrument necessary for his work. In the center was a furnace in which he heated instruments and melted bronze. In this furnace he cooked his delicious meals, burning them on purpose only to pretend that it had been an error. He ate at a counter and served lovely drinks made very carefully. . . . The whole place was covered in white dust from the sculptures.

Brancusi was a marvellous little man with a beard and piercing dark eyes. He was half astute peasant and half real god. He made you very happy to be with him.[68]

After the mid-1910s Brancusi had a number of studio assistants, including the Romanian sculptor Miliţa Pătraşcu, who worked with him between 1919 and 1923, and the American sculptor Isamu Noguchi, who worked with him between 1927 and 1929. Noguchi later recalled: "Wherever he was, everything had to be all white. He wore white, his beard was then already white. He had two white dogs that he fed with lettuce floating in milk. My memory of Brancusi is always of whiteness and of his bright and smiling eyes."[69]

As Peggy Guggenheim also recalled, Brancusi "liked to go to very elegant hotels in France and arrive dressed like a peasant, and then order the most expensive things possible. Formerly he had taken beautiful young girls traveling with him." The first of these sentences indicates Brancusi's mischievous side, while the second may refer, among others, to Brancusi's relationship with the American Eileen Lane, who met him through Ezra Pound and who traveled with the sculptor to Romania in 1922. Unfortunately, too little is known about Brancusi's links with Lane or other women to form any conclusions about those relationships, but the sculptor did refuse ever to commit himself to a permanent relationship with any woman. When his goddaughter asked him why he did not marry, he answered, "Can't you just see me . . . with a family, with children tugging at my beard and saying 'Papa, don't do this, don't do that!'"[70] Peggy Guggenheim also noted: "Most of [Brancusi's] life had been very austere and devoted entirely to his work. He had sacrificed everything to this, and had given up women for the most part to the point of anguish. In his old age he felt it very much and was very lonely."

Brancusi traveled outside France in the 1920s, often in connection with his work. In 1921 he visited Romania, via Italy, Greece, and Turkey, as well as going to Corsica; in 1922 he returned to Romania; in 1925 he traveled to London; and twice in 1926 he went to America. These American trips were made in connection with one-man exhibitions at the Wildenstein Gallery and at the Brummer Gallery in New York. On his second trip he visited Washington, D.C., staying with Eugene and Agnes Meyer. While visiting New York in 1926 and Bucharest in 1930, Brancusi declared his desire to erect versions of his *Endless Column* in such major cities; appropriately, the New York structure was to be a skyscraper,

with apartments in each module.

Two major projects failed to achieve realization during the 1920s and '30s. First, when visiting Romania in 1921 Brancusi investigated the possibility of making a war-memorial fountain in Peştişani, a small town adjacent to Hobiţa. Although he offered his services for nothing, asking only that the townspeople supply the stone, they were either unable or unwilling to afford it, and nothing came of the idea. Second, after 1930 Brancusi explored the idea of creating a Temple of Meditation in India, at the behest of the Maharajah of Indore, Prince Yeshwant Rao Holkar Bahadur. The maharajah was a highly cultivated man, having studied at Oxford, and he was completely in tune with Brancusi's metaphysical aspirations. He purchased three Bird in Space sculptures—in bronze, black marble, and white marble—and proposed to house them in a suitable building. The final form of the temple was never determined, but Brancusi seemed to have envisaged a rectangular enclosed chamber, with access through an underground passage. At the center was to be a long pool, with the three Bird in Space sculptures set in niches around the sides and at the lower end; either an Indian votive figure or the sculpture first known as *Spirit of Buddha* (later *King of Kings*) was to be the climactic piece at the other end.[71] Above each niche was to be a skylight, through which the bronze *Bird in Space* would be lit by the midday sun on a particular holy day. The walls between the niches were to be decorated with frescoes of birds by Brancusi, and he prepared some studies for these designs in gouache.[72]

Unfortunately, when Brancusi visited India in December 1937 the maharajah was away, so the sculptor had to hang around the palace in Indore with very little to do, other than observe the elephants. After waiting for three weeks, he returned to Bombay and spent a couple of days sightseeing before catching a ship to Egypt, where he visited the pyramids. He then returned to France. Eventually the project came to nothing, perhaps because the maharajah's enthusiasm had been diminished by the death of his first wife in 1937.

Any disappointment on Brancusi's part over these failures must have been mitigated by the triumphant realization of another grandiose scheme soon afterward. This was the Tîrgu-Jiu war-memorial ensemble, dating from 1935–38. The ensemble warrants examination in much greater detail than his previous sculptures, for its physical scope and complex symbolism make it not only Brancusi's masterpiece but also perhaps the supreme masterwork of twentieth-century sculpture.

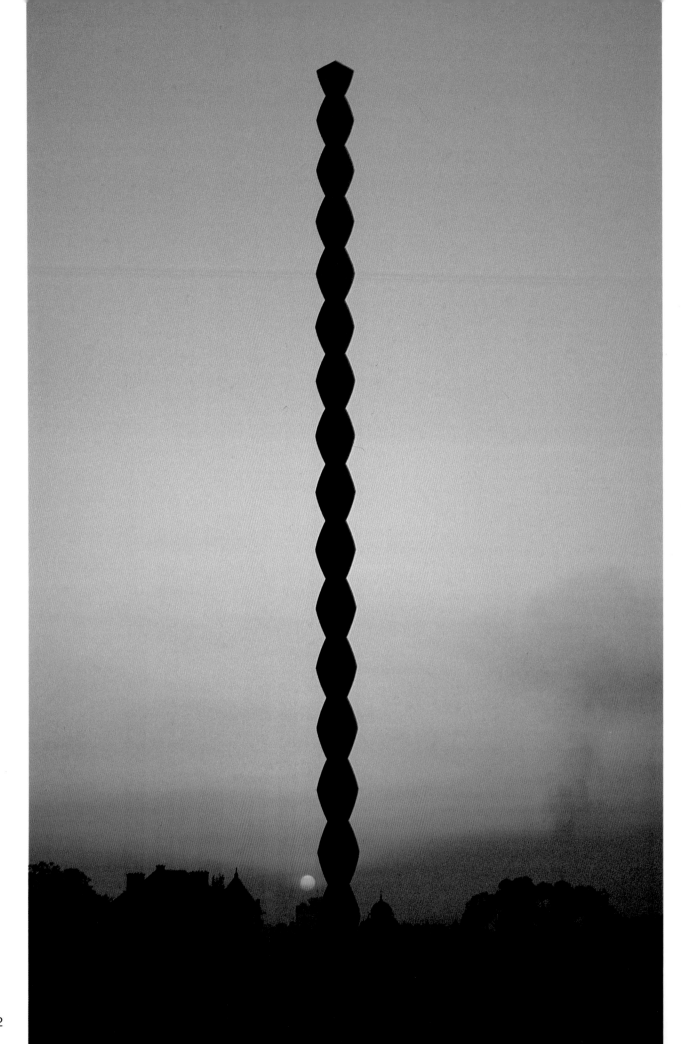

# ⑥ The Avenue of Heroes

On October 14, 1916, during World War I, a battle took place on the banks of the Jiu River and over its bridge at Tîrgu-Jiu; the invading German units were opposed by a force of "old people, women, boy scouts and the children of Gorj."[73] After a daylong struggle, in which there were more than a thousand Romanian casualties, the Germans were forced to withdraw by a Romanian regular army attack on their flanks.

In 1934–35, with the twentieth anniversary of the battle approaching, an important society for the promotion of regional culture and industry, the National League of Women of Gorj County, decided to commission a memorial to the battle. This decision was prompted by the League's president, Aretia Tătărăscu, who was also the wife of the Romanian prime minister.[74] Initially she offered the commission to her friend Miliţa Pătraşcu, a woman sculptor who had worked with Brancusi in 1919–23. Pătraşcu was familiar with Brancusi's earlier unrealized plan to build a war-memorial fountain in Peştişani (the site of another 1916 battle) and with his desire to create something monumental in his homeland—a desire that had been thwarted on more than one occasion—so she generously passed the commission on to him. He accepted it on February 11, 1935, and shortly afterward discussed the construction of a memorial, in the form of a column, with a Romanian engineer. A long delay ensued, for reasons that are still unclear.[75]

Not until July 25, 1937, did Brancusi return to Tîrgu-Jiu to begin work on the monument. Brandishing a photograph of one of his earlier carved columns, he announced that the memorial would take that unorthodox form and that "the project would consist of a path starting from the bridge of the Jiu, the place that witnessed the courage and bravery of the Romanians, and lead towards the Public Garden [see plan]. The path was to be called the 'Heroes Path' and at the end of it 'The Monument of Gratitude' was to stand. The Monument was to be 29 meters high, rising up endlessly, as our gratitude to the heroes should be."[76] If this proposal had been carried out, the column would have stood in the public garden alongside the Jiu, probably on the spot the *Table of Silence* now

91. *Endless Column*, 1937–38
Cast iron, 96 ft. 2⅞ in. x 35⅜ in. x 35⅜ in.
Tîrgu-Jiu, Romania

95

occupies. However, the suggested location of the column was soon changed to a more dominating site—a hillside over a mile to the east. This relocation was made feasible by the proposal to create an Avenue of Heroes (Calea Eroilor), linking the column to the Jiu just over a mile away and demolishing the buildings en route.

Soon after this change was made, Brancusi offered to make another work to complement the column: a monumental gate to stand in the public gardens near the river. The League had earlier planned to erect an ordinary gate at the entrance to the park from the town, and they gladly accepted Brancusi's offer instead. The sculptor twice moved the proposed location of the gate away from the park entrance so that the structure would be a "visually independent entity"[77]; clearly, he wanted visitors to be able to walk around it, just as they could do with any of his freestanding sculptures. In July 1937 Brancusi toured various local quarries to choose the stone for the gate, and the following month he began work on the wooden module from which the fifteen elements and two half-elements of the *Endless Column* were to be cast in iron. (The casting itself followed his return to Paris for almost two months on September 2.)

While Brancusi was away, on October 20, 1937, Tătărăscu wrote officially to the mayor of Tîrgu-Jiu, ratifying the proposal that the League would pay for all the materials and labor costs for the project (Brancusi gave his services free). She also stated: "It is the League's wish that this donation should have the following purpose: the creation of a road called 'The Avenue of Heroes' which will run from the bank of the river Jiu, through the public garden, to join the present site of the barracks [i.e., the hillside site for the column]. At the beginning of this road we will place the portal . . . and at its end erect the column of gratitude."[78]

Brancusi returned to Tîrgu-Jiu on October 27, 1937. He spent a fortnight supervising the erection of the *Endless Column* and attended the consecration of the restored Church of the Holy Apostles SS. Peter and Paul.[79] Known as the "heroes church" because it was dedicated to the battle victims of 1916, the building had been restored by the League. It was sited directly in the path of the proposed Avenue of Heroes and was certainly regarded as part of that mall by the League. Brancusi soon came to share that viewpoint.

On this visit to Tîrgu-Jiu, Brancusi offered to add yet another sculpture: a table that would stand in the public gardens near the bridge, at the spot where the defensive battle line had ended in 1916 (and probably where he had earlier proposed to erect his column). The suggestion certainly made sense, for placing a third sculpture at that location would strengthen the conceptual link between the battle site and the other two works in the ensemble. This connection was subsequently reinforced by the creation of a walkway leading from the *Table of Silence* to the beginning of the Avenue of Heroes beyond the *Gate of the Kiss*, a walkway that shares the title and the purpose of the Avenue of Heroes as a heroic mall.

The early history of the Tîrgu-Jiu project and the realization that the heroic mall was intrinsic to the scheme from the first strongly illuminate Brancusi's sculptural and conceptual intentions. It is particularly important to remember that from the time the

92

92. Brancusi supervising the erection of the central core of *Endless Column*, Tîrgu-Jiu, end of October or early November 1937. He can be seen to the right of center, his back to the camera.

93. The "beads" being threaded over the central core of *Endless Column*, November 1937

94. *Gate of the Kiss*, Tîrgu-Jiu, in June 1938. The first version of the *Table of Silence* can be seen by the riverbank in the distance.

93

sculptor first returned to Tîrgu-Jiu in order to develop the scheme in 1937 (if not before), he embraced the idea of a "path," and later a road, that would connect his sculptures with the site of the 1916 battle. The documentation in Tîrgu-Jiu relating to the project clearly demonstrates this, as do the sculptor's own comments. For example, when Brancusi was asked why there was so much distance between the *Table of Silence* and the *Endless Column*, he replied that it was because "the way of heroes is always hard and long"[80]: clearly, the distances between the works had symbolic importance for him. He also made it evident that at least two of his sculptures contain meanings appropriate to a war memorial. Both the Avenue of Heroes and the relationship of the sculptures to it are fundamental to understanding the individual pieces and the social purpose of the ensemble.[81]

In June 1938 Brancusi returned to Tîrgu-Jiu to work on the sculptures. A photograph taken at that time shows the *Gate of the Kiss* in an advanced state of construction but without any carvings; in the background can be seen a table. Early in July, Brancusi rejected that table and ordered a second to be cut to his directions, of slightly larger dimensions.[82] This also displeased him, and he finally took the upper drums from both tables and superimposed the new, larger one on the old, smaller one. He then threw the rejected lower drums into the river (they were later salvaged by the local inhabitants and pressed into service as park furniture). In July 1938 Brancusi also ordered some seats to be cut to his design: twelve circular stools were subsequently distributed around the *Table of Silence* and another thirty, of more square-cut shape,

94

94

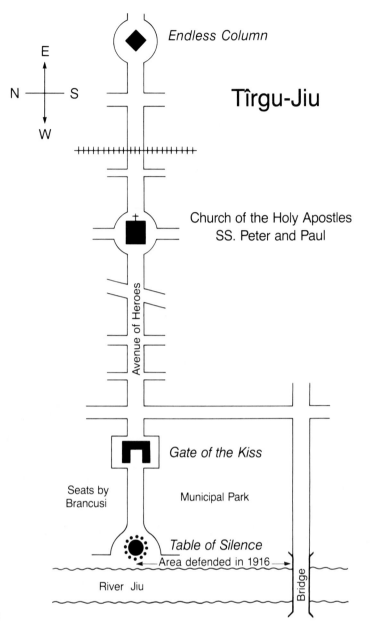

E
N — S
W

Endless Column

Tîrgu-Jiu

Church of the Holy Apostles
SS. Peter and Paul

Avenue of Heroes

Gate of the Kiss

Seats by
Brancusi

Municipal Park

Table of Silence

← Area defended in 1916 →

River Jiu

Bridge

95

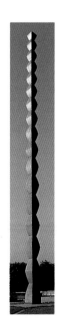

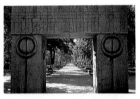

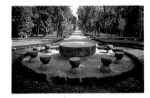

were placed along the path to the *Gate of the Kiss*. Stone left over from the *Gate* was employed to create two benches near either end of it. *Gate of the Kiss* was completed on July 28, 1938, as was *Endless Column*. The entire memorial was finally dedicated on October 27, 1938, with Brancusi present.

In 1937 Brancusi had indicated that the project started from the bridge and terminated with the "Monument of Gratitude"—a progression that Tătărăscu also cited in her letter of October 20, 1937. Certainly the tendency toward transcendence in Brancusi's work suggests that this is the correct way to approach the Tîrgu-Jiu ensemble, with the low *Table of Silence* coming first and *Endless Column* last.

96   Located some two hundred yards north of the bridge, *Table of Silence* is composed of Banpotoc travertine, as are the twelve stools that surround it, each in the form of two hemispheres placed back to back. In 1938 Brancusi referred to the work only as *Table;* later

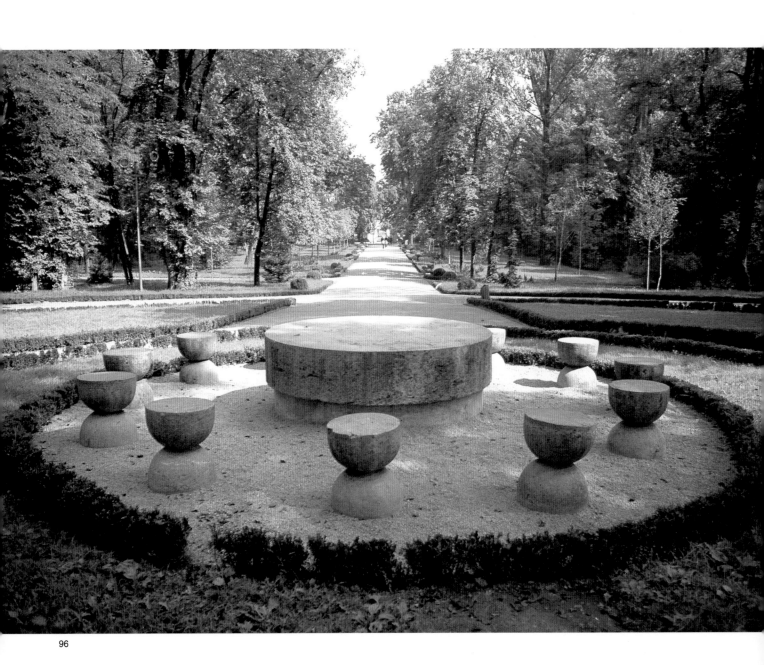

96

95.  Plan of Tîrgu-Jiu ensemble (not to scale).
The Avenue of Heroes is one mile and thirty
yards long.

96.  *Table of Silence*, looking along the
Avenue of Heroes
Banpotoc travertine, table: height: 31½ in.,
diameter: 84⅝ in.; stools: height: 21⅝ in.,
diameter: 17¾ in.
Diameter of installation: about 18 ft.
Tîrgu-Jiu, Romania

he called it *Table of the Hungry* and *Table of Silence*.[83] As the
last of these names is the one always given to the work, it will be
adopted here. The sculpture can be interpreted on a number of
levels. Most obviously, *Table of Silence* functions as park furniture,
a table at which people may sit. As Brancusi stated, "I have carved
this table and these stools for people to dine and rest."[84] Yet he
took care to place the stools so far from the table that one cannot
directly eat off it.[85]

But there is clearly more to *Table of Silence* than mere dining
and resting; as Brancusi noted, "the line of the Table of Silence
suggests the close curvature of the circle that gathers, rallies and
unites."[86] At Tîrgu-Jiu in October 1916 the people themselves had
certainly gathered, rallied, and united in the face of the enemy.
This sense of unity is reinforced by other local associations with
the circle. For example, it has been suggested that the work for-
mally derives from low, round, wooden peasant tables called *masa*

87

joasa.[87] That may well be the case, given the relative lowness of the piece; Romanian peasant furniture was similarly close to the ground in Brancusi's time. By creating a similarity to domestic furniture, Brancusi may well have been hoping that his table and stools would bring people together as a family, just as they had been united in 1916.

Originally the stools were grouped in pairs rather than distributed evenly around the table.[88] This pairing was obviously intended to complement the pairing of couples around the lintel of the *Gate of the Kiss*. Given that for Brancusi coupling led to generation and thus to the creation of families, it may also have denoted a familial role for the table. However, the final distribution of stools, plus their number, suggests that Brancusi eventually decided to encourage communal interchange rather than solitary or paired experience—a communality that contributes appropriate civic overtones to a war memorial. *Table of Silence* may equally harbor an underlying religious significance, for to the Greek Orthodox Church (of which Brancusi was a regular if desultory member and which was the prevailing faith in Oltenia), the act of eating is itself holy. Round communion tables are found in certain Greek Orthodox churches, including the old church in Hobiţa, where the sculptor worshiped as a child and where a round votive table can be seen behind the altar.

There is still another object from which Brancusi could have derived the *Table of Silence*. This is the millstone, which Romanian peasants often used to make alfresco tables. Brancusi himself not only made a table from one in his Paris studio[89] but even created two tables from millstones to serve as garden furniture in Tîrgu-Jiu in 1938. Made for the mayor of the town to thank him for his hospitality, they can still be seen in a private garden today.

Other meanings of *Table of Silence* emerge from numerical considerations. The fact that a central form is surrounded by twelve subsidiaries suggests links with the months of the year or hours of the day; both suggestions are promoted by the fact that the stools look very much like hourglasses, the most common type of timepiece in rural Romania during Brancusi's childhood. About 1948 Brancusi himself interpreted the one surrounded by the twelve as denoting Christ and the Apostles.[90] Yet all of these diverse connections are overshadowed by what is probably the most forceful meaning in *Table of Silence*, a meaning that becomes clear when the work is seen in the larger context of Brancusi's oeuvre.

The sculptor often employed a large drumlike form, mounted on a smaller one, as a base for his sculptures. Here he provides just such a base, but it is empty. And surely the ultimate meaning of *Table of Silence* resides in that very fact. At a spot where a visitor is asked to remember those who have died, the emptiness directly addresses their absence. The living are invited to sit on the low stools around the empty base and contemplate those who are now absent, invisible. And lest this interpretation be thought fanciful, it must be remembered that Brancusi had previously made a most definite statement about apprehending the invisible—namely, *Sculpture for the Blind*. Moreover, this interpretation would help explain why Brancusi called the work *Table of Silence*: silence is a total

97. Garden table made by Brancusi in 1938, Tîrgu-Jiu, Romania

98. Seats designed by Brancusi, Municipal Park, Tîrgu-Jiu, Romania

97

98

absence. *Table of Silence* is perhaps the ultimate reductive statement in the sculptor's oeuvre, going beyond even *Sculpture for the Blind* and *Beginning of the World*. Here vacancy is transformed into a positive statement. The emptiness is charged with meaning and a profound sense of loss.  85

From *Table of Silence* the visitor progresses to the *Gate of the Kiss*, about a quarter-mile to the east. In between the two sculptural statements are thirty seats made to Brancusi's design, which are clustered in five groups of three on either side of the connecting mall. These, too, are reminiscent of an hourglass in shape, although they are square rather than round. The seats were Tătărăscu's idea, not Brancusi's,[91] but the shape he gave them, with its connotations of time, is appropriate to a memorial.  98

*Gate of the Kiss* is made of the same sand-colored Banpotoc travertine as *Table of Silence*. Brancusi's kissing figures are repeated forty times as a linear motif incised around the entablature, sixteen times on front and back, four times on each side. The circular eye-to-eye motif seen in *The Kiss* is similarly repeated, on a large scale, appearing four times around each supporting column.  100

Brancusi had become aware of both the expressive potential and the utilitarian purpose of gates and doorways well before 1937–38. The first such object he carved—a doorway in wood of 1915—has a noticeably exaggerated lintel, a feature even more pronounced in an oak doorway made in 1930, which has serrated edges that are only slightly more pointed than those of the *Endless Column*. The sculptor made other entablatures and columns prior to making *Gate of the Kiss*. One is the large plaster *Column of the Kiss*, created about 1933 for the unrealized Temple of Meditation in India. Here a decorative entablature rests on a column bearing the  101  102

99

same circular eye-to-eye motif seen in *Gate of the Kiss.*

*Gate of the Kiss* works on a number of associative levels. Naturally it recalls triumphal arches, the traditional means of commemorating battles and wars. Yet if Brancusi did regard *Gate of the Kiss* as such an arch,[92] then here too he expressed his sense of paradox, as he had done with *Medallion* in 1918–19 and would do again with *Boundary Marker* in 1945: through the use of the Kiss motif and other devices, love symbolically triumphs over hatred.

In overall form *Gate of the Kiss* symbolizes on a grand scale the union represented by the linear Kiss motif, for the entablature links the two supporting columns of the gate. The entablature itself, with its narrow, lidlike top course and even narrower bottom course, is reminiscent in shape of a Romanian dowry chest. Such appurtenances of marriage are often decorated with crisscross diagonal lines incised into the wood; exactly those kinds of incisions also appear on some of Brancusi's bases. The introduction of associations of marriage into a gate decorated forty times with kissing couples seems highly appropriate.

Love displays its face in all directions beneath the *Gate's* entablature as well. The large, bisected orbs, which function as eyes on sculptures of *The Kiss,* are here detached from any facial setting. The meaning of the eyes (and the commemorative purpose of the sculpture) was clarified in a statement recorded by Petre Comarnescu: "'What is left behind when you are no more?' Brancusi used to explain. 'It is the memory of the eyes, of your looks that imparted love for man and people. These figures are a representation of the amalgamation of man and woman through love.'"[93] But Brancusi thought of the supporting columns as more than just objects bearing eyes. They also augment what appears above them: "On the columns are two lovers embraced, seen in profile. 'What is small up there,' explained Brancusi, pointing to the lintel, 'is here enlarged.'"[94] And that the sculptor thought of the circular, eyelike

99. *Gate of the Kiss*
Close-up of the entablature with the Kiss motif

100. *Gate of the Kiss,* 1937–38
Banpotoc travertine, 17 ft. 3½ in. x 21 ft. 7⅛ x 6 ft. 6 in.
Tîrgu-Jiu, Romania

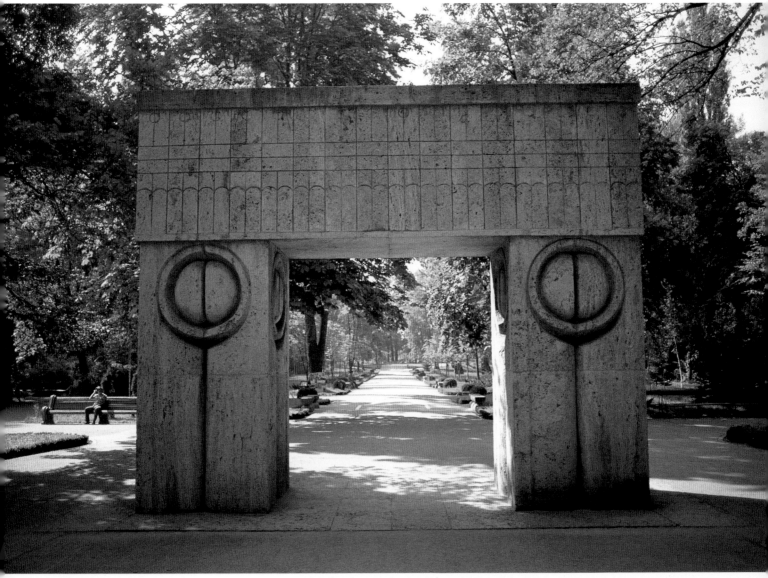

101

102

103

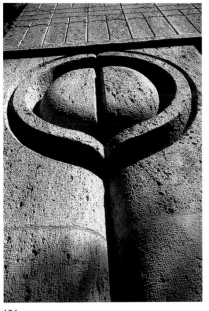

104

forms as more than eyes is made clear by a conversation he had with Malvina Hoffman in 1938:

"Here are the plaster models of the supporting columns [of *Gate of the Kiss*]; what do you see in them?" asked Brancusi. I thought for a few moments. "I see the forms of two cells that meet and create life. . . . The beginning of life . . . through love. Am I right?" "Yes, you are," he answered, "and these columns are the result of years of searching. First came this group of two interlaced, seated figures in stone . . . then the symbol of the egg, then the thought grew into this gateway to a beyond."[95]

The fact that for Brancusi the circular form symbolized both sexual union and an egg encourages the perception of additional sexual imagery in that shape—namely, the filling of the dilated female aperture with the twinned male genitals.[96] When the *Gate of the Kiss* is observed from below, the notch in the circular shape bears a marked resemblance to the female sexual cleft, a resemblance reinforced by the inward curve of each supporting column below.

Brancusi's declaration that the *Gate of the Kiss* is a "gateway to a beyond" throws light on the philosophical implications of the *Gate*, the Avenue of Heroes, and the *Endless Column*, where the walk comes to an end. From the *Gate of the Kiss* the visitor walks east for about a hundred yards before leaving the park and crossing a wide boulevard. Then begins the Avenue of Heroes proper, and after walking several city blocks, about half a mile, one arrives at a large plaza surrounding the Church of the Holy Apostles SS. Peter and Paul. Straddling the Avenue of Heroes, the church blocks any glimpse of the *Endless Column*. Tătărăscu's daughter has recalled Brancusi's initial annoyance at the location of this church and of the railway line behind it,[97] for he originally wanted a completely unobstructed view and walkway from the *Gate of the Kiss* to the *Endless Column*, if not from the more distant *Table of Silence*. Moreover, this mall should have been lined with poplar trees rather than buildings. However, the church could hardly be removed in 1937–38 (having just been rebuilt), and Brancusi quickly became reconciled to it. He made sure that "The axis of 'Calea Eroilor' was rigorously traced so as to pass through the middle of the altar," while also using the top of the belfry cross to check the verticality of the *Endless Column*.[98] Since Brancusi wanted the *Gate of the Kiss* to act as a "gateway to a beyond," the church does enter into the spirit of the Avenue of Heroes by suggesting a way that one might pass on to such a "beyond," and there can be no doubt that Brancusi came to think of the "heroes' church" as part of his ensemble.[99]

Returning to the Avenue of Heroes by passing around the church, the visitor at last catches sight of the *Endless Column*, about a quarter of a mile away. After crossing the railway track, one approaches a spacious park atop a low hill, at the brow of which stands the column itself. *Endless Column* is over 96 feet high and is made from cast-iron modules (which Brancusi called "beads"). The column has stood seven degrees off true vertical ever since the early 1950s, when a Stalinist mayor of Tîrgu-Jiu decided the work was a piece of Western formalist junk and tried to pull it down for

104

105

91

101. *Doorway*, 1930
Oak
Brancusi studio, Musée National d'Art Moderne, Centre Georges Pompidou, Paris

102. *Column of the Kiss*, c. 1933
Plaster, height: 118 in.
Brancusi studio, Musée National d'Art Moderne, Centre Georges Pompidou, Paris
Photograph by Brancusi

103. Wooden Romanian dowry chest from the early 19th century
Curtişoara Ethnographic Village, Gorj County, Romania

104. *Gate of the Kiss*
The "eye-cell" motif seen from below

105

smelting into industrial machinery. He had guy ropes attached, and for three days horses tried to pull the column over. Fortunately, Brancusi had fixed the base of the column in a pyramidal steel footing and embedded it in fifteen cubic feet of concrete, so it proved immovable, though it was left with a slight lean.

Climbing the hill, one approaches the *Endless Column* (which is square in section) not square-on but by a corner, so that the eye is immediately led around and beyond the sculpture. As one looks up, perspective makes each module seem to decrease in size, as if reaching to infinity. The repetition of the "beads" also imparts a strong sense of pulsation. Although the surface is now dulled, Brancusi clearly wanted the column to be as highly reflective as his bronzes. Imagining such a brilliance creates in the mind's eye the effect of soaring weightlessness that the sculptor must have sought.

To this day, when somebody dies in Hobiţa the local inhabitants cut down a fir tree and plant the dead tree at the head of the grave, a custom Brancusi would undoubtedly have known. As the fir tree sheds its needles, it is said to be weeping for the dead, the verb for *to shed* and *to weep* being the same (*a varsa*). The tree is also intended to keep the dead person company. A column must therefore have seemed to Brancusi a most appropriate form for a commemorative monument in his native region.

The shape of the Tîrgu-Jiu *Endless Column* derived partially if not wholly from his memory of the serrated forms of Oltenian folk architecture and artifacts, especially in Hobiţa. For example, an extremely similar serrated shape can be seen running along the outermost and innermost edges of the old gateway from Tălpăşeşti, near Hobiţa, that has been placed in front of a reconstruction of Brancusi's birthplace in Hobiţa. These serrations are not rhomboid, as are the "beads" on the *Endless Column*, but it seems likely that Brancusi softened those pointed forms into a rhomboid in order to increase their sense of upward rhythmic flow; such a small adjustment should not obscure the resemblance. The same gate has undu-

105. Distant view of *Endless Column*, looking along the Avenue of Heroes

106. Fir trees placed at the head of graves in the village churchyard, Hobiţa, Romania

107. Gate from Tălpăşeşti, near Hobiţa, which now stands at the entrance to Brancusi's reconstructed birthplace, Hobiţa, Romania

108. Carved stanchion on Brancusi's reconstructed birthplace, Hobiţa, Romania

109. The Hobiţa church was built by Brancusi's great-grandfather around 1825. The serrated pattern above the porch columns also runs entirely around the church.

106

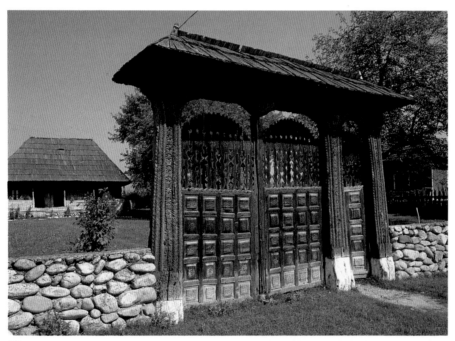

107

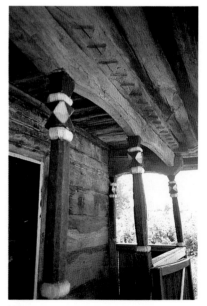

109

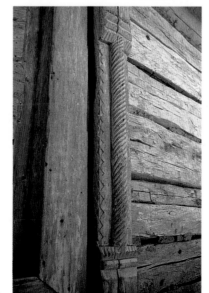

108

lating patterns cut out of the vertical slats mounted on its doors, typical patterns that could well have provided Brancusi with another model for the rhythmic shape of his column.

Making an overall shape that replicates the silhouette of the *Endless Column*, other serrated forms appear side by side along a decorated stanchion between the two doorways of the old house from Hobiţa that now represents Brancusi's birthplace. The original birthplace disappeared before World War II but in 1970–71 a house from three lots down the street replaced it.[100] The replacement was remembered by many people in Hobiţa as being identical to Brancusi's natal dwelling, having been built by the same village carpenter. It seems likely that the sculptor's own house had sported these serrated forms; if not, Brancusi could have seen them just down the street. Carola Giedion-Welcker, who knew Brancusi, recalled that the sculptor "never lost sight of, or ceased to emphasize . . . that his simple peasant house, built of rough tree trunks from the nearby forest, also contained churchlike elements of form, and had combined, across the centuries, the profane and the sacred."[101]

Serrated forms also appear on the old church in Hobiţa, where Brancusi worshiped as a child.[102] The church was built by Ion Brâncuşi, the sculptor's great-grandfather, and his own mother, sister, and brothers are all buried in its churchyard. Above stepped columns that also prefigure Brancusi's columnar forms, an arresting serrated motif identical to the one so often employed by the sculptor completely encircles the church.

Other Romanian carvings, such as veranda posts and pillars, often include repeated rhomboid sections and could have determined the forms of Brancusi's columns. The influence of these architectural sources was apparently augmented by the shape of the large winepress screw that Brancusi kept in his Paris studio. The sculptor's heirs have suggested that it provided an exact model for Brancusi's columns,[103] but it was surely the undulant repetitiousness of the shape that was influential rather than the shape itself, for the winepress screw does not resemble the columns as much as Romanian peasant carvings do. (In any case, the exact shape of the winepress screw does actually appear in one of Brancusi's sculptures, *King of Kings* of about 1938.) It has also been suggested that Brancusi developed his columns under the influence of African art,[104] but the shapes that decorate African totemic columns are very dissimilar to the serrated forms of Brancusi's columns.

Serration appears in over twenty of Brancusi's sculptures and bases, and in 1918 he carved a serrated column that was a fully autonomous sculpture. Two years later he carved a 23-foot 7½-inch column in Edward Steichen's garden at Voulangis, near Paris. An eighteen-foot plaster column was made about 1930 as a model for an *Endless Column* that Brancusi was proposing to erect in Bucharest. Obviously the Tîrgu-Jiu *Endless Column* was a sculptural statement he had been wanting to make on a suitably grandiose scale throughout the 1920s and early '30s. The idea behind that statement was the liberation from earthly constraint embodied in the Bird in Space sculptures and other works. Here it received expression in a

110

much more abstracted form through the large-scale projection of upwardly pulsating movement. Yet *Endless Column* is not simply an abstract sculpture that implies movement. Its pronounced metaphysical undertones are best conveyed by Brancusi's own explanation of its meaning, as expressed to Tătărăscu in 1938: "Let's call it a stairway to heaven."[105]

The details of *Endless Column* intensify its effect of cosmic endlessness. The sides of the lowest module rise vertically beyond the midway point of the module, then curve inward, which gives the impression that the column has suddenly materialized out of the ground and that the rhomboid shape has just come into being. The upward momentum produced by the modules continues through the half-module at the very top; we automatically connect it with its imagined other half and the column thus seems to continue out of sight. The effect is of perceiving only a section of something that has always approached us from below and will always continue beyond us. That "something" is not, of course, just an imaginary endless length of cast iron; in the context of Brancusi's thought it can only signify some divine and infinite rhythm of existence, the continuum of life itself.

It has been suggested that Brancusi based the Tîrgu-Jiu sequence of sculptures—circular table, arched gate, and tall column—on the sequence of a circular flowerbed and the Arc de Triomphe du Carrousel (in the Tuileries gardens), and the Egyptian obelisk (in the Place de la Concorde) in Paris.[106] A more fitting Parisian prototype for the Avenue of Heroes would be the Avenue des Champs-Elysées, which is used as a heroic mall, unlike the Tuileries gardens. It seems far more likely, however, that Brancusi's inspiration came from Washington, D.C., whose center is even more devoted to the commemoration of heroes than that of Paris. The sculptor visited Washington in the autumn of 1926, and he was particularly impressed by the "obelisk" (i.e., the Washington Monument) on the Mall.[107] Here, surely, was the heroic mall that the sculptor determined to emulate. Moreover, the Washington Mall is limited to pedestrians (at its center, at least), unlike the one in Paris, which serves mainly as a roadway for cars. (There is no doubt that Brancusi wanted a purely pedestrian mall at Tîrgu-Jiu.)

Brancusi's description of the *Gate of the Kiss* as a "gateway to a beyond" and of the *Endless Column* as a "stairway to heaven" suggests that a program underlies the Tîrgu-Jiu ensemble. *Table of Silence* is low to the ground and bears marked associations with communality and domesticity—the humble, familial beginnings of life. *Gate of the Kiss* addresses the next major step in human development: marriage, sexual fusion, generation. And by proceeding "to a beyond" beyond the church, along a lengthy, arduous, but ultimately heroic road, one arrives at a column leading to eternity. The Tîrgu-Jiu ensemble does not comprise just three highly inventive but unconnected sculptures. Instead, it seems likely that their maker intended those individual works to come together as a celebration of the entire passage of human life. The progress they embody forms the climactic statement of Brancusi's art and affords one of the most elevating spiritual journeys that twentieth-century art has to offer.

95

110

110. *Endless Column*

# 7 The Final Years

After completing the Tîrgu-Jiu ensemble in 1938, Brancusi began to slow down. He went on to make only a dozen or so works in the remaining nineteen years of his life (including four Bird in Space sculptures), compared with over two hundred sculptures made before 1937. Of the remaining works only four were on a new theme—the two versions of *The Seal* and the two turtles—although all of these last works display a marvelous sense of invention. But clearly Brancusi was a late starter—*The Prayer* dates from 1907, when he was thirty-one years old—and an early finisher, for he had completed virtually all of his major works by 1945, when he was sixty-nine years old. <span>45-48</span> <span>10</span>

In 1939 the sculptor again visited America, but the invasion of France the next year ended his years of travel. He stayed in Paris throughout the 1940s and '50s, tinkering with sculptures and leading a fairly isolated existence, even though an increasing appreciation of his art brought him scores of visitors and major retrospective exhibitions in New York, Philadelphia, and Bucharest in 1955–56. He was rescued from his emotional isolation by the friendship of two Romanian exiles who also lived in the Impasse Ronsin, Natalia Dumitresco and Alexandre Istrati. They subsequently cared for him and became his heirs. In 1952 Brancusi became a French citizen in order to bequeath the contents of his entire studio to the Musée National d'Art Moderne in Paris, on condition that the studio environment be recreated as part of the museum, a condition that was carried out first on the old site of the museum near the Trocadero and subsequently next to the Centre Georges Pompidou. Brancusi died in his sleep on March 16, 1957, and was buried in Montparnasse Cemetery, not far from his majestic statue of *The Kiss*, which had been placed there nearly half a century earlier. <span>111</span> <span>15</span>

The art of Constantin Brancusi is one of rare formal invention, responsiveness to materials, and intense beauty, achieved by acute self-discipline, meditative but nonetheless expressive detachment, and a profound intellectual capacity. The richness of meaning in his sculptures may seem to be at odds with their formal simplicity, but such a difference will trouble only the superficial or unsympa-

111.  Tools in Brancusi's studio

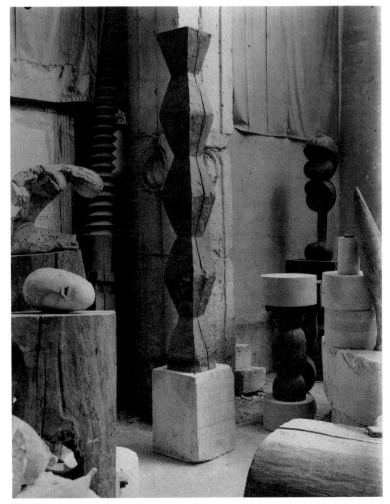

112

thetic viewer: formal simplification was essential to the creation of meaning for Brancusi. Yet the sculptor sternly resisted being categorized as an abstractionist, maintaining that he portrayed true reality, unlike representational art, which merely imitates superficial appearances. In this sense Brancusi was Michelangelo's direct heir. Although he abhorred the earlier sculptor's "biftek," what he rejected was the means Michelangelo had employed, not the end to which he had aspired: both sculptors shared the same goal, having been deeply influenced by Platonic philosophy in their desire to embody a perfect concept of form. By achieving such an aim Brancusi elevated the idealism of Renaissance art to a new plane, creating a modern sculptural language in the process. Henri Rousseau, for one, apparently understood what Brancusi was attempting: "I see what you are trying to do; you want to transform the ancient into the modern."[108]

Brancusi made two initially surprising assertions in 1927: "There hasn't been any art yet. Art is just beginning."[109] After one looks at the extraordinary richness of his sculptural language and discovers the complexity of meanings in his work, as well as the new public role for sculpture made possible by the Tîrgu-Jiu ensemble, these assertions seem less surprising. Indeed, given the advances made by Brancusi's art, one is tempted to agree with at least the second of them and to hope it will prove true.

112.   Interior of Brancusi's studio, c. 1925

# NOTES

1. For example, see Rosalind E. Krauss, "Brancusi and the Myth of Ideal Form," *Artforum* 9 (January 1970): 35–39; William Tucker, *Early Modern Sculpture: Rodin, Degas, Matisse, Brancusi, Picasso, González* (New York: Oxford University Press, 1974); and Robert Hughes, *The Shock of the New* (New York: Knopf, 1981).

2. Sidney Geist, "Brancusi, Brancusi," review in *New Criterion*, January 1988, p. 65; see also Sidney Geist, "Brancusi," in *"Primitivism" in 20th Century Art: Affinity of the Tribal and the Modern* (New York: Museum of Modern Art, 1984), vol. 2, pp. 345–67. Similar views have been expressed by Katherine Jánszky Michaelsen, "Brancusi and African Art," *Artforum* 10 (November 1971): 72–77; Robert Goldwater, *Primitivism in Modern Art* (Cambridge, Mass.: Harvard University Press, 1986); and Norbert Lynton, *The Story of Modern Art* (Oxford: Phaidon Press, 1980).

3. See Sidney Geist, "Brancusi Catalogued?" *Arts Magazine* 39 (January 1964): 68–69; and also Geist, "Primitivism," p. 346. To be fair, the same writer does make some very positive points about Brancusi and Romanian folk forms in Sidney Geist, *Brancusi: A Study of the Sculpture*, rev. ed. (New York: Hacker, 1983).

4. For example, see Edith Balas, "The Sculpture of Brancusi in the Light of His Rumanian Heritage," Ph.D. diss. (available in facsimile), University of Pittsburgh, 1973; Edith Balas, "The Myth of African Negro Art in Brancusi's Sculptures," *Revue roumaine d'histoire de l'art* (Bucharest, Romania) 14 (1977): 107–25; Dan Grigorescu, *Brancusi and the Romanian Roots of His Art*, trans. Mariana Chitoran (Bucharest, Romania: Meridiane, 1984); and Pontus Hulten, Natalia Dumitresco, and Alexandre Istrati, *Brancusi* (New York: Harry N. Abrams, 1987), p. 98.

5. It has even been asserted recently that Brancusi was influenced by Salon sculpture, which seems ridiculous, given that he disliked even the works of Michelangelo. See Sidney Geist, *Brancusi: The Kiss* (New York: Harper and Row, 1978). Geist has expounded this view even more forcibly in numerous lectures, arguing that Brancusi took certain of his forms from various "pompier" sculptures or from academic architecture. There is no evidence that Brancusi even visited exhibitions of academic art after about 1910. Had he done so, he would hardly have been likely to look at "pompier" sculpture, let alone take it seriously.

6. The correct accentuation of Brancusi's name is Brâncuşi, which will be omitted in this book as it is rarely observed in the West. Authentic pronunciation of his name would approximate that produced by the spelling "Broencush."

7. See Barbu Brezianu, *Brancusi in Romania*, trans. Delia Razdolescu and Ilie Marcu (Bucharest, Romania: Editura Academiei R.S.R., 1976), pp. 198–204.

8. Brancusi, in Ionel Jianou, *Brancusi* (Paris: Arted, 1963), p. 30.

9. See Athena T. Spear, "The Sculpture of Brancusi," *Burlington Magazine* 111 (March 1969): 154.

10. Brancusi, in Carola Giedion-Welcker, *Constantin Brancusi*, trans. Maria Jolas and Anne Leroy (New York: George Braziller, 1959), p. 13.

11. Brancusi and Auguste Rodin, in Jianou, *Brancusi*, p. 34.

12. Stefan Popescu, in Brezianu, *Brancusi in Romania*, p. 104.

13. Brancusi, in Claire Gilles Guilbert, "Propos de Brancusi," *Prisme des arts* 12 (December 1957): 5–7. The full quote reads: "I looked for and succeeded in finding the form of a kneeling woman and in rendering the idea of *The Prayer*. This was my salvation and I found the way to it. Prove your skills as an accurate copyist and your figures will look like corpses. It is only fools who could say my works are abstract; what they are categorizing as abstract is in fact the most realistic thing possible, for reality is not the outer form but the idea, the essence of things."

Although this quote dates from many years later, it nonetheless makes clear that Brancusi's commitment to "rendering the idea" began with *The Prayer*. Further verification is provided by a statement he made in 1949: "'Everything I do is a seeking after form,' says Brancusi. 'I can create "beefsteaks"' (read: academic work from life) 'but I left all that in 1907. I was asked to do a praying woman in a cemetery, and I simplified the subject down to its forms.'" (Russell Warren Howe, "The Man Who Doesn't Like Michelangelo," *Apollo* 49 [May 1949]: 124.)

14. Brancusi had studied aesthetics in Bucharest, which would undoubtedly have involved an analysis of Platonic and Neoplatonic philosophy. An indication of his thinking while a student in the School of Fine Arts in Bucharest is afforded by the aphorism he wrote in a sketchbook he used there: "Art is no mere chance." (See Brezianu, *Brancusi in Romania*, p. 158.)

15. Dorothy Adlow, "Brancusi," *Drawing and Design* (London) 2 (February 1927): 37–41. Dorothy Adlow (1901–1964) graduated from Radcliffe College in 1923 and for forty-one years was an art critic for the *Christian Science Monitor*, Boston, in time becoming its senior art critic. She received the American Art Critics Award in 1954 and the Boston University Art Citation of Merit in 1957.

16. The head survives in the Tate Gallery, London; it is now entitled simply *Head*. (See Geist, *Brancusi: A Study*, cat. no. 152.)

17. Brancusi's library now belongs to the library of the Musée National d'Art Moderne, Paris.

18. The dialogues included in the *Oeuvres de Platon*, ed. Henri Poincafe (Paris: Editions Garnier, [1914]), owned by Brancusi, are *Ion*, *Lysis*, *Protagoras*, *Phaedrus*, and *The Symposium*. In 1949 Brancusi also made it clear that he had read Plato's *Republic* (see Howe, "The Man Who Doesn't Like Michelangelo," p. 127). Brancusi's Platonism could also have had roots in his youth. While staying at the Madona Dudu Foundation school during summer vacations from the School of Crafts in Craiova between 1894 and 1898, he might well have come across a poem that was universally taught in Romanian secondary schools, "The Court of Justice of the Soul and the Body" (1710–11), by the Romanian poet Dimitrie Cantemir, Prince of Moldavia, which states a Platonic position.

19. Brancusi, in Petre Pandrea, "The Laws of Craiova," in *Portraits and Controversies* (Bucharest, Romania, 1946), vol. 1, pp. 95–173; reprinted in *Romanian Review* (Bucharest, Romania) 19 (January 1965): 120.

20. In carving, the entire three-dimensional form has to be conceived from the outset, for a mistake made with materials like wood and stone—such as carving away too much—cannot be rectified.

21. Brancusi, in M.M., "Constantin Brancusi: A Summary of Many Conversations," *Arts* 4 (July 1923): 17.

22. Brancusi, in Bodhan Urbanowicz, "Vizyta u Brancusiego w Grudniu 1956 roku," *Przeglad Artystyczny* (Warsaw), July 1957; quoted in Brezianu, *Brancusi in Romania*, p. 111.

23. A summary of these views, with sources, appears in Brezianu, ibid., pp. 112–13.

24. See ibid., p. 232, for a summary of these myths and their sources.

25. See Pandrea, *Portraits and Controversies*, p. 165, where Brancusi is quoted as saying: "Prince Charming was in search of Ileana Cosinzene. The magic bird is the bird that spoke and showed the way to Prince Charming." See also James Johnson Sweeney, "The Brancusi Touch," *Artnews* 54 (November 1955): 24, for a variant on this story.

26. See Isac Pascal, "Atelierul din Paris," *Arta* (Bucharest, Romania) 10 (1972); quoted in Brezianu, *Brancusi in Romania*, p. 233.

27. See Brezianu, ibid., p. 144.

28. Brancusi, in Jianou, *Brancusi*, p. 46.

29. This includes one *Bird in Space*, listed in Geist, *Brancusi: A Study*, cat. no. 221, which was begun earlier, in 1923, and completed later, in 1952.

30. Brancusi, ibid., p. 115. The full passage is quoted (in French) by Athena T. Spear, *Brancusi's Birds* (New York: New York University Press, 1969), p. 116.

31. Ibid.

32. Brancusi, in Giedion-Welcker, *Brancusi*, p. 220.

33. Brancusi, in Aline Saarinen, "The Strange Story of Brancusi," *New York Times Magazine*, October 23, 1955, p. 42.

34. See Friedrich Teja Bach, *Brancusi* (Cologne, West Germany: Du Mont, 1987), p. 435, cat. no. 107, for the link with Charcot.

35. Dr. Cornel Cosmutza, "Cu Brancusi," trans. Andrei Brezianu, *Ramuri* (Craiova, Romania, June 15, 1965. I am indebted to Barbu

Brezianu for drawing my attention to this observation. Giedion-Welcker also records (*Brancusi*, p. 31) that in the 1920s Brancusi rescued an injured cock and nursed it back to health in his studio. No date is put on this story, although it is located in time by mention of Brancusi's dog Polaire, which he owned in the 1920s. If the event occurred before 1924, it could have inspired *The Cock*.

36. Brancusi, in Flora Merrill, "Brancusi, the Sculptor of the Spirit, Would Build Infinite Column in Park," *New York World*, October 3, 1926, p. 4E.

37. Brancusi, in Malvina Hoffman, *Sculpture Inside and Out* (New York: W. W. Norton and Co., 1939), p. 52.

38. Giedion-Welcker, *Brancusi*, p. 202. The girl was Florence Homolka (see Hulten et al., *Brancusi*, p. 237).

39. Sweeney, "Brancusi Touch," pp. 22–24.

40. Brancusi, in Hulten et al., *Brancusi*, p. 315.

41. For the source of this quotation, see Geist, "Primitivism," ibid., p. 361.

42. See M. M., "Constantin Brancusi: A Summary of Many Conversations," p. 17, where Brancusi is quoted as saying: "Christian primitives and negro savages proceeded only by faith and instinct. The modern artist proceeds by instinct guided by reason." This equation of Christianity with African primitivism is not very surprising in one so guided by classical and modern philosophy. In the early 1930s Brancusi rejected the notion that he had earlier been influenced by African art. Sidney Geist has attempted to demonstrate the apparent disingenuity of such a rejection (see "Primitivism," vol. 2, pp. 345–67). However, he fails to acknowledge how Brancusi employed "primitivism" for associative reasons.

43. Friedrich Teja Bach points out that the sculpture derived from a work known as *The First Step II*, and he therefore calls it *The First Step III* (*Der Erste Schritt III*). However, he gives the title in French simply as *Le Premier Pas* without any numbering (see Bach, *Brancusi*, p. 452, cat. no. 143), which adds to the confusion. In his catalog Geist calls the carving *Little French Girl* (see *Brancusi: A Study*, p. 261, cat. no. 92). The title *Little French Girl* was given to the work by James Johnson Sweeney when director of the Solomon R. Guggenheim Museum, New York (see Geist, "Primitivism," vol. 2, p. 367 n. 23).

44. Brancusi probably destroyed the work (except for the head) in 1923. Interestingly, when he exhibited the head of *Plato* in New York in 1933–34 (Brummer Gallery, no. 47), it was under the title *Child's Head*; the association of Plato with children was an apparently fixed one.

45. See Hulten et al., p. 298, cat. no. 130. This connection was also stated earlier by Sidney Geist, *Constantin Brancusi, 1876–1957: A Retrospective Exhibition* (New York: Solomon R. Guggenheim Museum, 1969), p. 92.

46. Geist, *Brancusi: A Study*, p. 52.

47. There has been some confusion as to whether it was the marble or the bronze *Princess X* that was withdrawn from the Salon des Indépendants in 1920. However, the matter is resolved by a letter quoted in Hulten et al., *Brancusi*, p. 132. This is from the secretary of the Salon to Brancusi, asking him to withdraw "your metal sculpture."

48. Brancusi, in Roger Devigne, *L'Ere nouvelle*, January 28, 1920; quoted in Hulten et al., *Brancusi*, pp. 130–32.

49. See *Torso*, Geist, *Brancusi: A Study*, cat. no. 66, and Bach, *Brancusi*, cat. no. 95, dating from 1908–9; *Torso*, Geist, cat. no. 86, and Bach, cat. no. 110, dating from 1912; *Torso of a Young Woman*, Geist, cat. no. 117, and Bach, cat. no. 148, dating from 1918.

50. Brancusi, in David Lewis, *Constantin Brancusi* (London: Alec Tiranti, 1957), p. 28. Brancusi also gave a ridiculously fanciful explanation of the *Eve* part of this sculpture to an unidentified New York newspaper reporter in 1926 (see Geist, "Primitivism," pp. 352–54). As Geist notes, it is an "exegesis uniquely detailed among his utterances." However, the quote related by Lewis is entirely consistent with the Platonic tenor of Brancusi's other explanations of his works, and one can only assume that in 1926 the sculptor was being playful with the New York reporter.

51. Ovide, *Les Métamorphoses* (Paris: E. Flammarion, n.d.), p. 76. The passage quoted here, translated from the French by Tessa Henderson, is from the copy in the Brancusi library in the Musée National d'Art Moderne, Paris. The original passage reads as follows: Là Narcisse s'arrête, épuisé par les fatigues de la chasse et par la chaleur: charmé de la beauté du site et de la limpidité des eaux, il veut étancher sa soif; mais une autre soif augmente. Tandis qu'il boit, épris de son image qu'il aperçoit dans le miroir des eaux, il aime une ombre vaine et lui prête un corps.

52. Compare the use of the term "mere 'shadows and reflections'" in the Dorothy Adlow memoir (see note 15) with the imagery of the Ovid quotation given above. It is possible that Brancusi's use of the term derived from Ovid rather than Plato.

53. Agnes E. Meyer, *Out of These Roots* (New York: Brown and Co., 1953), p. 82. Brancusi evolved the forms of the "head" part of the *Portrait of Mrs. Eugene Meyer, Jr.* from a wooden carving possibly begun about 1916 and completed at about the same time as the marble. That sculpture (Geist, *Brancusi: A Study*, cat. no. 196, and Bach, *Brancusi*, cat. no 239) is now entitled *Study for Portrait of Mrs. Eugene Meyer*, although when it was exhibited in 1933–34 at Brummer Gallery it was entitled simply *Study—(wood)*.

54. Meyer, ibid.

55. For example, compare the lower half of the Brancusi with the lower halves of Smith's *Cubi XVII* (Dallas Museum of Fine Arts) and *Cubi XX* (University of California, Los Angeles). The closest that Smith came to Brancusi was probably *The Hero* of 1951 (Brooklyn Museum).

56. Brancusi, in Hulten et al., *Brancusi*, p. 148.

57. It is usually suggested that *Socrates* came into being under the influence of the composer and friend of Brancusi, Erik Satie, and that the sculpture is merely a witty adjunct to the kind of playful iconoclasm encountered in Satie's music, particularly his large-scale vocal "symphonic drama," *Socrate* (1918). (For example, see Edith Balas, "Brancusi, Duchamp and Dada," *Gazette des Beaux-Arts* 95 [April 1980]: 172, caption to fig. 15.) However, Satie's *Socrate* is a wholly serious work, being a setting of passages selected from Plato's dialogues, in which the composer set out to write a work that would be "white and pure like antiquity," an especially Brancusian aspiration. Given that Brancusi was expressing his responses to Plato by the late 1900s, it seems more likely that Brancusi influenced Satie than vice versa.

58. This photo was almost certainly taken after 1934, for the lower part of the sculpture was damaged in the 1933–34 Brummer Gallery exhibition; see Hulten et al., *Brancusi*, p. 298, cat. no. 130. The damage was repaired in 1950 by Constantin Antonovici (see Bach, *Brancusi*, p. 467, cat. no. 182).

59. Brancusi, in Alexander Liberman, *The Artist in His Studio* (New York: Viking, 1960), p. 48. However, the sculptor was clearly ambivalent about religion; see note 102 below.

60. See Edith Balas, "The Sculpture of Brancusi in the Light of His Rumanian Heritage," p. 67.

61. *The Sleeping Child*, Geist, *Brancusi: A Study*, cat. no. 38, and Bach, *Brancusi*, cat. no. 53, dated 1906–7; *Head of a Sleeping Child*, Geist, cat. no. 61, and Bach, cat. no. 85, dating from c. 1908; and *Sleeping Child*, Geist, cat. no. 62, and Bach, cat. no. 87, dating from c. 1908.

62. Sweeney, "Brancusi Touch," p. 24.

63. Henri-Pierre Roché, in Geist, *Retrospective Exhibition*, p. 77. It is worth quoting another of Roché's recollections in connection with this observation: "In my mind I see Brancusi again, several years ago, receiving beautiful women in his studio, putting a fine handkerchief over their eyes, and in their mouths crushed onion in strong cream cheese, and saying, 'Taste it and guess what it is.' They savour it, and find it delicious, but they would be unable to guess, even when he gave them a little drop of Rumanian alcohol to help them on. And then he would have some droll words to say on tongues and tastes, on hands and the quality of touch." Henri-Pierre Roché, in Lewis, *Brancusi*, p. 17 n. 23.

64. Hoffman, *Sculpture Inside and Out*, p. 52.

65. Barbara Hepworth, *Barbara Hepworth, Carvings and Drawings*, introduction by Herbert Read (London: Lund Humphries, 1952), section 2, n.p.

66. Brancusi, in Howe, "The Man Who Doesn't Like Michelangelo," p. 127.

67. Hulten et al., *Brancusi*, p. 136.

68. Peggy Guggenheim, *Out of This Century: Confessions of an Art Addict* (London: A. Deutsch, 1960), pp. 210–11. The two subsequent quotations from Guggenheim are also from p. 211.

69. Isamu Noguchi, *A Sculptor's World* (London: Thames and Hudson, 1967), p. 17.

70. Hulten et al., *Brancusi*, p. 196.

71. See ibid., p. 219, for a sketch that indicates the layout of the proposed temple.

72. For the reproduction of one of these designs in color, see ibid., p. 195.

73. From the inscription on a memorial plaque mounted on the bridge at Tîrgu-Jiu.

74. For information on Aretia Tătărăscu and the National League of Women of Gorj County, see Alexandra Parigoris, "Brancusi at Tîrgu-Jiu: The Return of the 'Prodigal Son,'" *Burlington Magazine* 126 (February 1984): 79.

75. Sidney Geist's contention that Brancusi worked on a model for the memorial gate in 1935–37 (see Geist, "Brancusi: The Centrality of the Gate," *Artforum* 12 [October 1973]: 74) cannot be sustained, as it is clear from the Tîrgu-Jiu documentation that Brancusi undertook to sculpt the gate only *after* his return to Tîrgu-Jiu in July 1937.

76. State Archives, Tîrgu-Jiu, Record of Town Council for Tîrgu-Jiu for 1937, p. 86 and verso (translated by Mary Jones).

77. See Brancusi's letter to Aretia Tătărăscu, in Hulten et al., *Brancusi*, p. 227.

78. Aretia Tătărăscu to the mayor of Tîrgu-Jiu, October 20, 1937, State Archives, Tîrgu-Jiu, Record of Town Council for Tîrgu-Jiu, univ. 108, dossier no. 1-141/1937 (translated by Mary Jones). Tătărăscu's letter also indicates that the total cost of "these two monuments" (i.e., *Endless Column* and *Gate of the Kiss*), plus that of reconstructing the church and the 750,000 lei paid for the expropriation of buildings that obstructed the proposed roadway and their demolition, came to 2,200,000 lei—an amount that had been raised entirely by the National League of Women of Gorj County. A memorandum dated October 2, 1937, from Ion Vintila, head of the technical department of the Tîrgu-Jiu Town Council (State Archives, Tîrgu-Jiu, dossier no. 119/1937), records that the funds for creating a new park around the *Endless Column* (on a site that had previously been used for the weekly market in Tîrgu-Jiu) and for building the Avenue of Heroes were boosted by a grant of five million lei from the Ministry of Communications and Public Works.

79. Hulten et al., *Brancusi*, p. 227.

80. Brancusi, in Brezianu, *Brancusi in Romania*, p. 130.

81. For other interpretations of the memorial, see Geist, "Centrality of the Gate"; Tucker, *Early Modern Sculpture*, 127–42; Sanda Miller, "Brancusi's 'Column of the Infinite,'" *Burlington Magazine* 122 (July 1980): 470–74; and Parigoris, "Brancusi at Tîrgu-Jiu." Both Tucker and Miller adopt a purely formalist approach to the ensemble and thus make no conceptual sense of it; the others address aspects of its symbolism but not in relation to its identity as a war memorial. No one pays much, if any, attention to the Avenue of Heroes.

82. The dimensions of the first table were 78⅝ by 17⅝ in. (upper drum) and 63 by 17⅝ in. (lower drum); those of the second table, 84⅝ by 17⅝ in. and 68⅞ by 17⅝ in., respectively.

83. For discussion of these and other titles for the work, see Brezianu, *Brancusi in Romania*, p. 147 n. 5.

84. Brancusi, in Guilbert, "Propos de Brancusi," p. 6.

85. Brezianu, *Brancusi in Romania*, p. 150, and Parigoris, "Brancusi at Tîrgu-Jiu," p. 84 n. 29.

86. S. Sterescu, "Scurt popas lîngă pretutindenarul Brâncuşi" (A Short Rest before the Omnipresence of Brâncuşi), *Inainte* (Craiova, Romania), December 4, 1966.

87. Geist, *Brancusi: A Study*, p. 125.

88. Hulten et al., *Brancusi*, p. 314, cat. no. 207.

89. See Walter Pach, *Queer Thing, Painting* (New York and London: Harper and Brothers, 1938), p. 173.

90. See Constantin Antonovici, "How I Knew the Great Brancusi," in *Constantin Antonovici, Sculptor of Owls* (Cleveland: Educational Research Council of America, 1975 [?]), p. 13. Antonovici also recalls that Brancusi told him: "I took my inspiration [for the stools] from the orange, an orange cut in two and united at the opposite ends. I did not take the orange by chance, I selected it because it represents something specific of Palestine, being its national fruit and something perpetual." Geist (*Brancusi: A Study*, p. 120) usefully points out that "the stools, while appearing to be made of the reassembled halves of a sphere, are almost four inches taller than the sphere of their diameter."

91. Hulten et al., *Brancusi*, p. 314, cat. no. 207.

92. Tătărăscu had evidently wanted Brancusi to make a gigantic triumphal arch instead of a gate, a proposal he flatly rejected because it would have looked too pompous in such a setting. Brancusi recalled: "They wanted a monumental arch. They asked 'Don't we have enough stone in our mountains?'" (Petre Pandrea, *Brancusi, Amintiri şi exegeze* [Memories Explained] [Bucharest, Romania: Meridiane, 1967], p. 35.) Brancusi explained why he could not give them what they wanted: "At Tîrgu-Jiu I was working at the gate of the city. The street was 6 meters wide. They probably wanted a monumental gate through which they could see the tower of the church. But they had just a 6-meter-wide street! I made a gate for poor people who have scarce means for urban monuments." (Pandrea, *Portraits and Controversies*, p. 166.) However, this rejection does not mean that Brancusi did not want his gate to function as such an arch, albeit in a more humble and intellectually complex way.

93. Brancusi, in Brezianu, *Brancusi in Romania*, p. 143.

94. Brancusi, ibid., p. 139.

95. Hoffman, *Sculpture Inside and Out*, p. 53.

96. Geist, *Brancusi: The Kiss*, p. 76.

97. Sanda Negropontes (daughter of Aretia Tătărăscu), interview with the author, September 1982.

98. Barbu Brezianu to the author, November 23, 1984; regarding the alignment of the *Endless Column* with the top of the belfry cross, see Brezianu, *Brancusi in Romania*, p. 130.

99. For verification of this acceptance by Brancusi, see Hulten et al., *Brancusi*, p. 223.

100. The move—which required numbering every timber—was supervised by Elena Udrişte of the Regional Museum, Tîrgu-Jiu; she is also responsible for the Curtişoara Ethnographic Museum near Tîrgu-Jiu.

101. Giedion-Welcker, *Brancusi*, p. 207.

102. In 1922 Brancusi gave 6,000 lei toward the building of a new church in Peştişani, which signifies his continuing identification with the church in Oltenia. (His gift is recorded on a plaque in the new church.) That Brancusi continued his allegiance to the Greek Orthodox Church is demonstrated by the fact that after his mother's death in 1919 he had prayers said on her behalf "as long as he lived." (See Hulten et al., *Brancusi*, p. 124.)

103. Hulten et al., *Brancusi*, p. 135.

104. Geist, "Primitivism," p. 358.

105. Brancusi, recorded by Dan Iovanescu and quoted in Brezianu, *Brancusi in Romania*, p. 134 and n. 5. Brancusi was not simply indulging Tătărăscu here; he had earlier provided a similar description of his other columns in ethereal terms (see the catalog of the Brancusi exhibition, Brummer Gallery, New York, 1933–34, in which three of the columns were described as "Project of columns which, when enlarged, will support the arch of the firmament").

Brancusi gave many titles to the *Endless Column*, including *Monument of Gratitude*, *Column of Endless Remembrance*, and *Column of Endless Gratitude for the Dead Heroes*. Other titles for the work are *Infinite Column* (see Stefan Georgescu-Gorjan, "The Genesis of the 'Column Without End,'" *Revue roumaine d'histoire de l'art* 1, no. 2 [1964]: 284 and n. 6); *Column Without End*; *The Monument of the Heroes*; and *The Column of Endless Memory*. The official title for the work recorded on a plate near the work in Tîrgu-Jiu is *The Column of Endless Gratitude*.

106. See Geist, "Centrality of the Gate," pp. 76ff. The fact that Brancusi did not determine the sequence of sculptures at Tîrgu-Jiu invalidates Geist's thesis that the complex reiterated the sequence of the flowerbed, the Arc de Triomphe du Carrousel, and the obelisk.

107. Merrill, *New York World*.

108. Henri Rousseau, in Giedion-Welcker, *Brancusi*, p. 25.

109. Brancusi, in Albert Dreyfus, "Constantin Brancusi," *Cahiers d'art* 2, no. 2 (1927): 70.

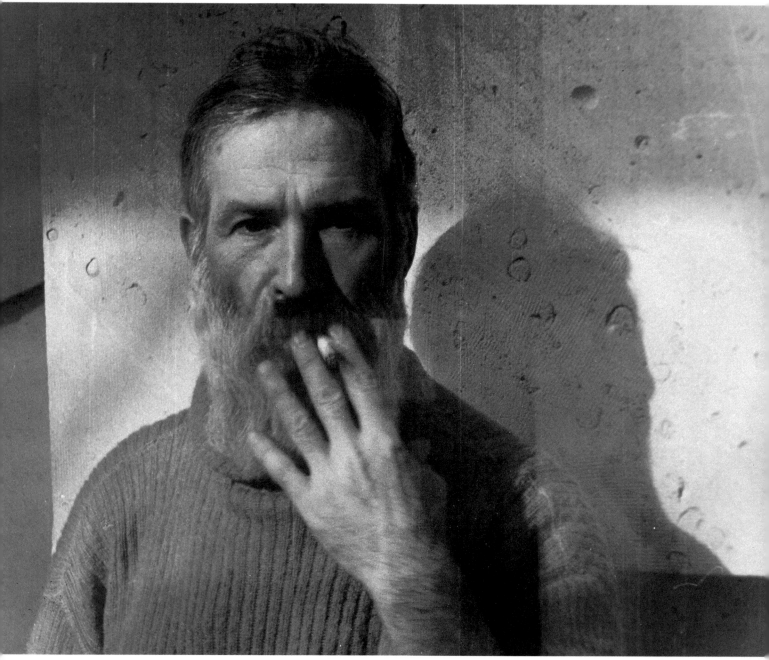

113

# Artist's Statements

"Simplicity is not an end in art, but one arrives at simplicity in spite of oneself, in approaching the real sense of things. Simplicity is at bottom complexity and one must be nourished on its essence to understand its significance."

> Catalog of Brancusi exhibition, Brummer Gallery, New York, 1926.

"Beauty is absolute balance."

> Ibid.

"What is real is not the external form, but the essence of things. Starting from this truth it is impossible for anyone to express anything essentially real by imitating its exterior surface."

> Ibid.

"Sculpture must be lovely to touch," [Brancusi] said, "friendly to live with, not only well made . . . fancy living with Moses, by Michelangelo, even if we do acknowledge and admire his power! We should not be made to feel like atoms in its presence, but we should respond and vibrate to the miracles of life. What is so glorious as the privilege that man enjoys of being alive, and being able to see and discover beauty all around him!"

> Quoted by Malvina Hoffman, *Sculpture Inside and Out* (New York: W. W. Norton, 1939), p. 53.

"It is an attempt, he says, to solve the 'maddeningly difficult problem of getting all the forms into one form. . . . Look at the body of a man, or of a woman. Isn't it a lovely thing? But how foolish it is to try and copy it. Is it not better for the artist to create something beautiful on his own?'"

> Quoted by Angus Wilson, "A Visit to Brancusi's," *New York Times Book Review and Magazine*, August 19, 1923.

". . . We sympathized with what [Brancusi] had to say next, about the poses in which the human figure is often represented. 'They [representational sculptors] will work for years,' he said, 'learning how to represent an outstretched arm, and then the poor arm has to stay outstretched forever. You'd think it would get tired. . . .

113. Self-portrait photograph by Brancusi.

Think of all the nude statues at this moment in the Tuileries or the Luxembourg Gardens, freezing cold, dripping rain and icicles. . . .' 'No,' he added, 'the only true art will come from what you find inside yourself.'"

Quoted by Adeline L. Atwater, *New York Herald Tribune Magazine*, January 12, 1930, p. 12.

"If one has reproduced nature realistically it is not creation. An artist must create. A reproduction of a horse in marble or bronze is a corpse of a horse. There is something more to a horse than the mere corpse, there is the essence—or what do you call it?—the spirit, perhaps."

Quoted by Flora Merrill, "Brancusi, the Sculptor of the Spirit, Would Build 'Infinite Column' in Park," *New York World*, October 3, 1926, p. 4E.

"If he had the power to fulfill one ambition he would build one of his columns of infinity in Central Park, New York. 'I would like to make my column in Central Park,' he said. 'It would be greater than any building, three times higher than your obelisk in Washington, with a base correspondingly wide—sixty meters or more. It would be made of metal. In each pyramid there would be apartments and people would live there, and on the very top I would have my bird—a great bird poised on the tip of my infinite column.'"

Ibid.

"Besides . . . you cannot make what you want to make, but what the material permits you to make. You cannot make out of marble what you would make out of wood, or out of wood what you would make out of stone. . . . Each material has its own life, and one cannot without punishment destroy a living material to make a dumb senseless thing. That is, we must not try to make materials speak our language, we must go with them to the point where others will understand their language."

Quoted by Dorothy Dudley, "Brancusi," *Dial* 82 (February 1927): 124.

"It is not the work itself, it is to keep oneself in condition to do it, that is difficult."

Ibid., p. 126.

"I never seek to make what they call a pure or abstract form. Pureness, simplicity is never in my mind; to arrive at the real sense of things is the one aim."

Ibid.

"Outside of popular unconscious art (what we would call folk art), outside of what a few individuals here and there have made, the arts have never existed by themselves. They have always been the apanage [or adjunct] of the religions. Each time we look at a religion we see that very beautiful things have been created and that afterwards decadence follows.

One can't take this product of the religions as universal art. Water is always water. Yet each time it has a different quality,

alkali, iron, sulphur. We must find the source of pure water so that everyone can drink.

Art begins to be born. Once rid of the religions and the philosophies, art is the one thing that can save the world. Art is the plank after the shipwreck, that saves someone. . . ."
> Ibid., p. 126–27.

"When we are no longer children, we are already dead."
> Ibid., p. 127.

"Theories are samples without value; only action counts."
> Ibid., p. 129.

"Art must give suddenly, all at once the shock of life, the sensation of breathing."
> Ibid., p. 130.

"If one could create as one breathes. That would be true happiness. One should arrive at that."
> Quoted by Alexander Liberman, *The Artist in His Studio* (New York: Viking, 1960), p. 48.

"My life has been a succession of miracles."
> Quoted by Carola Giedion-Welcker, *Constantin Brancusi* (New York: George Braziller, 1959), p. 1.

"Look at the sculptures until you see them. Those closest to God have seen them."
> Ibid., p. 219.

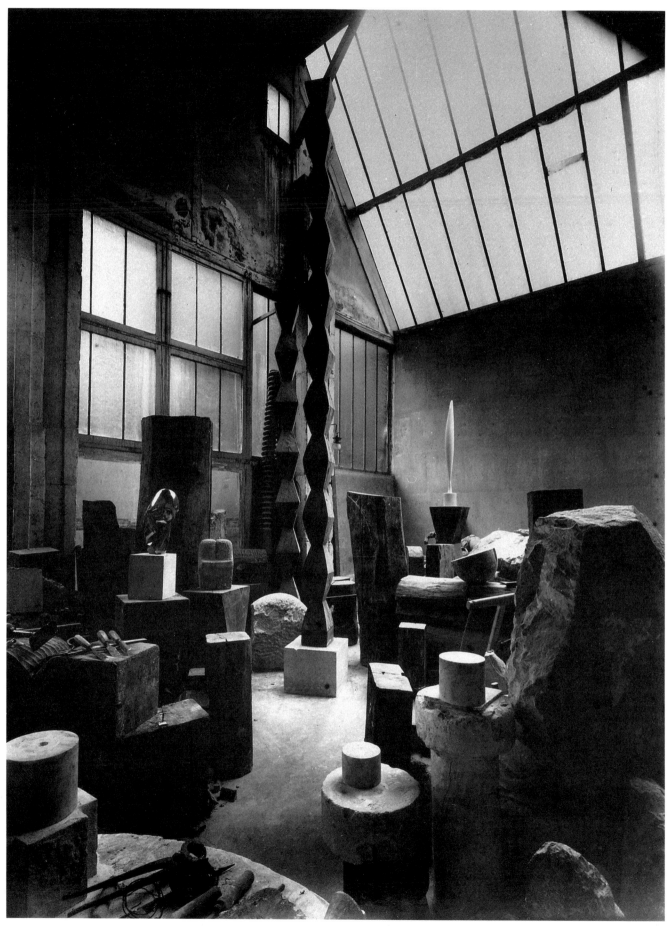

# Notes on Technique

Brancusi occupied three studios in Paris before moving to a studio at 8 Impasse Ronsin in 1916. In 1928 he had to move to a larger studio at 11 Impasse Ronsin because the floor at number 8 had collapsed under the weight of his sculptures. In 1930 he rented 9 Impasse Ronsin (the previous leaseholder had been Marcel Duchamp) and knocked a hole through a shared wall to join the two studios, subsequently carving an elaborate doorframe for the entryway. In 1941 he rented yet another adjacent studio, breaking through the wall to link it to his other studios. The entire four-room studio complex covered 34,000 cubic feet (according to figures worked out by the sculptor himself during World War II when he had to apply for heating coupons[1]).

From the plaza in front of the Centre Georges Pompidou one enters the reconstructed L-shaped studio directly into the largest of its four rooms. This houses an array of sculptures, now kept behind a low barrier instead of being distributed throughout the room as they were originally. The room is furnished with sofas and stools carved by Brancusi himself, as well as with the original mirrors and pictures on the walls. As in the original studio, an area of wall is painted Pompeian red to set off the golden color of a 1941 *Bird in Space*. Beyond the first room is a smaller studio, also filled with sculptures; at the far end is a fireplace built by the sculptor, with a dark screen on the wall that Brancusi sometimes employed as a backdrop when photographing his works.

Returning to the first room, one turns through the angle of the L to pass through the ornately carved doorway of 1930 to Brancusi's principal workshop, which also houses the raised platform where he slept. Along the side of the workshop is the long workbench made by the sculptor and the huge number of tools he amassed. In the far corner is a forge made by Brancusi, in which he would both shape the armatures for his sculptures and cook his meals. From the workshop one moves on to the last room, another area of about the same size as the workshop. The predominance of white throughout and the light streaming through the enormous skylights recapture the serene atmosphere in which he liked to work.

114. Columns in Brancusi's studio at 8 Impasse Ronsin, c. 1925. Note the winepress screw leaning against one of the columns at center. Photograph by Brancusi.

115

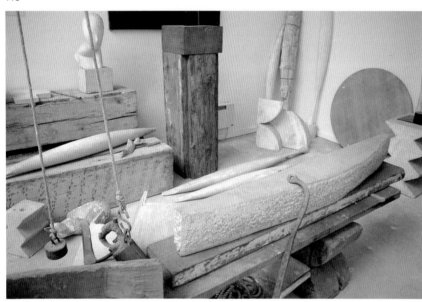

116

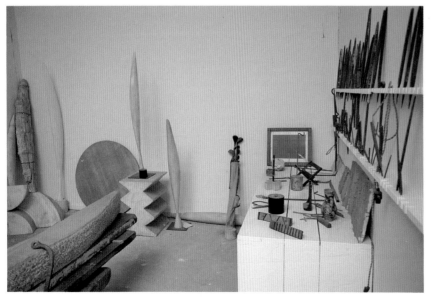

117

Brancusi's tools range from small fretsaws to large, two-handled saws and framesaws that ideally would have had a man pulling at each end; Brancusi would attach a counterweight for balance and work such saws alone, which required both great strength and evenness of cutting to avoid snagging the saw in the wood. The studio houses a vast array of chisels, hammers, bushhammers, planes, calipers, files, and the mallets he made himself. There are a number of pneumatic chisels, electric drills (which also drove sanding and polishing attachments), and electric hammers that could be modified to rough out stone, rivet, and drill. The sculptor also owned a machine fitted with chamois, felt, and cotton disks with which to polish his bronzes. Hanging from the ceiling on tracks are pulleys, counterweights, and ropes from which he 116 suspended heavier tools such as the electric drills, pneumatic chisels, and hammers.

Until 1907, with the completion of *The Prayer*, Brancusi was a 10 modeler, working in plaster or clay and subsequently casting a number of his models in bronze. Thereafter he began direct carving in stone and, after 1913, in wood. He said of carving: "Direct cutting in the chosen material is the true road to sculpture."[2] The sculptor frequently began by chalking a design onto the block, or sometimes he even sketched a simple layout on the wall. As far as his choice of wood was concerned, Brancusi often preferred old timber to new, obtaining weather-worn beams from dilapidated barns in Brittany or demolished houses in Paris, wood that might be hundreds of years old. When carving the wooden columns, he began by chalking straight lines at regular intervals around the circumference of the beams to denote the widest point of each module and the narrowest points between them. He sawed down the lines denoting the narrowest points, then roughed out the curves of the modules down to the deepest point of the incisions, hacking away at the wood with a huge ax before planing and sanding it. The surfaces were not wholly smoothed, for Brancusi wished to retain some evidence of facture.

When making bronze or other metal casts, Brancusi would create intermediate molds either from his finished works in stone or wood or from original plaster models. A great many of these plaster models remain in the Paris atelier, and the sculptor lavished 118 an enormous amount of care on them, sometimes spending months polishing them so that the subsequent bronzes would be as perfect as possible. He employed professionals to cast his bronzes, including the Hébrard, Valsuani, Converset, Rudier, and Andro foundries. Only rarely did Brancusi produce more than four casts of any given sculpture, as he evidently did not care much for the idea of editions. More usually he would create slight variations in each sculpture; these variants should be regarded as separate sculptures rather than straightforward, editioned casts, although there is still much confusion over this in the various catalogs of Brancusi's works.[3] The sculptor's heirs have not helped matters by continuing to cast works from Brancusi's molds after his death.[4]

Brancusi's plaster models are generally supported by metal armatures. Surprisingly, so are a number of his carvings, especially the marble Bird in Space sculptures. First Brancusi would rough

115–17. Brancusi's studio.

out a piece of stone to establish the basic curve of the final form. Into this he would drill a long hole, fill it with wet cement, and insert a metal rod. When the cement had hardened, he would begin carving the surrounding stone. Guided by precise measurements, he would whittle away the marble (preferring the smoother drive of a pneumatic chisel to a hammer-driven one) until the finest tolerance of the stone had been reached at the narrowest point. Since marble is an extremely fragile stone, he would carve along the grain rather than against it. He had philosophical as well as practical reasons for doing so; as he stated in 1930: "In bad form . . . the surfaces and planes all come to an end. They finish themselves within the mass. I think the true form ought to suggest infinity. The surfaces ought to look as though they went on forever, as though they preceded out from the mass into some perfect and complete existence."[5] Exploiting the grain helped Brancusi achieve this effect.

Brancusi's earliest bronzes were cast by the lost-wax process; to avoid the small pitholes this produced, he started using the sand-casting technique, which yields more brilliant surfaces when polished. By using ever-finer files and progressing from rough to fine emery paper, he would slowly bring the metal to a high sheen; the process was completed with jeweler's rouge or fine buffing powder. (At a later date Brancusi also used the polishing machine mentioned earlier.) The sculptor would maintain the brilliance by cleaning his bronzes regularly with ordinary brass polish. There can be no doubt that he wanted their high reflectivity to be maintained, and since cleaning requires only periodic maintenance there is no excuse for allowing his bronzes to dull (as in many museums). As to what that brilliance should reflect, Brancusi didn't mind, "as long as it's life itself."[6]

Brancusi himself worked the majority of his stone carvings from beginning to end. In the case of the two Tîrgu-Jiu carvings (*Gate of the Kiss* and *Table of Silence*), all the initial stages were handled by craftsmen working from a model (for the *Gate*), drawings, and Brancusi's verbal directions, the sculptor being directly involved only in the final stages. As Sidney Geist has demonstrated,[7] the model for the *Gate* was made to exactly one-tenth scale to facilitate the proportioning of the final version. Brancusi also wanted evidence of the carving process to remain apparent on the *Table of Silence*: "The Master told me I should keep an eye on the stone cutters. They shouldn't cut the stone fine, but in a rough manner like the peasant cuts his posts for his gate. 'I want,' said Brancusi, 'that they leave irregular marks of the chisel; that is to say I want it to be apparent that it was sculpted by hand, not cast.'"[8] Such evidence of craftsmanship is equally to be seen in many of Brancusi's other wood and stone carvings, and for the same reason.

*Endless Column* was only indirectly made by Brancusi. He carved a model for the modules out of limewood, from which a mold was made; the modules were then cast in iron. The modules and half-modules were numbered in the foundry so they would match up perfectly on site; once at Tîrgu-Jiu they were carefully threaded over a central pillar made of three sections of high-resistance rolled steel bolted together. The joints between the modules were

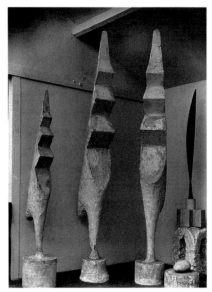

118

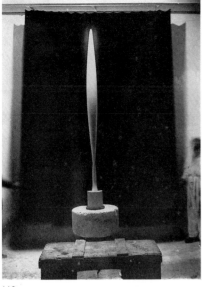

119

118.　Left: *Grand Cock I*, 1924
Plaster, 100¼ x 11¾ x 22½ in.
Center, *Grand Cock II*, 1930
Plaster, 143¾ x 17¾ x 31½ in.
Right: *Grand Cock III*, 1930
Plaster, 146½ x 17¾ x 32½ in.
Brancusi studio, Musée National d'Art
Moderne, Centre Geroges Pompidou, Paris
Photograph by Brancusi

119.　*Bird in Space*, 1930
White marble, height: 74⅜ in.
Private collection, New Jersey
Photograph by Brancusi
Brancusi can be seen at right.

filled with a fine metallic putty containing brass powder, and after the modules had been sand-blasted to obtain a fine surface, a coat of molten brass was sprayed over them from a revolving sprayer. The column contains three lightning rods and terminates in a flat waterproof plate welded on top.[9]

When Brancusi was planning *Endless Column*, he sketched the sculpture over photographs of the final hilltop site.[10] Doubtless the difficulties of conceiving the piece in relation to its surroundings dictated this method, which was unusual for him. For the most part, he used photography not as a planning medium but as a recording one. There are 560 original negatives and 1,250 prints in the Brancusi archive in Paris, the majority taken of sculptures after they had been finished. The photographs did not merely record the completion of works; often Brancusi would photograph sculptures because some effect of lighting took his fancy or perhaps struck him as ideal. As he frequently shifted sculptures and bases around in his studio, new affinities constantly appeared between them, which photography could capture; these, in turn, could spark new inspirations.

Brancusi took the mechanics of photography very seriously, and he was friendly with some of the leading photographers of his day, including Alfred Stieglitz, Edward Steichen, and Charles Sheeler. About 1921 Man Ray helped him build a darkroom at the 8 Impasse Ronsin studio. In 1929, just a year after moving to 11 Impasse Ronsin, Brancusi built another darkroom alongside his new studio, which consisted of two rooms, one for developing film, the other for printing.[11]

In addition to photographing his works, Brancusi also drew them. He rarely brought the same degree of imagination to his drawings as to his sculptures; most of his drawings seem to have been made as a means of relaxation from the rigors of sculpting. In his maturity Brancusi rarely sketched ideas for sculptures on paper, preferring to find the form in the act of carving or modeling.[12] The drawings he made for the first *Maiastra* in 1910 demonstrate the concentration on pure line that is the predominant feature of his mature drawing style, although occasionally the sculptor would bring a rough vigor to his drawings, as in the large study he made in crayon of *The First Step* in 1913[13] or the layout drawings he prepared for the unrealized Temple of Meditation in India. Brancusi made a fair number of drawings unrelated to sculpture, but he gave many of these away rather than selling them; some thirty-five drawings were also found in his studio after his death. (He was given to signing letters and decorating Easter eggs with the Kiss motif drawn in outline.) Most of his mature drawings are in pen and ink, a medium whose spareness of line acts as an equivalent to the reductive simplicity of his sculptures. Brancusi also painted a number of gouaches, which demonstrate the same characteristic simplicity—a good example is the *Study for "The Newborn"* in pencil and gouache from 1914.

For Brancusi, drawing and painting were principally diversions from sculpture. "Once when I broke a leg and couldn't get about I did a lot of drawing. I even did things in colour. . . . But those things on paper have no importance."[14] Ancillaries far more

120

crucial to his sculptures were their bases.

Brancusi revolutionized the base, both in its form and in its role in presenting a sculpture to the viewer. During the 1907–12 period his views on the base crystallized, and with the 1908–12 *Maiastra*, if not before, he finally established the exact kind of relationship he required between sculpture and base.[15] Thereafter, although he did not always provide bases for his works and sometimes exchanged the bases, when he wanted a sculpture to have a base, it became integral to the sculpture it supported; as he stated, "The pedestal should be part of the sculpture, or otherwise I must do completely without it."[16] Certainly he devoted as much mental energy to the making of his bases as he did to his sculptures, for as he wrote to John Quinn in 1919, "You must know that I have worked as much on these works as upon [my sculptures] and they are in no way the product of some chance or whim."[17] In the 1926 Brummer Gallery exhibition Brancusi exhibited five bases as works of art, rather than merely as supports. Many of the forms that appear in his bases also appear in his sculptures, or even *as* sculptures, as in *Table of Silence* and *Endless Column*.[18] And in certain of his works, such as the 1945 *Boundary Marker*, there is no dividing line between sculpture and base.

Nonetheless, it has been asserted—inaccurately, I believe—that none of the sculptor's bases are anything more than mere adjuncts to his works, just as picture frames are subsidiary to pictures.[19] Admittedly, Brancusi could appear to be arbitrary when assigning bases to his works—he would sometimes swap the bases, so that it is not always safe to postulate that a given base was linked to the sculpture it finally supports. But this arbitrariness is more apparent than real, for in most cases the bases play some kind of associative role, if only through textural contrast. Partly these contrasts were used to intensify the effect of materials, as in the numerous works juxtaposing rough wood with marble or bronze. But in works where a smooth form appears above a rough one, the contrast was probably also intended to symbolize transcendence of the rough and earthly by the smooth and unearthly (alternatively, as in *The Prodigal Son*, it could be reversed to emphasize the earthly). This symbolic relationship also appears in another guise in many of Brancusi's sculptures. He often mounted his works on large supports such as a block or drum with a smaller support beneath, and these lower forms act as metaphors for a lowly state that is transcended above the intermediate block or drum by the exalted or magical forms placed upon them. In these terms Brancusi's associative relationships between sculpture and base survive any exchanges of similar support he might make.

NOTES

1. Brancusi's studios after 1905 were located at: 10 place de la Bourse (March 1905–October 27, 1906); 16 place Dauphine (until no later than November 28, 1907); 54 rue du Montparnasse (until October 10, 1916); 8 Impasse Ronsin (officially until December 31, 1927); 11 Impasse Ronsin (from January 1, 1928). For a reference to the collapse of the 8 Impasse Ronsin studio floor, see Isamu Noguchi, *A Sculptor's World* (London: Thames and Hudson, 1967), p. 17; for information on the 1930 rental of 9 Impasse Ronsin, see Pontus Hulten, Natalia Dumitresco, and Alexandre Istrati, *Brancusi* (New York: Harry N. Abrams), p. 195; for the 1941 rental and the studio dimensions, see ibid., p. 234; for a plan

120. *Study for "The Newborn,"* 1914
Pencil and gouache on beige paper, 14¾ x 21¾ in.
Philadelphia Museum of Art; Louise and Walter Arensberg Collection

of the layout of both the 8 and 11 Impasse Ronsin studios, see ibid., p. 237.

2. Brancusi, in catalog of the Wildenstein Galleries exhibition, New York, 1926.

3. For example, Sidney Geist, *Brancusi: A Study of the Sculpture*, rev. ed. (New York: Hacker, 1983), p. 260, cat. no. 88, lists four casts of *Mlle. Pogany*, two of them with a black patina added and two without the patina. Elsewhere in the book (p. 175) Geist states that "Brancusi does not cast his works in so-called editions," so it is mystifying as to why he lists each of these sculptures under the same heading. Such confusing catalog entries are duplicated in the two other catalogues raisonnés, Hulten et al., *Brancusi*, and Friedrich Teja Bach, *Brancusi* (Cologne, West Germany: Du Mont, 1987), which lists three casts of *Mlle. Pogany* with the black patina added.

4. See the catalog of the Tokoro Gallery, Tokyo, Brancusi exhibition, 1985, for color reproductions of satin-finished bronze casts made in the 1970s and '80s by Alexandre Istrati and Natalia Dumitresco, who were also responsible for making a stainless-steel cast of *Grand Coq IV* in 1974–77.

5. Brancusi, in Adeline L. Atwater, "A Recluse of Modern Art," *New York Herald Tribune Magazine*, January 12, 1930, p. 12.

6. Brancusi, in James Thrall Soby, "Constantin Brancusi," *Saturday Review*, December 3, 1955, p. 51.

7. Sidney Geist, "Brancusi: The Centrality of the Gate," *Artforum* 12 (October 1973): 74.

8. Paul Anghel, in Edith Balas, "The Sculpture of Brancusi in the Light of His Rumanian Heritage," Ph. D. diss. (available in facsimile), University of Pittsburgh, 1973, p. 25.

9. For the definitive account of the production of the column, see Stefan Georgescu-Gorjan, "The Genesis of the 'Column Without End,'" *Revue roumaine d'histoire de l'art* (Bucharest, Romania) 1, no. 2 (1964): 279–93.

10. The photographs are reproduced in Barbu Brezianu, *Brancusi in Romania*, trans. Delia Razdolescu and Ilie Marcu (Bucharest, Romania: Editura Academiei R.S.R., 1976), p. 131; and in Hulten et al., *Brancusi*, pp. 223–23.

11. For information regarding Brancusi's photographic equipment, see Marielle Tabart and Isabelle Monod-Fontaine, *Brancusi photographe* (Paris: Musée National d'Art Moderne, 1977), p. 12 n. 2; and Hulten et al., *Brancusi*, pp. 190–91.

12. A complete sketchbook, containing mostly life studies and preparatory drawings for the *Ecorché* and dating from around 1901–2 when Brancusi was a student at the School of Fine Arts in Bucharest, survives in a private collection in Bucharest. For reproductions of the entire sketchbook, see Brezianu, *Brancusi in Romania*, pp. 158–92.

13. This work is now in the Museum of Modern Art, New York (see John Elderfield, *The Modern Drawing* [New York: Museum of Modern Art, 1983], pp. 88–89).

14. Brancusi, in Russell Warren Howe, "The Man Who Doesn't Like Michelangelo," *Apollo* 49 (May 1949): 127. Brancusi broke his leg badly on July 8, 1918, and the drawings presumably dated from that time (see Hulten et al., *Brancusi*, p. 116).

15. He had, of course, thought about the sculpture-base relationship with the Stănescu portrait and *The Prayer* in 1907, even if he did not establish those relationships until he went to Buzău in 1914 to carve the pedestals for the two works. And even earlier he had certainly thought about the integration of sculpture and base with a first, rejected version of *The Prayer* (see Brezianu, *Brancusi in Romania*, p. 102, for a photograph of that work showing Brancusi's amalgamated figure and base). Unfortunately, there is at present no catalogue raisonné of Brancusi's bases, and there is a real need for one that would also record the exchanges of bases that Brancusi sometimes made.

16. Brancusi, in Goran Schildt, "Colloqui con Brancusi," *La Biennale di Venezia* 32 (June–September 1958): 24.

17. Brancusi to John Quinn, January 27, 1919, New York Public Library.

18. See Edith Balas, "Object-Sculpture, Base and Assemblage in the Art of Constantin Brancusi," *Art Journal* 38 (Fall 1978): 36–47, for some particularly pertinent points concerning the ways that Brancusi used the same forms in furniture, bases, and sculptures.

19. See Geist, *Brancusi: A Study*, pp. 168–69.

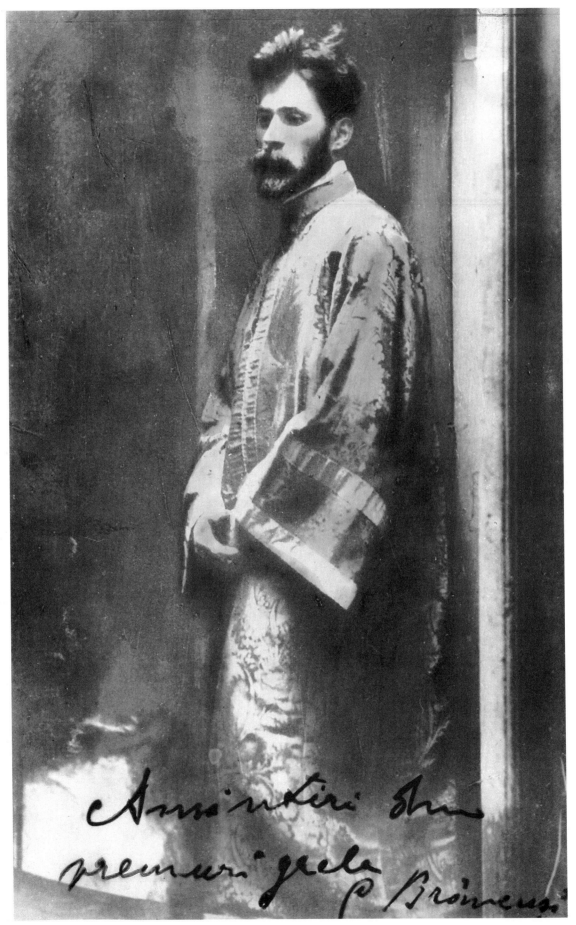

121

# Chronology

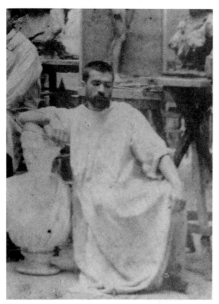

122

121. Brancusi dressed as a sacristan in the Romanian Church, Paris, 1905

122. Brancusi in a studio at the Bucharest School of Fine Arts, 1901

**1876** February 19—Constantin Brancusi born in Hobiţa, Romania (near Peştişani in Gorj County), son of Nicolae Brâncuşi (1833–1885) and Maria Deaconescu (1851–1919).

**1883** Runs away from home. Mother finds him in Tîrgu-Jiu and brings him home. Attends school in Peştişani.

**1884** Plays truant and is apprenticed to a dealer in casks.

**1885** Returns to school in adjacent village of Brâdiceni. Father dies.

**1886** Finally abandons school, works as a shepherd.

**1887** Leaves Hobiţa for Tîrgu-Jiu and is again forcibly returned home.

**1888** Leaves home for good. Goes to Slatina, sixty-five miles from Tîrgu-Jiu, to work in a shop.

**1889** Goes to Craiova, fifty miles from Tîrgu-Jiu, where he works in a tavern.

**1893** Works for Ion Zamfirescu in his tavern and grocery store; attends part-time courses at the Craiova School of Crafts.

**1894** Makes a violin from a crate, which attracts the attention of both his employer and one of the customers, who collect money to send him full time to the Craiova School of Crafts. September 1—enters school, where wood carving, joinery, foundry work and smithing, mechanics, and wheel making are taught.

**1895** Awarded a scholarship by the Madona Dudu church foundation and becomes a boarder at the Craiova School of Crafts. August 31—accepted there as a sculpture student.

**1897** Summer—goes to Vienna to work in a furniture factory.

**1898** September 28—graduates with honors from both practical and theoretical courses at the Craiova School of Crafts: awarded the highest grade (9.33). September 30—enrolls at the Bucharest School of Fine Arts, to study sculpture with Ion Georgescu. October 14—exhibits publicly for the first time (*Portrait of Gheorghe Chitu*) at the *Regional Exhibition* in Craiova. November—Ion Georgescu dies; Brancusi transfers to study under Wladimir C. Hegel. December—receives honorable mention for "bust after the antique," a portrait of Emperor Vitellius.

**1899** Grant doubled by Madona Dudu church foundation in Craiova.

**1900** June—receives bronze medals for *Laokoön Study* and *Character Study*, honorable mentions for four other works. December—receives bronze medal for *Character Study*.

**1901** June—receives bronze medal for *Ecorché* (plate 5) and honorable mentions for three other works. August—completes *Ecorché* in clay (subsequently cast in plaster in 1901–2 and again cast in plaster in 1902 and 1903). December—receives honorable mentions for aesthetics, history of art, and perspective; receives silver medal, the highest distinction, for study from nature.

**1902** April—graduates from Bucharest School of Fine Arts but continues to use its facilities. September—receives second diploma from Bucharest School of Fine Arts. October—having evaded military service, receives technical discharge from army. Works as a carpenter in Tîrgu-Jiu and nearby villages, including Hobiţa.

**1903** Makes two portraits of General Dr. Carol Davila for military hospital in Bucharest; casts work in March. May—*Ecorché* is his first work to be exhibited in Bucharest, at the Athenaeum Palace. Ministry of Education acquires the work and has several casts made for teaching purposes.

**1904** May—sets off for Budapest, Vienna, and Munich, where he works briefly as a hospital attendant and takes classes at the Royal Academy of Fine Arts. Leaves, intending to walk to Paris; travels by foot to Langres (Haute-Marne), France, thence by train to Paris, arriving July 14. Takes lodgings with his friend Daniel Poiana on the eighth floor of 9 Cité Condorcet. Washes dishes in Chartier chain restaurant and Mollard tavern; works as sacristan in Romanian church.

**1905** January–February (?)—enrolls at Ecole Nationale des Beaux-Arts, as pupil of Antonin Mercié. March—takes lodgings at 10 place de la Bourse. Granted scholarship of 600 lei by Romanian Ministry of Education. Takes up photography during this year. Works completed include *Pride* (plate 7).

**1906** February—requests extension of Romanian government scholarship because he is destitute, having only 75 lei per month left. March—works accepted for Salon des Beaux-Arts at the Grand Palais, his first group exhibition in Paris; Auguste Rodin, Emile-Antoine Bourdelle, and Charles Despiau are among the jurors. June—receives Romanian government scholarship of 500 lei to cover period April 1, 1906–March 31, 1907. October 27—moves to new studio, at 16 place Dauphine. November—lottery to help Brancusi organized by Stefan Popescu; Craiovan student Victor N. Popp wins first prize, a bronze version of *The Child*. Works completed include *Portrait of Nicolae Dărăscu* (plate 9).

**1907** January—works in Rodin's studio at Meudon (until March). Romanian State Picture Gallery purchases plaster version of *The Child*. April 18—obtains commission from widow of Petre Stănescu for funerary ensemble in Buzău. Begins *The Prayer* (plate 10) and completes it by late autumn. Autumn—cuts first sculptures directly from stone. Before November 28—moves to better studio, at 54 rue du Montparnasse. Works completed include *Torment I* (plate 8) and *Portrait of Petre Stănescu* (plate 11).

**1908** Receives last scholarship from Romanian government. Contracts typhus. Works completed include *The Kiss* (plates 13, 14); *Wisdom* (plate 20); the caryatid figures of the 1908–12 *Maiastra* (plate 22); *Sleep* (plate 81).

**1909** March—sends three works to the *Tinerimea Artistica* (Artistic Youth) exhibition in Bucharest. April—visits Leghorn with Amedeo Modigliani, with whom he had become friendly the previous year. May—visits Bucharest and is awarded the second prize at the official Salon. Romanian Ministry of Education purchases plaster *Portrait of Nicolae Dărăscu* (plate 9) for 2,000 lei. Romanian collector Anastase Simu buys marble *Sleep* (plate 81). Works completed include *The Kiss* (plate 15).

**1910** October—Anastase Simu buys bronze *Portrait of Nicolae Dărăscu* (plate 9). December (or possibly January 1911)—installs large stone version of *The Kiss* (plate 15) as tombstone for Tatiana Rashewskaia in Montparnasse Cemetery. Works completed include *Sleeping Muse* (plate 3).

**1911** Works completed include *Prometheus* (plate 80).

**1912** June—awarded first prize of 2,000 lei by the Bucharest Salon for *Study* (*Torso of a Girl*). September—bust of General Dr. Carol Davila installed at the Military Hospital, Bucharest. Works completed include *Three Penguins* (plate 38); *Maiastra* (plates 22, 26, 29, 30); *Mlle. Pogany* (plate 64).

**1913** February—five of his works go on display in the Armory Show, his first group exhibition in New York. Invited by Romanian Minister of Education, V. G. Mortun, to compete for commission to make monument to the mathematician Spiru Haret (*Narcissus Fountain*, plate 63). July—three works included in the sixth *Allied Artists* exhibition at the Royal Albert Hall, London; critic Roger Fry declares that the "three heads are the most remarkable works of sculpture at the Albert Hall." First carves in wood during this year. Works completed include *Mlle. Pogany* (plate 65).

**1914** Carves verses by Guillaume Apollinaire on Henri Rousseau's gravestone in Bagneux Cemetery. March 12—first one-man exhibition opens at Little Galleries of the Photo-Secession, New York, organized by Alfred Stieglitz and Edward Steichen. May—visits Romania and carves stone pedestal (plate 12) for *Portrait of Petre Stănescu* (plate 11) and *The Prayer* (plate 10) in Dumbrava Cemetery, Buzău. Also visits Craiova and Hobiţa. Spiru Haret memorial proposal (*Narcissus Fountain*) rejected by V. G. Mortun. June—returns to Paris. Works completed include *Two Penguins* (plate 39).

**1915** Makes first wood carvings with which he is satisfied, including *The Prodigal Son* (plate 55); other works completed include *The Newborn* (plate 82).

**1916** Before October 10—moves to new studio, at 8 Impasse Ronsin. Works completed include *Princess X* (plates 56, 57); *Sculpture for the Blind* (plate 84); *The Kiss* (plate 16).

**1917** Joins Relief Committee for Romanian Refugees. Publishes photographs of his sculptures (with his aphorisms) in *De Stijl* (Leyden), the journal of the Dutch avant-garde movement. Works completed include *The Child in the World* (plate 51); *The First Cry* (plate 83).

**1918** Carves first *Endless Column*. July 8—breaks right leg while staying in Chausse, France; spends thirty-eight days in hospital at Alès, followed by twenty-five days in convalescent home. November—attends Guillaume Apollinaire's funeral. Works include *Child* (plate 50); *Chimera* (plate 78).

**1919** January 26—mother dies in Hobiţa. Miliţa Pătraşcu becomes Brancusi's studio assistant (until 1923). Works completed include *Medallion* (plate 17); *Yellow Bird* (plate 2); *Golden Bird* (plate 31); marble *Mlle. Pogany II* (plate 66).

**1920** January—forced to withdraw bronze *Princess X* (plate 57) from 31st Salon des Indépendants. April—erects *Endless Column* in garden of Edward Steichen outside Paris. May—attends Dada festival and signs "Contre Cubisme, Contre Dadaisme" manifesto. Works completed include *Beginning of the World* (plate 85); *Leda* (plate 86); *Plato* (plate 52); bronze *Mlle. Pogany II* (plate 67).

**1921** With Man Ray's help, builds photographic darkroom in studio. June—visits Italy, Greece, Turkey, and Romania. Offers to make a stone fountain in Peştişani for heroes lost in battle of Peştişani. Returns to Paris via Prague and Brussels. August—visits Corsica. September—Ezra Pound publishes essay on Brancusi in the *Little Review*, illustrated with twenty-four reproductions. Works completed include *Adam and Eve* (plate 61).

**1922** May—Lizica Codreanu wears a costume designed by Brancusi at a dance recital. September—visits Romania to choose stone for Peştişani monument. October—returns to Paris. Works completed include *Fish* (plate 41); *Socrates* (plate 74); *Torso of a Young Man* (plate 59).

**1923** May—financial difficulties force termination of Peştişani memorial project. Completed works include *The White Negress* (plate 69).

**1924** April—works exhibited in the Romanian pavilion at the Venice Biennale. Summer—is nearly drowned in flash flood while staying in Saint-Raphaël, France. Works completed include *Torso of a Young Man* (plate 60); *The Cock* (plate 39); *Bird in Space* (plates 32, 33); *The Sorceress* (plate 79); *Grand Coq I* (plate 118); *Fish* (plate 42).

**1925** January—forty-six reproductions of Brancusi's sculptures are published along with aphorisms and a fable by him in *This Quarter* (Paris). September—visits London to attend *Exhibition of Tri-National Art* at the New Chenil Galleries. Works completed include *The Chief* (plate 76); *Bird in Space* (plate 34); *Torso of a Young Woman III* (plate 58); *Head of a Woman* (plate 73).

**1926** January 28—arrives in New York for one-man exhibition at Wildenstein Galleries. March 22—returns to France. September 1—sails again to United States. *Bird in Space* (plate 33) charged import duty on arrival in U.S. Works completed include *Bird in Space* (plate 35); *Caryatid* (plate 53); *Leda* (plate 87).

**1927** Summer—Isamu Noguchi becomes studio assistant (until 1929). Studio floor at 8 Impasse Ronsin collapses. Works completed include *Portrait of Nancy Cunard* (plate 71); *The Newborn II* (plate 88).

**1928** January 1—takes new studio, at 11 Impasse Ronsin. November—decision made in Brancusi's favor at U.S. Customs court trial regarding import duty paid on *Bird in Space*. Works completed include *Bird in Space* (plate 125).

**1929** Builds photographic darkroom next to studio. Summer—visits Aix-les-Bains and the Maritime Alps, France.

**1930** Has telephone installed in studio and carves "telephone chair" to accompany it. February 11—signs lease on adjacent studio at 9 Impasse Ronsin and subsequently knocks doorway through to connect the two studios. Summer—spends holidays at Villefranche, France. September—visits Bucharest, Hobiţa, and Peştişani. Probably begins discussing Temple of Meditation project with the Maharajah of Indore. Works completed about this time include *Portrait of Mrs. Eugene Meyer, Jr.* (plate 72); *Nocturnal Creature* (plate 44).

**1931** September 22—awarded Order of Cultural Merit for Plastic Arts by Romanian government. Works completed include *Mlle. Pogany III* (plate 49).

**1932** Henry Moore and Barbara Hepworth visit studio. Works completed include *The Seal* (plate 44).

**1933** Maharajah of Indore purchases bronze *Bird in Space* and commissions two marble versions of same subject. August—invited to go to Spain by Marcel Duchamp but is refused visa. November—sends large number of works to New York for Brummer Gallery exhibition; consignment weighs twenty-four tons. Works completed include *Blond Negress II* (plate 70).

**1934** November or December—Miliţa Pătraşcu offers Brancusi the Tîrgu-Jiu commission.

**1935** January—considers Tîrgu-Jiu offer; discusses possibility of erecting column with Stefan Georgescu-Gorjan. February 11—accepts offer by letter to Aretia Tătărăscu. Works completed include *The Cock* (plate 40).

**1936** Completes two Bird in Space sculptures for the Maharajah of Indore (plate 36).

**1937** July 25—arrives in Tîrgu-Jiu to begin work on war-memorial ensemble and proposes to erect *Endless Column* (plate 91); also offers to make *Gate of the Kiss* (plate 100). Late July—tours quarries near Tîrgu-Jiu looking for suitable marble. August—works on module for *Endless Column*. September 2—goes back to Paris. October 27—returns to Tîrgu-Jiu. November—discusses adding *Table of Silence* (plate 96). November 10–14—visits Bucharest, then returns to Paris. December—embarks at Genoa for India, where he stays at the Maharajah of Indore's palace.

**1938** January—visits Egypt; returns to Paris by February. June—returns to Tîrgu-Jiu to complete carving of *Gate of the Kiss*. July 28—*Gate of the Kiss* and *Endless Column* completed. New *Table of Silence* replaces old one defaced with signature by council officials (new *Table* therefore paid for by Tîrgu-Jiu council, not National League of Women of Gorj County). October 27—dedication of Tîrgu-Jiu war-memorial ensemble.

**1939** May—visits New York and Chicago.

**1940** Completes *Bird in Space* (back cover).

**1941** Completes final bronze Bird in Space sculptures (plate 37). July—rents another adjacent studio and subsequently links it to 11 Impasse Ronsin.

**1943** Works completed include *The Seal* (plate 46) and, about this time, *Walking Turtle* (plate 47).

**1944** In solidarity with French Résistance refuses to show work and hides Résistance fighters in studio.

**1945** Completes *Flying Turtle* (plate 48) and makes *Boundary Marker* (plate 19).

**1948** Two Bird in Space sculptures exhibited in Twenty-fourth Venice Biennale. Completes *Caryatid* about this time (plate 54).

**1949** Natalia Dumitresco and Alexandre Istrati move into studio next to Brancusi in Impasse Ronsin.

**1952** Becomes a French citizen in order to bequeath studio and contents to Musée National d'Art Moderne, Paris. Completes last work, plaster of *Grand Coq IV*.

**1954** Philadelphia Museum of Art accepts Louise and Walter Arensberg collection, including seventeen works by Brancusi.

**1955** January 6—incapacitated by broken thigh bone, spends 112 days in hospital (until May 3); takes most of year to recover. October 25—large retrospective exhibition opens at Solomon R. Guggenheim Museum, New York.

**1956** January—retrospective exhibition moves to Philadelphia Museum of Art. March—approached by Chicago citizens' committee to make 1,312-foot-high stainless-steel *Endless Column* to stand on the shores of Lake Michigan; Brancusi states that if realized "it will be one of the wonders of the world." April 12—draws up deed bequeathing studio and works; appoints Dumitresco and Istrati his heirs. December—one-man exhibition held at Museum of Art, Bucharest.

**1957** March 16—Constantin Brancusi dies in Paris. March 19—funeral takes place at Montparnasse Cemetery.

123. Brancusi with Marcel Duchamp and Mary Reynolds at Villefranche, France, 1925

# Exhibitions

## Solo Exhibitions

### 1914

Little Galleries of the Photo-Secession, New York, March 12–April 1.

### 1916

Modern Gallery, New York, October 23–November 11.

### 1926

*Sculpture by Brancusi*, Wildenstein Gallery, New York, February 18–March 3.

Brummer Gallery, New York, November 17–December 15, and tour to Arts Club of Chicago.

### 1933

Brummer Gallery, New York, November 17–January 13, 1934.

### 1954

*Sculpture by Constantin Brancusi*, Museum of Modern Art, New York, July 7–August 15.

### 1955

*Brancusi: A Retrospective Exhibition*, Solomon R. Guggenheim Museum, New York, October 25–January 8, 1956, and tour to Philadelphia Museum of Art.

### 1956

*Brancusi: A Retrospective Exhibition on the Occasion of the Artist's Eightieth Birthday*, Muzeul de Arta R.S.R., Bucharest, Romania, December–January 1957.

### 1960

*Brancusi*, Staempfli Gallery, New York, November 29–December 31.

### 1962

First reconstruction of Brancusi studio, Musée National d'Art Moderne, Paris, March.

### 1967

*Hommage à Brancusi*, Musée National d'Art Moderne, Paris, opened June 12.

### 1969

*Constantin Brancusi, 1876–1957: A Retrospective Exhibition*, Philadelphia Museum of Art, September 23–October 30, and tour to Solomon R. Guggenheim Museum, New York, and Art Institute of Chicago.

### 1970

*Brancusi: A Retrospective Exhibition*, Muzeul de Arta R.S.R., Bucharest, Romania, June 5–August 20.

*Brancusi—Turning Point in the Art of Sculpting*, Haags Gemeentemuseum, The Hague, September 19–November 29.

### 1973

*Brancusi*, Museu de Arte Contemporanea, São Paulo, Brazil, October 3–21.

### 1975

*Brancusi: 25 Dessins*, Musée National d'Art Moderne, Centre Georges Pompidou, Paris, December 10–February 8, 1976.

### 1976

*Constantin Brancusi: From the Guggenheim Collection*, Solomon R. Guggenheim Museum, New York, April 15–May 19.

Muzeul de Arta R.S.R., Bucharest, Romania, May–July.

*Inauguration de l'Atelier de Brancusi*, Musée National d'Art Moderne, Centre Georges Pompidou, Paris, June 21.

*Constantin Brancusi: Plastiken–Zeichnungen*, Wilhelm Lehmbruck Museum, Duisburg, West Germany, July 11–September 5.

Städtische Kunsthalle, Mannheim, West Germany, September 25–November 7.

*Constantin Brancusi. Der Künstler als Fotograf seiner Skulptur: Eine Auswahl, 1902–1943*, Kunsthaus Zurich, November 12–January 9, 1977.

*Brancusi: Photographe*, Musée National d'Art Moderne, Centre Georges Pompidou, Paris, and international tour (through 1980).

Tokoro Gallery, Tokyo, October 15–November 19.

## 1985

*Constantin Brancusi: Sculptures, Drawings, Photographs*, Tokoro Gallery, Tokyo, June 15–July 31.

*Délicatesse de Brancusi: L'Atelier 1946, Pascu Atanasiu*, Galerie de France, Paris, June–July.

## Selected Group Exhibitions

## 1903

Palatul Ateneului Roman, Bucharest, Romania.

## 1906

*Société Nationale des Beaux-Arts*, Grand Palais, Paris, April 15–June 30. Also included in 1907 and 1908.

*Société du Salon d'Automne*, Grand Palais, Paris, October 6–November 15. Also included in 1907 and 1909.

## 1907

*Tinerimea Artistica*, Bucharest, Romania, March 15–May 1. Also included in 1908, 1909, 1910, 1913, and 1914.

## 1910

*Société des Artistes Indépendants*, Cours la Reine, Paris, March 18–May 1. Also included in 1911, 1912, 1913, 1920, and 1926.

## 1913

*International Exhibition of Modern Art* (the Armory Show), Armory of the 69th Infantry, New York, February 17–March 15, and tour.

## 1917

*Society of Independent Artists*, New York, Grand Central Palace, April 10–May 6.

## 1920

*Salon des Indépendants*, Paris, January 28–February 29.

## 1922

*Contemporary French Art*, Sculptors' Gallery, New York, March 24–April 16.

## 1925

*Tri-National Exhibition of Contemporary Art: American, French and English*, Galerie Durand-Ruel, Paris, May 28–June 25, and tour.

## 1926

*International Exhibition of Modern Art*, Brooklyn Museum, November 19–January 1, 1927.

## 1927

*French Art Today*, Museum of Modern Art, Moscow, May 1–30, and tour.

## 1930

*Modern Rumanian Art*, Haags Gemeentemuseum, The Hague, May 3–June 9, and tour.

## 1933

*A Century of Progress Exhibition*, Art Institute of Chicago, June 1–November 1.

## 1934

*Modern Works of Art: Fifth Anniversary Exhibition*, Museum of Modern Art, New York, November 19–January 20, 1935.

## 1936

*Art of Today*, Albright-Knox Art Gallery, Buffalo, January 3–31.

*Cubism and Abstract Art*, Museum of Modern Art, New York, March 2–April 19, and tour.

## 1937

*Origines et développement de l'art international indépendant*, Musée du Jeu de Paume, Paris, July 30–October 31.

## 1940

*Modern Masters from European and American Collections*, Museum of Modern Art, New York, January 26–March 24.

*International Exhibition of Watercolors*, Art Institute of Chicago, April 25–May 26.

## 1941

*From Rodin to Brancusi*, Buchholz Gallery, New York, February–March 18.

## 1942

*Twentieth-Century Portraits*, Museum of Modern Art, New York, December 9–January 24, 1943.

## 1946

*Origins of Modern Sculpture*, Detroit Institute of Arts, January 22–March 3.

*Four Modern Sculptors: Brancusi, Calder, Lipchitz, Moore*, City Art Museum, Saint Louis, March 30–May 1.

*Contemporary Sculpture, Objects, Constructions*, Yale University Art Gallery, New Haven, Connecticut, April 4–May 6.

## 1947

*Vingt-cinq Ans d'art sacré français*, Palais Galliera, Paris, March 10–April 20.

*Peintures et sculptures contemporains*, Palais des Papes, Avignon, France, June 27–September 30.

## 1948

*Themes and Variations in Painting and Sculpture*, Baltimore Museum of Art, April 15–May 23.

*XXIV Biennale*, Venice, June 24–September 8. Also included in 1982.

*Timeless Aspects of Modern Art*, Museum of Modern Art, New York, November 16–January 23, 1949.

*40,000 Years of Modern Art: A Comparison of Primitive and Modern*, Institute of Contemporary Arts, London, December 20–January 29, 1949.

## 1949

*Sculpture since Rodin*, Yale University Art Gallery, New Haven, Connecticut, January 14–February 13.

*Les Maîtres de l'art abstrait*, Galerie Maeght, Paris, May 27–June 30.

*Outdoor Sculpture*, Sonsbeek Park, Arnhem, Netherlands, July 1–September 30.

## 1950

*A Century of Sculpture, 1850–1950*, Museum of Art, Rhode Island School of Design, Providence, March 30–May 18.

## 1951

*De Stijl*, Stedelijk Museum, Amsterdam, July 6–September 25.

## 1952

*L'Oeuvre du XXᵉ siècle*, Musée National d'Art Moderne, Paris, May–June, and tour.

*Sculpture of the Twentieth Century*, Philadelphia Museum of Art, October 11–December 7, and tour.

## 1953

*Le Cubisme, 1907–1914*, Musée National d'Art Moderne, Paris, January 30–April 9.

*75 Years of Sculpture*, Houston Museum of Fine Arts, November.

*II Bienal de São Paulo*, Museu de Arte Contemporanea, São Paulo, Brazil, November 1953–February 1954.

## 1954

*Begründer der modernen Plastik: Arp, Brancusi, Chauvin, Duchamp-Villon, González, Laurens, Lipchitz, Pevsner*, Kunsthaus Zurich, November 27–December 31.

## 1955

*Dessin de sculpteurs*, Galerie Creuzevault, Paris, January–February.

*Exposition internationale de sculpture contemporaine*, Musée Rodin, Paris, June–July.

## 1956

*Rodin to Lipchitz, Part II*, Fine Arts Associates, New York, October 9–November 3.

## 1957

*The Struggle for New Form*, World House Galleries, New York, January 22–February 23.

*Four Masters: Rodin, Gauguin, Brancusi, Calder*, World House Galleries, New York, March 28–April 20.

*Art abstrait, 1910–1939*, Musée d'Art et d'Industrie, Saint-Etienne, France, April 7–May 26.

*Brancusi to Giacometti*, Sidney Janis Gallery, New York, April 22–May 11.

*Triennale di Milano*, Palazzo dell'Arte al Parco, Milan, Italy, July 27–November 4.

*European Masters of Our Time*, Museum of Fine Arts, Boston, October 11–November 17.

**1958**

*Sculpture contemporaine*, Galerie Claude Bernard, Paris, February.

*50 Ans d'art moderne*, Exposition Universelle, Brussels, April 17–October 19.

*The Trojan Horse: Art Exhibit of the Machine*, Contemporary Arts Museum, Houston, September 25–November 9.

**1959**

*Prestige de l'art dans l'industrie*, Palais des Nations, Paris, May.

*Documenta II*, Orangerie, Kassel, West Germany, July 11–October 11. Also included in 1964.

*Drawings, Watercolors and Collage by 20th-Century Masters*, World House Galleries, New York, December 8–January 9, 1960.

**1960**

*Art from Ingres to Pollock*, University Art Museum, University of California, Berkeley, March 3–April 3.

*Hommage à Brancusi, XXX Biennale*, Venice, June 18–September 30.

*Paths of Abstract Art*, Cleveland Museum of Art, October 4–November 13.

*Les Sources du XX^e siècle*, Musée National d'Art Moderne, Paris, November 4–January 23, 1961.

**1961**

*Deuxième Exposition internationale de sculpture*, Musée Rodin, Paris, July–September.

*L'Art roumain du XIX^e siècle à nos jours*, Musée National d'Art Moderne, Paris, October 25–December 4.

**1962**

*Twenty Sculptors*, Staempfli Gallery, New York, January 2–20.

**1963**

*Armory Show: 50th Anniversary*, Munson-Williams-Proctor Institute, Utica, N.Y., February 17–March 31, and tour.

*Rumänische Malerei und Plastik: Ciucurencu, Brancusi, Caragea,* Künstlerhaus, Vienna, May 28–June 30.

**1964**

*The Classic Spirit in 20th-Century Art*, Sidney Janis Gallery, New York, February 4–29.

*Meisterwerke der Plastik*, Museum des 20. Jahrhunderts, Vienna, July 3–August 30.

**1965**

*Sculpture of the 20th Century*, Dallas Museum of Fine Arts, May 12–June 13.

*The Heroic Years: 1908–1914*, Museum of Fine Arts, Houston, October 21–December 8.

**1966**

*Light and Color*, Carpenter Center for Visual Arts, Harvard University, Cambridge, Massachusetts, January 6–February 20.

*Old Masters in 20th-Century Art*, Sidney Janis Gallery, New York, February 8–March 5.

*Fifty Years of Modern Art*, Cleveland Museum of Art, February 8–March 8.

*Rumanian Art of the 20th Century: Brancusi and His Countrymen*, Royal College of Art, London, October 26–November 26.

**1967**

*Man and His World*, Expo '67, Montreal, April 28–October 27.

*Colloque Brancusi*, Muzeul de Arta R.S.R., Bucharest, Romania, October 12–21.

**1968**

*Twentieth-Century Paintings and Sculpture*, Grosvenor Galleries, London, July.

**1969**

*20th-Century Masters*, Sidney Janis Gallery, New York, January 8–February 1.

**1970**

Expo '70, Tokyo, May.

*La Figure humaine dans l'art contemporain, 1910–1960*, Centre Culturel de la Ville, Malines, Belgium.

**1972**

*Modern French Art in Soviet Collections*, Rijksmuseum Kröller-Müller, Otterlo, Netherlands.

**1973**

*Pioneers of Modern Sculpture, 1890–1918*, Hayward Gallery, London, July 20–September 23.

**1975**

*20th-Century Masters: Brancusi, Arp, Mondrian, Kandinsky*, Sidney Janis Gallery, New York, October 29–November 22.

**1976**

*Un Siècle de dessins de sculpteurs (1875–1975)*, Musée des Beaux-Arts, Calais, France, March.

*Exhibition on Brancusi's Centennial*, Muzeul de Arta R.S.R., Bucharest, Romania, April 22–September 19, and tour.

**1977**

*Forty Modern Masters: An Anniversary Show*, Solomon R. Guggenheim Museum, New York, December 16–February 1, 1978.

**1978**

*The Noble Buyer: John Quinn, Patron of the Avant-garde*, Hirshhorn Museum and Sculpture Garden, Smithsonian Institution, Washington, D.C., July–September.

*Aspects of 20th-Century Art*, National Gallery of Art, Washington, D.C., October.

**1979**

*Paris–Moscou: 1900–1930*, Musée National d'Art Moderne, Centre Georges Pompidou, Paris, May 31–November 5.

**1980**

*Paris–Paris: 1937–1957*, Musée National d'Art Moderne, Centre Georges Pompidou, Paris, May 28–November 2.

**1981**

*Rodin Rediscovered*, National Gallery of Art, Washington, D.C., June 28–January 31, 1982.

*Primitivism in Modern Sculpture*, Art Gallery of Ontario, Toronto, November 7–January 3, 1982.

**1984**

*"Primitivism" in 20th Century Art: Affinity of the Tribal and the Modern*, Museum of Modern Art, New York, September 19–January 15, 1985.

**1986**

*Qu'est-ce que la sculpture moderne?*, Musée National d'Art Moderne, Centre Georges Pompidou, Paris, July 3–October 13.

**1987**

*Early Twentieth-Century European Masters*, Sidney Janis Gallery, New York, March 12–April 25.

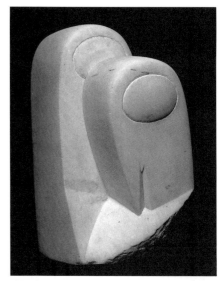

124

# Public Collections

Basel, Switzerland, Basel Kunstmuseum
Boston, Massachusetts, Museum of Fine Arts
Bucharest, Romania, Institutul Sanitar Militar
Bucharest, Romania, Socialist Republic of Romania Museum of Art
Bucharest, Romania, N. I. Grigorescu Art Institute
Bucharest, Romania, School of Fine Arts
Buffalo, New York, Albright-Knox Art Gallery
Cambridge, Massachusetts, Fogg Art Museum, Harvard University
Canberra, Australia, National Gallery of Art
Chicago, Illinois, Art Institute of Chicago
Chicago, Illinois, Arts Club of Chicago
Cleveland, Ohio, Cleveland Museum of Art
Craiova, Romania, Museum of Art
Dallas, Texas, Dallas Museum of Art
Des Moines, Iowa, Des Moines Art Center
Duisburg, West Germany, Wilhelm Lehmbruck Museum
Hamburg, West Germany, Hamburger Kunsthalle
Houston, Texas, Museum of Fine Arts
Humlebaek, Denmark, Louisiana Museum
Lincoln, Nebraska, Sheldon Memorial Art Gallery, University of Nebraska-Lincoln
London, England, Tate Gallery
Louisville, Kentucky, J. B. Speed Art Museum
Minneapolis, Minnesota, Minneapolis Institute of Arts
New Haven, Connecticut, Yale University Art Gallery
New Orleans, Louisiana, Isaac Delgado Museum of Art
New York, New York, Metropolitan Museum of Art
New York, New York, Museum of Modern Art
New York, New York, Solomon R. Guggenheim Museum
Paris, France, Musée de Sculpture en Plein Air de la Ville de Paris
Paris, France, Musée National d'Art Moderne
Pasadena, California, Norton Simon Museum
Philadelphia, Pennsylvania, Philadelphia Museum of Art
Portland, Maine, Portland Museum of Art
Rio de Janeiro, Brazil, Museu de Arte Moderna

San Francisco, California, San Francisco Museum of Modern Art
Stockholm, Sweden, Moderna Museet
Toronto, Canada, Art Gallery of Ontario
Venice, Italy, Peggy Guggenheim Collection
Washington, D.C., Hirshhorn Museum and Sculpture Garden, Smithsonian Institution
Washington, D.C., National Gallery of Art
West Palm Beach, Florida, Norton Gallery and School of Art
Winterthur, Switzerland, Kunstverein
Zurich, Switzerland, Kunsthaus Zurich

124. *Two Penguins*, 1914
White marble, 21¼ x 11 x 12 in.
The Art Institute of Chicago; Ada Turnbull Hertle Fund, 1961

125. *Bird in Space*, 1928(?)
Polished bronze (unique cast), height: 54 in.
Collection, The Museum of Modern Art; Given anonymously

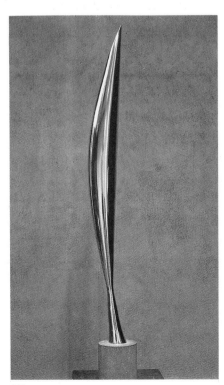

125

# Selected Bibliography

## Statements

Brancusi, Constantin. "Réponses de Brancusi; Aphorismes; Histoire de brigands." *This Quarter* (Paris) 1, no. 1, art supplement (1925): 235–46.

———. "Hommage à Rodin." Catalog of the *Quatrième Salon de la jeune sculpture*. Paris: Musée Rodin, 1952.

———. "Aphorisms." *Rumanian Review* 19, no. 1 (1965): 117–20.

## Monographs and Solo-Exhibition Catalogs

Bach, Friedrich Teja. *Brancusi*. Cologne, West Germany: Du Mont, 1987. Contains the most extensive bibliography to date as well as the best available catalogue raisonné of the sculptures.

Balas, Edith (Edit Pogámy-Balas). "The Sculpture of Brancusi in the Light of His Rumanian Heritage." Ph.D. diss., University of Pittsburgh, 1973. Available in facsimile.

Bălintescu, Alexandru. "Contribuţii documentar referitoare la Constantin Brâncuşi." In *Brâncuşi*, introduction by Nicolle Borteş, articles by V. G. Paleolog and Stefan Georgescu-Gorjan. Craiova, Romania: Muzeul de Arta, 1967.

*Brancusi*. New York: Brummer Gallery, 1926.

*Brancusi*. New York: Brummer Gallery, 1933.

*Brancusi—Turning Point in the Art of Sculpting*. The Hague: Haags Gemeentemuseum, 1970.

Brezianu, Barbu. *Brâncuşi: A Retrospective Exhibition*. Bucharest, Romania: Muzeul de Arta R.S.R., 1970.

———. *Brancusi in Romania*. Translated by Delia Razdolescu and Ilie Marcu. Bucharest, Romania: Editura Academiei R.S.R., 1976. Contains the most extensive bibliography of Romanian sources on Brancusi. Originally published as *Opera lui Constantin Brâncuşi în România*. Bucharest, Romania: Editura Academiei R.S.R., 1974.

Comarnescu, Petru. *Brâncuşi. Mit şi metamorfoză în sculptura contemporană*. Bucharest, Romania: Meridiane, 1972.

Comarnescu, Petru, Mircea Eliade, and Ionel Jianou. *Témoignages sur Brancusi*. Paris: Arted, 1967.

Eliade, Mircea, Ionel Jianou, and Constantin Noica. *Brancusi, Introduction, Témoignages*. Paris: Arted, 1982.

Geist, Sidney. *Constantin Brancusi, 1876–1957: A Retrospective Exhibition*. New York: Solomon R. Guggenheim Museum, 1969.

———. *Brancusi: The Sculpture and Drawings*. New York: Harry N. Abrams, 1975.

———. *Brancusi: The Kiss*. New York: Harper and Row, 1978.

———. *Brancusi: A Study of the Sculpture*. Rev. ed. New York: Hacker, 1983.

Giedion-Welcker, Carola. *Constantin Brancusi*. Basel, Switzerland: B. Schwabe, 1958. English ed., New York: George Braziller, 1959.

Grigorescu, Dan. *Brancusi and the Romanian Roots of His Art*. Translated by Mariana Chitoran. Bucharest, Romania: Meridiane, 1984.

Hulten, Pontus, Natalia Dumitresco, and Alexandre Istrati. *Brancusi*. New York: Harry N. Abrams, 1987.

Jianou, Ionel. *Brancusi.* Paris: Arted, 1963. English ed., New York: Tudor Publishing Co., 1963.

Jianou, Ionel, and Constantin Noica. *Introduction à la sculpture de Brancusi.* Paris: Arted, 1976.

Kramer, Hilton. *Brancusi: The Sculptor as Photographer.* Lyme, Conn.: Callaway Editions, 1979.

Lewis, David N. *Constantin Brancusi.* New York: St. Martin's Press, 1974.

Paleolog, V. G. *Brancusi.* Bucharest, Romania: Forum, 1947.

———. *Brâncuşi-Brâncuşi.* Craiova, Romania: Scrisul Românesc, 1976.

Pandrea, Petre. *Brâncuşi, amintri şi exegeze.* Bucharest, Romania: Meridiane, 1967; 2d ed., 1976.

Salles, Georges. "Discours prononcé à l'enterrement de Brancusi." In *Hommage de la sculpture à Brancusi.* Paris: Editions de Beaune, 1957.

Spear, Athena Tacha. *Brancusi's Birds.* New York: New York University Press, 1969.

Tabart, Marielle, and Isabelle Monod-Fontaine. *Brancusi, Photographer.* Preface by Pontus Hulten. New York: Agrinde Publications, 1979. Originally published as *Brancusi photographe.* Paris: Musée National d'Art Moderne, 1977.

Varia, Radu. *Brancusi.* New York: Rizzoli, 1987.

Zervos, Christian. *Constantin Brancusi: Sculptures, peintures, fresques, dessins.* Paris: Cahiers d'Art, 1957.

### Periodicals, Books, and Group-Exhibition Catalogs

Adlow, Dorothy. "Brancusi." *Drawing and Design* (London) 2 (February 1927): 37–41.

———. "Brancusi and Modern Sculpture." *Christian Science Monitor,* October 26, 1955, p. 4.

Ashton, Dore. "Art." *Arts and Architecture* 72 (December 1955): 10, 33. On the Brancusi retrospective at the Guggenheim.

Balas, Edith. "The Sculpture of Brancusi in the Light of His Rumanian Heritage." *Art Journal* 35, no. 2 (Winter 1975–76): 94–104.

———. "The Myth of African Negro Art in Brancusi's Sculpture." *Revue roumaine d'histoire de l'art* (Bucharest, Romania) 14 (1977): 107–25.

———. "Object-Sculpture, Base and Assemblage in the Art of Constantin Brancusi." *Art Journal* 38 (Fall 1978): 36–47.

———. "Brancusi, Duchamp and Dada." *Gazette des Beaux-Arts* 95 (April 1980): 165–74.

*Begründer der modernen Plastik: Arp, Brancusi, Chauvin, Duchamp-Villon, González, Laurens, Lipchitz, Pevsner.* Zurich: Kunsthaus Zurich, 1954.

Bell, Clive. "The Art of Brancusi." *Vogue* 67 (June 1, 1926): 82–83, 98.

Boime, Albert. "Brancusi in New York: Ab ovo ad infinitum." *Burlington Magazine* 112 (May 1970): 334–36.

Brezianu, Barbu. "Pages inédites de la correspondance de Brancusi." *Revue roumaine d'histoire de l'art* 1, no. 2 (1964): 385–400.

———. "The Beginnings of Brancusi." *Art Journal* 25, no. 1 (Fall 1965): 15–25.

———. "Brancusi l'artisan." *Revue roumaine d'histoire de l'art* (Bucharest, Romania) 6 (1969): 19–30.

———. "Omaggio a Brancusi. Bienala de la Venetia." *Arta* (Bucharest, Romania) 29, no. 9 (1982).

Burnham, Jack W. "Sculpture's Vanishing Base." *Artforum* 6 (November 1967): 47–55.

Chastel, André. "Brancusi dans son atelier." *Le Monde,* April 6, 1962, p. 12.

Chelimsky, Oscar. "Memoir of Brancusi." *Arts Magazine* 32 (June 1958): 18–21.

Comarnescu, Petru. "Universalitate si specific national." *Tribuna* (Jassy, Romania) February 24, 1966, pp. 1, 7. Reprinted in French as "National et universel dans l'oeuvre de Brancusi." *Revue roumaine* (Bucharest, Romania) 20, no. 1 (1966): 178–89.

"Constantin Brancusi, 81, Dies; Abstract Sculptor." *New York Herald Tribune,* March 17, 1957, p. 50.

"Constantin Brancusi: Sculptor roman." *Contemporanul* (Bucharest, Romania) 4 (January 1925). Issue devoted almost entirely to Brancusi, with texts by Marcel Janco and Miliţa Pâtraşcu, and a poem by I. Venea.

Deac, Marcel. "Brancusi: Fragmente monografice." *Arta plastica* (Bucharest, Romania) 9, no. 6 (1965): 310–11.

Doesburg, Theo van. "Constantin Brancusi." *De Stijl* (Leyden, Netherlands), nos. 79–84, Jubileum-Serie 14 (1927): 81–86. Reprint ed., Amsterdam: Athenaeum et al., 1968, vol. 2, pp. 569–71.

Dreyfus, Albert. "Constantin Brancusi." *Der Querschnitt* (Berlin) 3, nos. 3–4 (1923): 117–21.

———. "Constantin Brancusi." *Cahiers d'art* 2, no. 2 (1927): 69–74.

Dudley, Dorothy. "Brancusi." *Dial* 82 (February 1927): 123–30.

Eddy, Arthur Jerome. *Cubists and Post-Impressionism.* Chicago: A. C. McClurg, 1914.

Elgar, Frank. "Brancusi." *Dictionnaire de la sculpture moderne.* Paris: F. Hazan, 1960.

Elsen, Albert E. *Origins of Modern Sculpture: Pioneers and Premises.* New York: George Braziller, 1974.

Fondane, Benjamin. "Brancusi." *Cahiers de l'étoile* 2, no. 12, supplement (1929): 708–25.

Geist, Sidney. "The Birds." *Artforum* 9 (November 1970): 74–82. Critique of *Brancusi's Birds* by Athena Tacha Spear.

———. "Brancusi: The Centrality of the Gate." *Artforum* 12 (October 1973): 70–78.

———. "Brancusi, The Meyers and Portrait of Mrs. Eugene Meyer, Jr." *Studies in the History of Art.* Washington, D.C.: National Gallery of Art, 1974.

———. "Rodin/Brancusi." In *Rodin Rediscovered.* Washington, D.C.: National Gallery of Art, 1981.

———. "Brancusi." In *"Primitivism" in 20th Century Art: Affinity of the Tribal and the Modern,* vol. 2. New York: Museum of Modern Art, 1984.

———. "Brancusi, Brancusi." *New Criterion,* January 1988, pp. 60–67. Review of *Brancusi* by Pontus Hulten et al. and of *Brancusi* by Radu Varia.

Georgescu-Gorjan, Stefan. "The Genesis of the 'Column Without End,'" *Revue roumaine d'hisoire de l'art* (Bucharest, Romania), no. 2 (1964): 279–93.

———. "Ansamblul monumental de la Tîrgu-Jiu: 40 de ani la inaugurare." *Arta* (Bucharest, Romania) 25, no. 10 (1978): 32–35; summary in French.

———. "Catalogul expoziţiei Brâncuşi, Brummer Gallery." *Arta* (Bucharest, Romania) 26, no. 1 (1979).

Giedion-Welcker, Carola. *Contemporary Sculpture: An Evolution in Volume and Space.* Rev. ed. New York: George Wittenborn, 1964. Originally published as *Moderne Plastik: Elemente der Wirklichkeit, Masse und Auflockerung.* Zurich: H. Girsberger, 1937.

———. "Constantin Brancusi." *Horizon* 19 (March 1949): 193–202.

———. "Constantin Brancusis Weg." *Werk* 35, no. 10 (1948): 321–31. Reprinted in English in *Magazine of Art* 42 (December 1949): 290–95.

———. "Les Forces vitales et spirituelles dans la sculpture de Brancusi." *Pour l'Art* (Lausanne, Switzerland), no. 82 (1962): 25–32.

———. "Le Message de Brancusi." *XXᵉ Siècle* 26 (December 1964): 11–17.

Glueck, Grace. "'The Muse' by Brancusi Returns to Guggenheim." *New York Times*, December 21, 1985.

Guggenheim, Peggy. *Out of This Century: Confessions of an Art Addict.* Foreword by Gore Vidal; introduction by Alfred H. Barr, Jr. New York: Universe Books, 1979.

Guilbert, C. G. "Propos de Brancusi." *Prisme des arts* 2 (December 1957): 5–7.

Hamilton, George Heard. *Collection of the Société Anonyme, Museum of Modern Art, 1920.* New Haven, Conn.: Yale University Art Gallery, 1950.

———. *Painting and Sculpture in Europe, 1880–1940.* Harmondsworth, England: Penguin Books, 1967.

Hammacher, A. M. *The Evolution of Modern Sculpture: Tradition and Innovation.* New York: Harry N. Abrams, 1969.

Hoffman, Malvina. *Sculpture: Inside and Out.* New York: W. W. Norton and Co., 1939.

Howe, Russell Warren. "The Man Who Doesn't Like Michelangelo." *Apollo* 49 (May 1949): 124, 127.

Jianou, Ionel. *La Sculpture et les sculpteurs.* Paris: Fernand Nathan, 1966.

Kramer, Hilton. "Noble in Mind, Pure in Form." *New York Times Book Review*, May 26, 1968, pp. 6–7.

———. "Tracing Brancusi's Career Influences." *New York Times*, September 27, 1969.

Krauss, Rosalind E. *Passages in Modern Sculpture.* New York: Viking, 1977.

Kuhn, Walt. Walt Kuhn Papers (documents of the Armory Show), Archives of American Art, Smithsonian Institution.

Lewis, David N. "Constantin Brancusi." *Architectural Design* 28 (1958): 26–27.

M.M. "Constantin Brancusi: A Summary of Many Conversations." *Arts* 4 (July 1923): 14–29.

Merrill, Flora. "Brancusi, the Sculptor of the Spirit, Would Build 'Infinite Column' in Park." *New York World,* October 3, 1926, 4E.

Meyer, Agnes E. *Out of These Roots.* New York: Brown and Co., 1953.

Miller, Sanda. "Brancusi's 'Column of the Infinite.'" *Burlington Magazine* 122 (July 1980): 470–78.

Mocioi, Ion. "Documente brâncuşiene inédite." *Cronica* (Jassy, Romania), May 29, 1971.

Mumford, Lewis. "Brancusi and Marin." *New Republic* 49 (December 15, 1926): 112–13.

Noguchi, Isamu. *A Sculptor's World.* London: Thames and Hudson, 1967.

Opresco, George. *La Sculpture roumaine.* Bucharest Romania, 1958.

Pach, Walter. *The Masters of Modern Art.* New York: B. W. Huebsch, 1924.

———. "Brancusi." *Nation* 123 (December 1, 1926): 566.

———. *Queer Thing Painting.* New York: Harper and Bros., 1938.

Parigoris, Alexandra. "Brancusi at Tîrgu-Jiu: The Return of the 'Prodigal Son.'" *Burlington Magazine* 126 (February 1984): 76–84.

Pollack, Reginald. "Brancusi's Sculpture vs. His Homemade Legend." *Artnews* 48 (February 1960): 26–27, 63–64.

Pound, Ezra. "Brancusi." *Little Review,* Fall 1921, pp. 3–7. Reprinted in *Literary Essays of Ezra Pound.* London: Faber and Faber, 1954.

Quinn, John. John Quinn Collection, Manuscript Division, New York Public Library.

Read, Herbert. *A Concise History of Modern Sculpture.* New York: Praeger, 1964.

Ritchie, Andrew Carnduff. *Sculpture of the Twentieth Century.* New York: Museum of Modern Art, 1952.

Roché, Henri-Pierre. "Souvenirs sur Brancusi." *L'Oeil,* no. 29 (May 1957): 12–17.

Saarinen, Aline. "The Strange Story of Brancusi." *New York Times Magazine,* October 23, 1955, pp. 26–27, 38, 42.

Salzman, Gregory. "Brancusi's Woods." Master's thesis, Courtauld Institute of Arts, London, 1972.

Schildt, Goran. "Colloqui con Brancusi." *La Biennale di Venezia* 32 (June–September 1958): 21–25.

Spear, Athena Tacha. "A Contribution to Brancusi Chronology." *Art Bulletin* 48 (March 1966): 45–54.

———. "The Sculpture of Brancusi." *Burlington Magazine* 111 (March 1969): 154–58. Review of Geist's Solomon R. Guggenheim Museum exhibition catalog.

Seiwert, Franz W. "Constantin Brancusi, der Bildhauer." *a bis z* (Cologne) 2 (November 1929): 5–8.

Steichen, Edward. "Brancusi *vs.* United States." *Art in America* 50, no. 1 (1962): 55–57.

Sweeney, James Johnson. "The Brancusi Touch." *Artnews* 54 (November 1955): 22–25.

Tucker, William. "Four Sculptors. Part I: Brancusi." *Studio International* 179 (April 1970): 156–61.

———. "The Man Who Created Modern Sculpture." *Arts Guardian* (London), November 25, 1970.

———. *Early Modern Sculpture: Rodin, Degas, Matisse, Brancusi, Picasso, González.* New York: Oxford University Press, 1974.

———. "The Road to Târgu-Jiu." *Art in America* 64 (November 1976): 96–101.

Wilson, Angus. "A Visit to Brancusi's." *New York Times Book Review and Magazine,* August 19, 1923, pp. 16–17.

Zervos, Constantin. "Reflexions sur Brancusi propos de son exposition à New York, 1934." *Cahiers d'art* 9, nos. 1–4 (1934): 80–83.

Zorach, William. "The Sculpture of Constantin Brancusi." *Arts* 9 (March 9, 1926): 143–50.

## Films

*Eighty Sculptures and Twenty-three Drawings by Constantin Brancusi.* Produced by Paul Falkenberg and Hans Namuth. New York: Solomon R. Guggenheim Museum, 1972.

*Heureux comme le regard en France.* Produced by Frédéric Rossif. Paris: Centre National d'Art et de Culture Georges Pompidou, 1978.

*The Rumanian Brancusi.* Produced by Sean Hudson. London: Arts Council of Great Britain, 1976.

# Index

**Photography Credits**
The photographers and sources of photographic material other than those indicated in the captions are as follows:
Courtesy Christie's, London: plate 73; The Courtauld Institute, London: plates 9, 13; Florin Dragu, Paris: plates 37, 63; Courtesy Galerie Claude Bernard, Paris: plate 14; Courtesy Sidney Geist: plate 7; Carmelo Guadagno and David Heald: plates 50, 77; David Heald: plates, 30, 45, 61, 79; Robert E. Mates: plate 38; Courtesy Musée National d'Art Moderne, Centre Georges Pompidou, Paris: endpapers, plates 5, 51, 62, 76, 112–14, 119; Robert Rubic, New York: plate 35; Eric Shanes: plates 1, 4, 15, 23, 27, 87, 91, 95–100, 104–9, 111, 115–17; Courtesy Eric Shanes: plates 10–12, 20, 89, 90, 92–94, 103, 110, 121–23; Courtesy Tokuro Gallery, Tokyo: plate 14; Michael Tropea, Chicago: plates 31, 66.

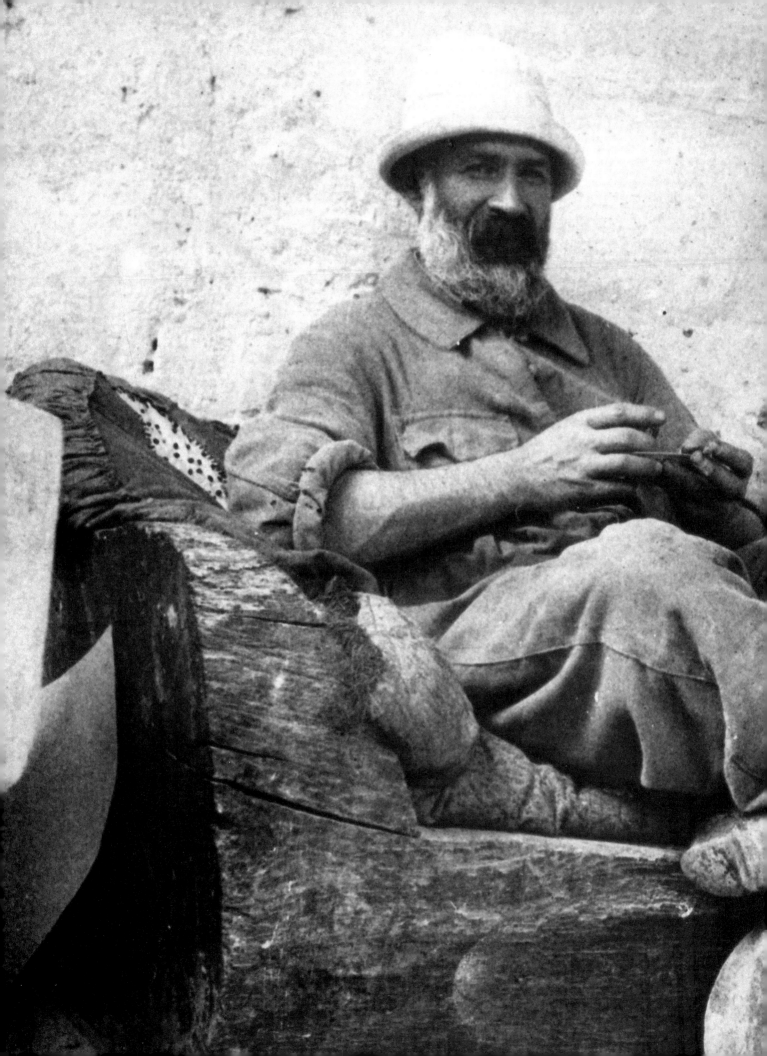